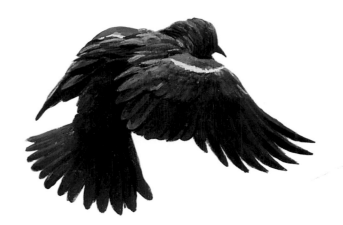

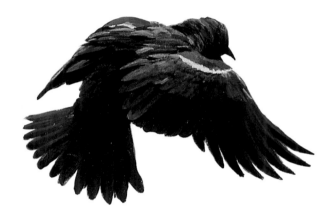

A Crescent/Madison Press Book

The Art of
ROBERT BATEMAN

Introduction by Roger Tory Peterson

Text by Ramsay Derry

CRESCENT BOOKS
NEW YORK • AVENEL, NEW JERSEY

This 1993 edition published by Crescent Books, distributed by Outlet Book Company, Inc., a Random House Company, 40 Engelhard Avenue, Avenel, New Jersey 07001

Random House
New York • Toronto • London • Sydney • Auckland

First published in Canada by Allen Lane, Penguin Books Canada Limited
First published in Great Britain by Allen Lane, Penguin Books Ltd.
First published in the United States of America by The Viking Press

First edition 1981
Reprinted 1982, 1983, 1984, 1986, 1987, 1988, 1990, 1993

Library of Congress Cataloging in Publication Data
Bateman, Robert, 1930–
 The art of Robert Bateman.
1. Bateman, Robert, 1930– 2. Birds – Pictorial works. 3. Mammals – Pictorial works. 4. Naturalists – Canada – Biography. 5. Artists – Canada – Biography. I. Derry, Ramsay. II. Title.
QH31.B255A32 759.11 81-43019
ISBN 0-517-08783-9

Produced by:
Madison Press Books
40 Madison Avenue
Toronto, Ontario
Canada M5R 2S1

The publisher would like to thank the following people whose encouragement, support, and co-operation helped make this book possible:

Ian Ballantine, Tom Beckett, Major and Mrs. Brian Booth, Jack Coles, Dr. Bristol Foster, Dr. Alan Gordon, Alfred King III, David M. Lank, Richard Lewin, Mr. and Mrs. Robert Lewin, Norman Lightfoot, Terence Shortt, William Whitehead.

The publisher is also grateful to the following for permission to use their photographs:

Birgit Freybe Bateman: pages 17, 24, 50 (below), 51, 52, 57, 168, 172; Bristol Foster: page 40; H. M. Halliday: page 31; Norman Lightfoot: pages 18, 25, 26, 27; Dave MacLachlan: page 37 (below); Donald A. Smith: pages 33, 37 (above).

Page 5/Red-winged Blackbirds and Rail Fence (detail)
Pages 6, 7/Awesome Land; acrylic, 24 × 43″, 1980
Page 9/Stream Bank – June; acrylic, 18 × 29″, 1968
Page 10/Bluffing Bull; acrylic, 24 × 32″, 1979
Page 12/Rocky Wilderness – Cougar; acrylic, 36 × 48″, 1980

Printed in Italy

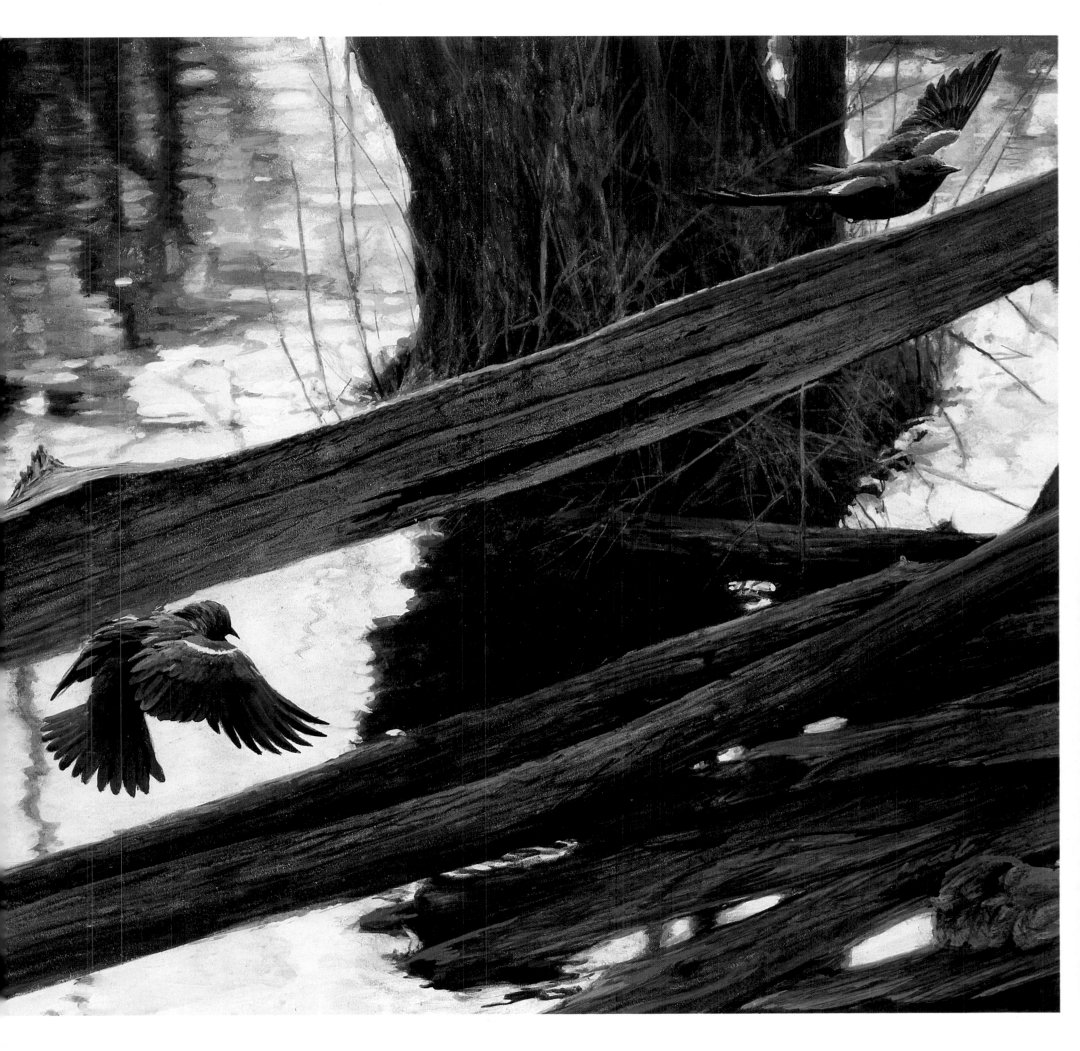

To my mother, Annie Bateman, who has shared with me her enthusiasm and her sense of pride and joy, and to my wife, Birgit, who has blessed my life with happiness, companionship and intelligent encouragement.

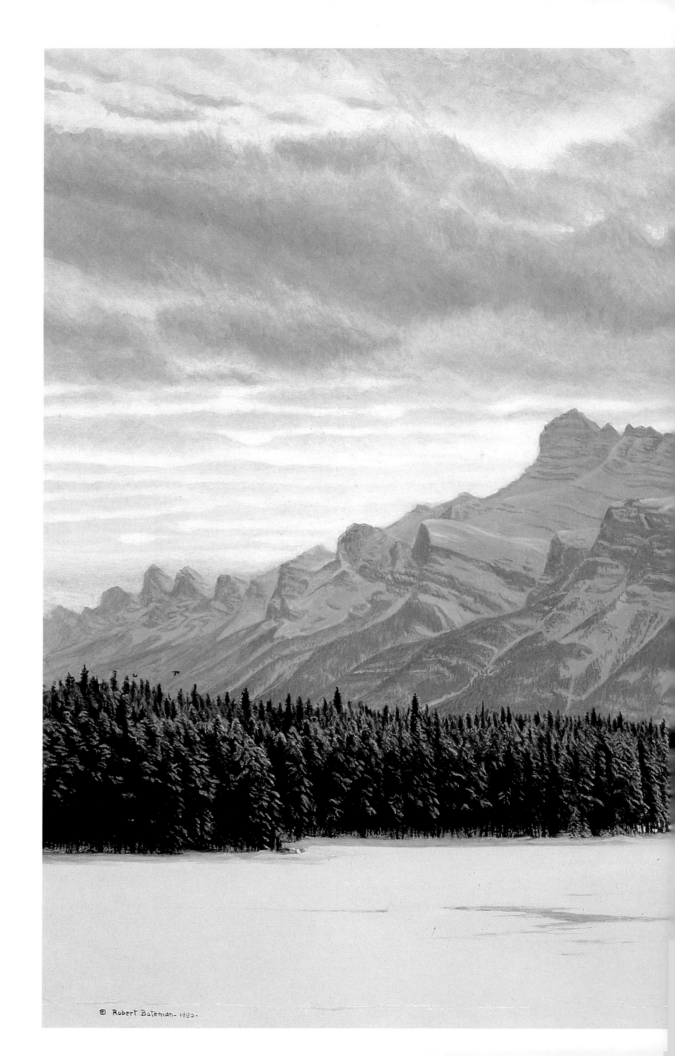

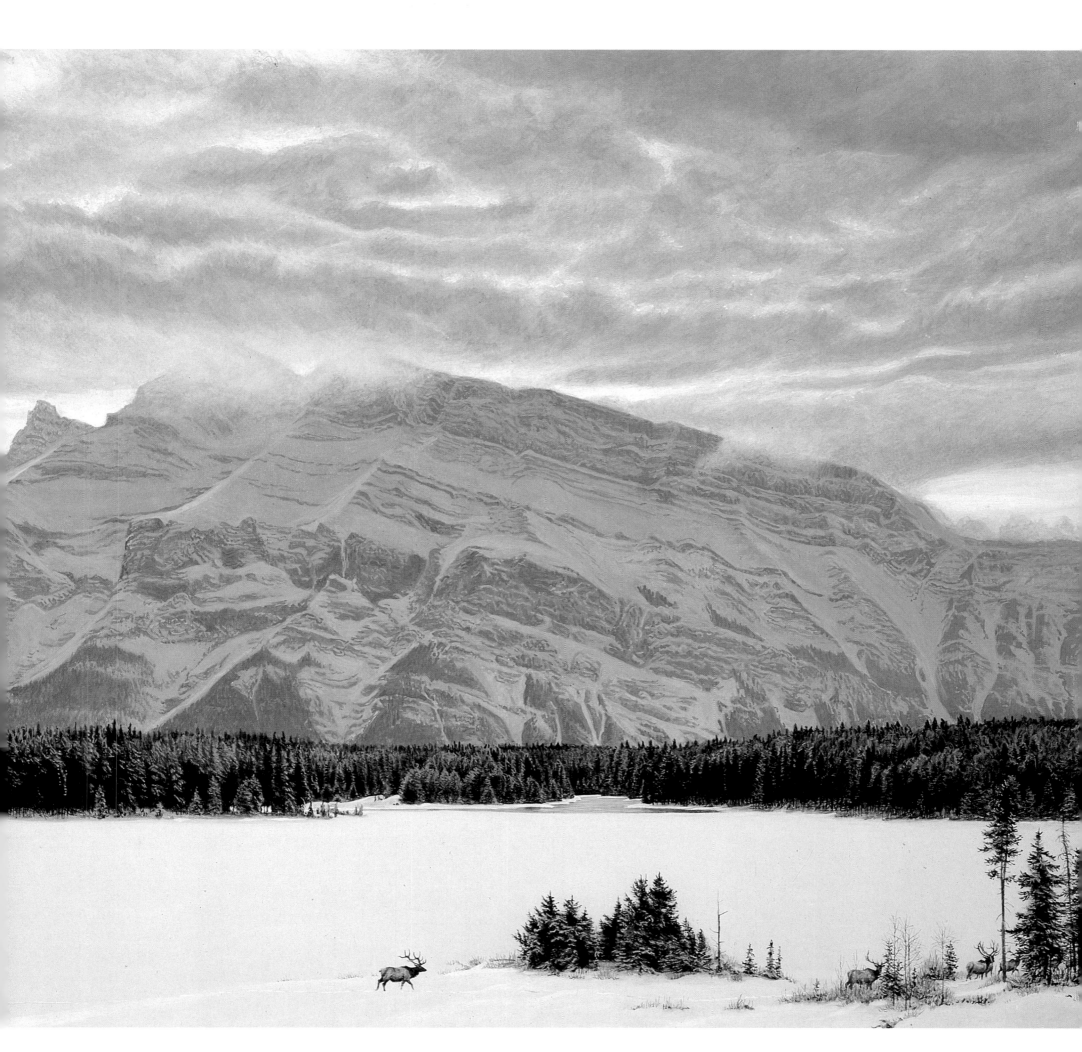

8 *It is interesting to contemplate an entangled bank, clothed with many plants of many kinds, with birds singing on the bushes, with various insects flitting about, and with worms crawling through the damp earth, and to reflect that these elaborately constructed forms, so different from each other, and dependent on each other in so complex a manner, have all been produced by laws acting around us.*

Charles Darwin

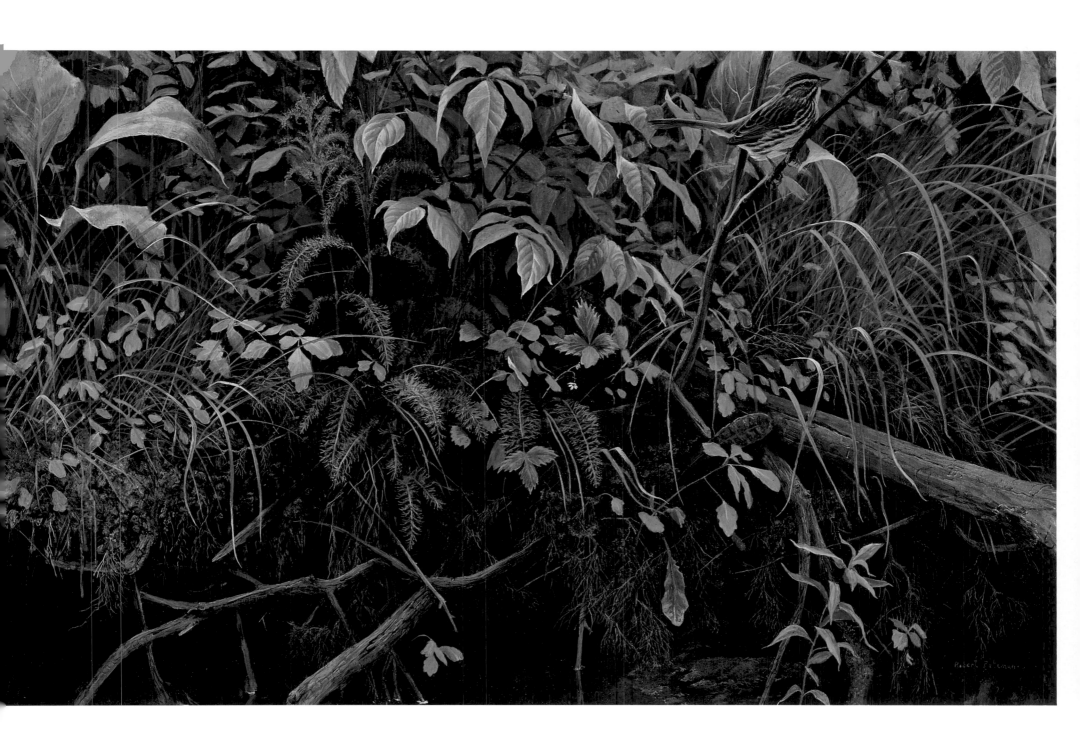

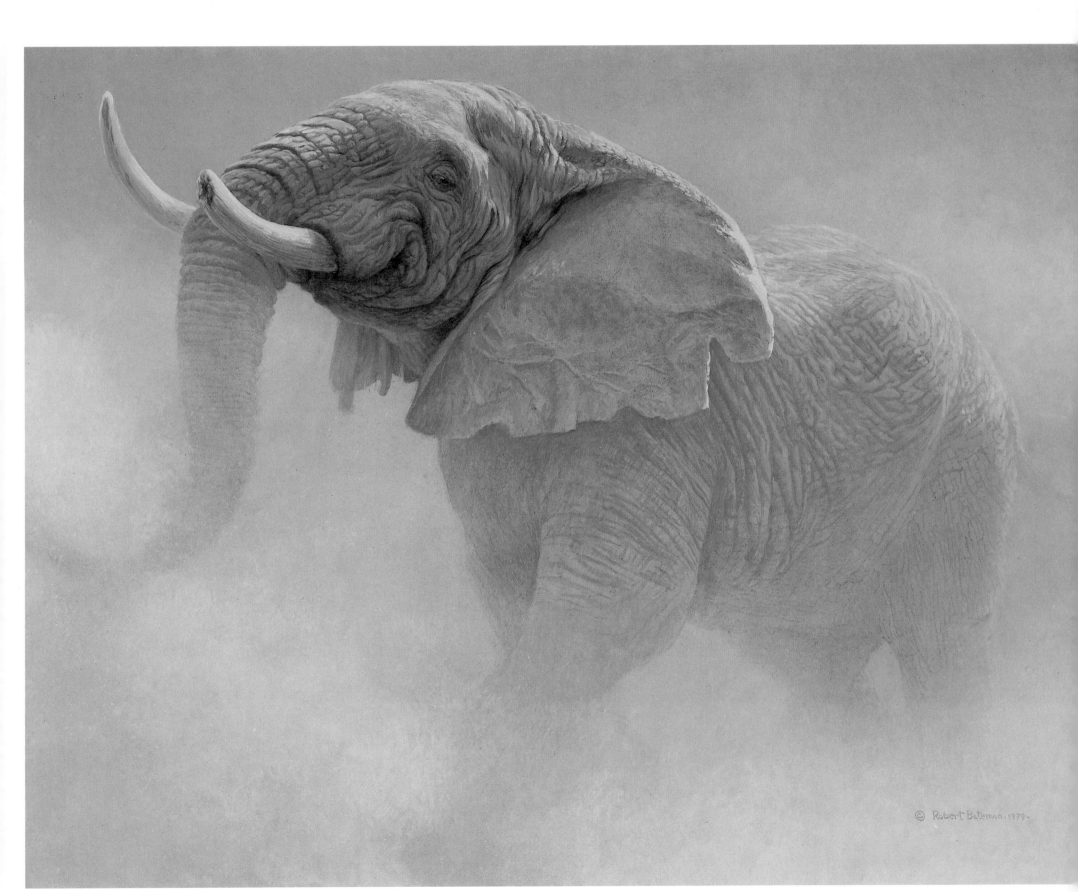
© Robert Bateman · 1979 ·

CONTENTS

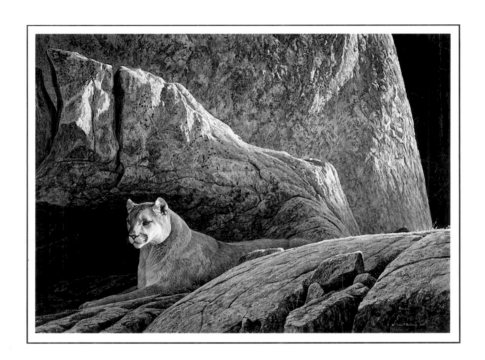

Introduction

ROGER TORY PETERSON

In the mid-sixties I saw my first Bateman — a spirited painting of a wildebeest in full gallop — which was hanging above the mantelpiece in a house in Nairobi, Kenya. The wildebeest on the wall was handled simply and impressionistically, reminding me not a little of the wall paintings of game animals by Stone Age men in the caves of southern Europe, except that it was obviously more sophisticated. The painting, I was told, was by a young Canadian, Robert Bateman, who at that time was in Nigeria teaching geography and art under Canada's External Aid programme.

Ten years later I met this remarkable artist at an exhibition entitled Animals in Art at the Royal Ontario Museum in Toronto. I immediately recalled the wildebeest painting I had seen in Nairobi. In the intervening years Robert Bateman had produced an outstanding body of work, characterized by superb naturalistic observation, by great technical skill, and by a powerful artistic imagination.

Robert Bateman's work has been likened to that of Andrew Wyeth. I might point out that Wyeth's early watercolours, done in his late teens, were very splashy, almost explosive, and one marvels that a man so young could paint with such confidence and panache. But as the years went on Wyeth regarded these works more as preliminary studies than as finished paintings. Without losing the underlying abstraction and emotion, he began to put in more and more detail until he was sometimes spending weeks, even months, on a single canvas. Bateman acknowledges a debt of gratitude to Wyeth, whose work he first saw at an exhibition in Buffalo in 1963. Like Wyeth, he begins a picture by first establishing bold patterns and then works things over with glazes and scumbling until his finished painting is highly detailed. No life is lost in the process; rather he is able to add life by digging into the subtleties of the composition.

There is an immediacy in the paintings of both Bateman and Wyeth but there is also a profound difference between them. Wyeth nostalgically freezes the moment, holds on to it, whether he portrays the boy in the coonskin hat, the farmhouse of yesteryear, or the nubile young girl brushed by light from an open window. It is a moment suspended forever. In contrast, Bateman's subjects are ready to go somewhere else, to fly away. His creatures are invariably off-centred. They enter from off canvas or are heading out towards the edge. A pheasant hurtles beyond the limits of the painting rather than flying towards the centre. This apparent imbalance gives Bateman's compositions a marvelous sense of action; a split second later the bird would be gone.

This off-centre placement of the subject is a violation of one of the standard formulas by which most other artists work, but it is effective in more than one way. Most wildlife artists will place the animal so that it faces *into* the picture area — a bird on a bough is placed just left of centre or right of centre, entering the scene. Bateman may do quite the opposite in his paintings. Take, as an example, his young barn swallow sitting on a window-ledge. The stonework and timbers of the barn's interior dominate the composition, while the small bird sits on the sill towards the lower right-hand corner, facing the immensity of the outdoor world and the sky that it will soon explore. Placing the swallow at the very edge looking out evokes a feeling of the limitlessness of its aerial domain, unrestricted by the rectangular confines of the picture. In many of Bateman's paintings, such as *Winter Elm — American Kestrel,* the bird is almost incidental to its environment. The artist is fascinated by the patterns of branchwork and the trunks of trees in this painting. The kestrel becomes the accent that brings this rather abstract composition to life.

Like many other developing artists of his generation,

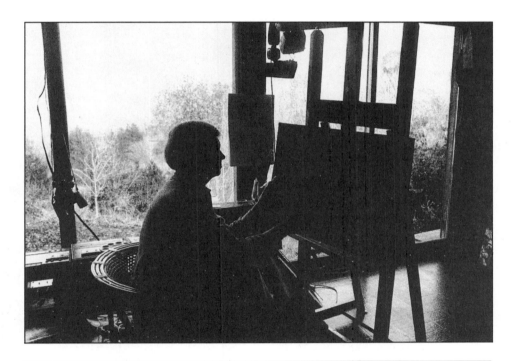

ROBERT BATEMAN

A PROFILE BY RAMSAY DERRY

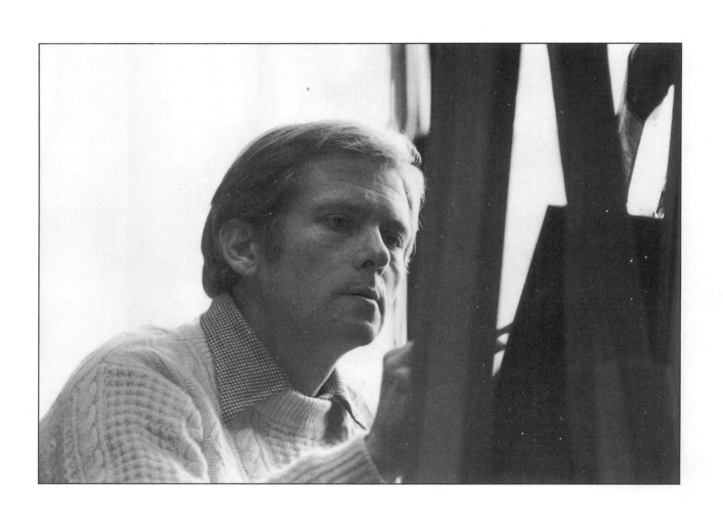

I

The view from the studio stretches northward for over eighteen miles across rolling Ontario farmlands and woods, with scarcely a sign of another house. It is a late October afternoon and there is a faint haze in the air that emphasizes the distances between the receding lines of hills. High in the sky, a tiny silhouette is soaring, and Robert Bateman turns from his easel and identifies it for his visitor as a turkey vulture, demonstrating the distinctive dihedral angle of the bird's wings with mime-like gestures of his hands. As we talk, he resumes painting, occasionally waving his brush in the air to make a point during the conversation.

"I've always done art," he says. "Most kids start drawing and painting when they are three or four years old and stop when they are ten or twelve. I never stopped. I knew by the time I was twelve that I was going to spend a lot of my life doing art and a lot of it looking at birds." He steps back from the large painting he is at work on and adopts a fierce frown – a passable imitation of a hawk's expression. Glaring out past him from the painting is the object of his impersonation, a handsome red-tailed hawk. The painting, which is nearly finished, is a powerful, direct presentation of the bird.

"Sometimes I try to hold my face in the expression of the animal I'm painting," Bateman says. "I feel I am getting inside its skin and this helps me get a good likeness." For much of his life he has been thinking about what a good likeness is, and how to convey it in a painting not just by knowing an animal's appearance, but by watching its behaviour and movement, trying to understand how it thinks and feels, and learning how it relates to the world around it.

The results of his efforts have been, by any standards, spectacularly successful. For the past ten years or so he has been recognized as one of the great artists of wildlife, with an international reputation and a demand for his paintings that he could not possibly satisfy.

This painting of the red-tailed hawk, for all its detail, has been executed fairly quickly, for Bateman has dazzling technical skills and works swiftly and steadily. But, in a way, it has a long history. Bateman has been watching, sketching and painting red-tailed hawks and other birds for more than thirty years. He has known them as pets; he has notebooks crammed with sketches of them in different poses and stages of growth, and he possesses a huge collection of photographs. He keeps their feathers around his studio, and he often borrows a skin or a stuffed specimen from a museum to check the modulation and arrangement of feathers.

Like all his pictures, this one, *Red-tailed Hawk on Mount Nemo,* began as an idea that was first expressed as a series of scarcely discernible outlines on a sketch pad. "I don't laboriously work out the whole picture before I start painting. I do little thumbnail sketches, almost doodles, of some of the principal features — for example, the placing of the animal, if it is the major subject, or the fundamental shapes of the work." Then, on a masonite board, he begins to work on the painting, first roughing in broad abstract strokes. "I start out just trying to capture the action and the composition, and I slap the paint down using fairly bold gestures to get the main rhythms and elements. At this stage I work very quickly, and I don't worry at all about the finish of it.

"A great master teacher once said, 'In order to learn how to draw you have to make two thousand mistakes. Get busy and start making them.' I've always thought that was a good principle. I just jump in and start working away, and assume that whatever I do is leading me toward my goal. At this early stage the picture looks very much the way my pictures looked twenty years ago when I was more interested in abstract and painterly qualities. Now I want to go on, retaining the rhythm of the earlier strokes, but giving them more and more finish, trying to capture the surface of the real world rather than the surface of the paint." This is a

process of revising and refining and filling in. When it is finished, parts of the picture will have been executed in a trice, while others will have been reworked many times.

A Bateman picture is full of information. It reflects a scientific knowledge of the species and a feeling for its nature and behaviour, and it shows a landscape that is accurately detailed and fully realized; a botanist can identify the various elements of vegetation, a geologist the rock types and perhaps where they may be found. Season and weather are conveyed. It is a painting that depicts the whole environment of the species, alive, inter-relating, and constantly changing. This sensitivity to an animal's environment is the hallmark of a Bateman painting.

The wealth of information in his paintings, and the brilliance with which it is presented, make them so instantly understandable to a viewer that it requires an effort to look beyond the subject matter to appreciate the handling of space and depth, the subtle presentation of mood, and the powerful and recurring abstract shapes.

All of Bateman's wildlife pictures have a strong abstract composition, and they are as much about painting as they are about wildlife. He has a great love for Oriental and for primitive art and he is at ease with the various movements of modern art and is an enthusiast for the work of the abstract expressionists. Over the years he has himself painted in a variety of styles, including the purely abstract.

Bateman revels in his eclectic taste in art and in the diversity of influences he has responded to as an artist. Consequently he resists the idea of categorizing art, maintaining that all good art should be enjoyed and respected for its own merits. Likewise, he looks at nature as an ecologist, seeing each species of animal or insect or plant in relation to its environment, with its own role, and its own importance and value.

Bob Bateman is a compact, handsome man, the regularity of his features disarmingly relieved by a slightly gap-toothed smile. Here, in the studio, he talks easily as he works, sometimes welcoming a distraction that may let him resolve a problem or create an element more intuitively. He is far along with this painting, not often referring now to the agglomeration of sketches, notes, photographs, and models that he used at an earlier stage. Occasionally he steps back and turns to look at the picture through an angled mirror behind him. "I often use a mirror to see the power and rhythm in a painting," he says. "Looking at a picture in reverse gives it a new perspective so that you can see the dynamic forces — or their absence."

His brush strokes are quick, regular, and surprisingly loose. The effect of meticulous detail, often the thing people first exclaim about when they see his pictures, is brought about more by his assured draughtsmanship and painterly techniques deriving from impressionism and cubism, than by the microscopic application of paint. The effect of detail alone is not of much interest to him, and he is never excited by praise for it. The richness of a Bateman painting frequently derives from the series of glazes and washes he applies. He often uses the renaissance technique of underpainting, blocking in the main forms in opaque greys and sepias and then building up the painting with alternating layers of transparent and opaque paint, finishing with transparent.

When Robert Bateman says he has always done art, he means it. He started young and has practically never stopped. He sketches and paints every day. As an artist he is now extraordinarily productive even though he often rejects, repaints, and revises. He appears cheerful and playful about his art, though he admits that most of the time spent on a painting is a struggle. "It certainly is not a pleasant relaxation, any more than playing golf is a pleasant relaxation for Arnold Palmer. It's serious work and very often it can get, well, almost depressing. I get very, very discouraged soon after I start a picture. The first five per cent is exciting

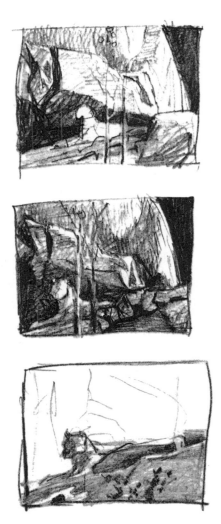

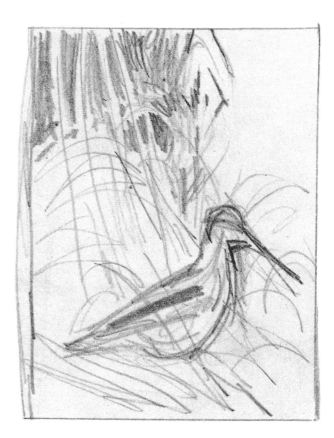

Originating sketches for *Rocky Wilderness* (p. 12) and *Snipe* (p. 92).

and I think it looks great, but then it starts looking worse and worse and eventually I put it to one side. I know from experience what is going to happen, so I don't give up. I start another picture, and then perhaps another, each of them getting to this same awful stage. Eventually, by comparison the first one looks better to me, so I return to it. It isn't until I get to the last two per cent that it begins to look good to me again.

"Sometimes, when I'm about halfway through a painting and it's gone flat and dead on me I like to put it in a frame, if I have one the right size, and this encourages me and cheers me up. It also helps to enclose the picture and show me where I can develop the forces in it."

Around him in the studio, stacked against the walls, are half a dozen pictures still underway. This is partly because he is working hard now for an upcoming exhibition, but, as he says, there are always a number on the go. Sometimes he changes from one to another several times a day to give himself a change of pace or a temporary escape from a problem, or perhaps just to give a painting time to dry.

The studio, like his house and his mind, is unashamedly eclectic. He is surrounded by the traditional bric-à-brac of the artist — easel, palette, paints, knives, brushes, pencils, erasers, razor blades, various overhead lights, the mirror behind him. There is also a great collection of electronic equipment — a radio, a tape recorder and numerous cassettes, a television set with a Betamax to save some of the good shows (by no means all of them related to art or wildlife). He enjoys such aspects of the electronic world, and listens as he works to the mix of current affairs and classical music on the Canadian Broadcasting Corporation radio stations. His musical tastes are eclectic too. Besides baroque and chamber music, he likes bluegrass and country-and-western, and he has played the guitar and sung folk songs since he was a teenager.

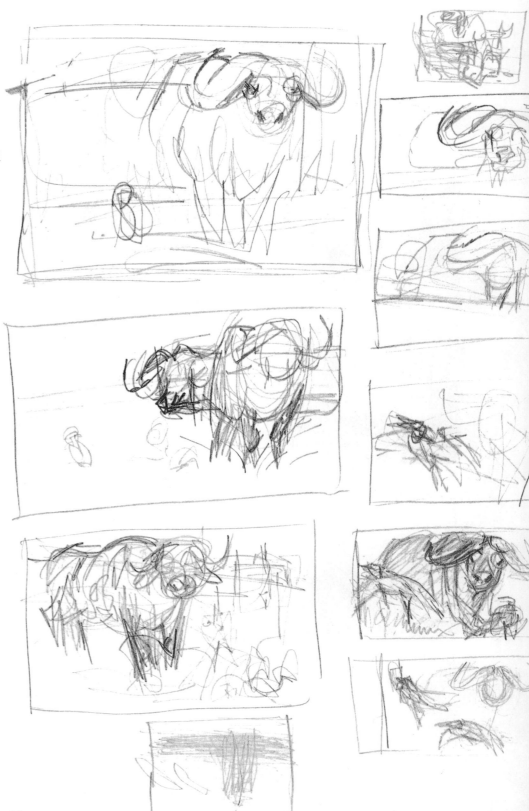

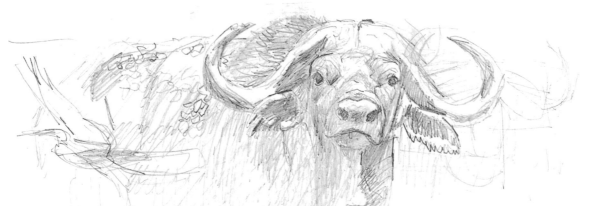

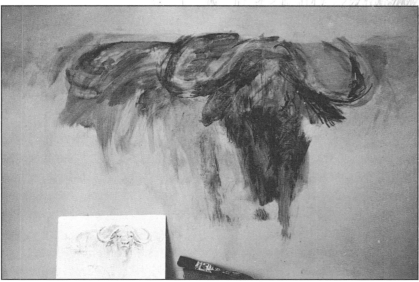

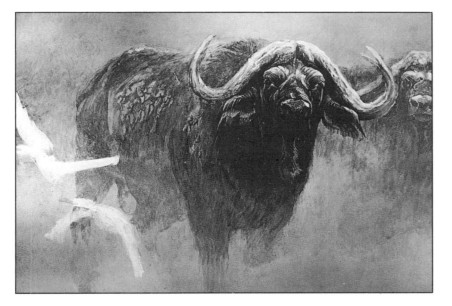

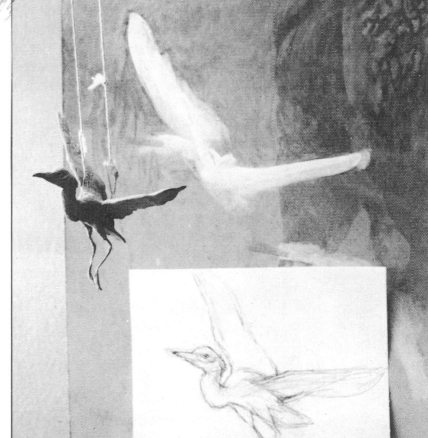

The evolution of a painting – *Master of the Herd* (p. 143). In the sketchbook (*opposite*) Bateman moves through a series of rough sketches and compositional studies until he arrives at the basic T shape that he wants for the picture in the final little sketch on the bottom left of the page. He then begins the painting itself by roughing in the same shape. A more detailed drawing is used as a guide as he begins filling in the picture. (*top left*) The egrets flying off to the left of the painting begin as quite casual shapes. Later, Bateman makes Plasticine models of them so that he can experiment with positions and perspectives before filling in the final detail.

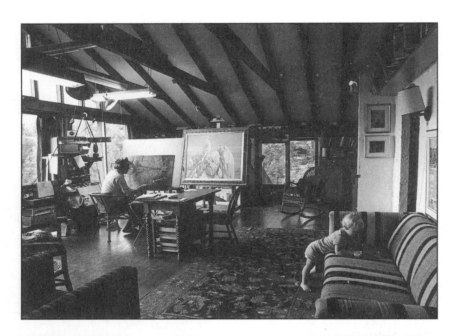

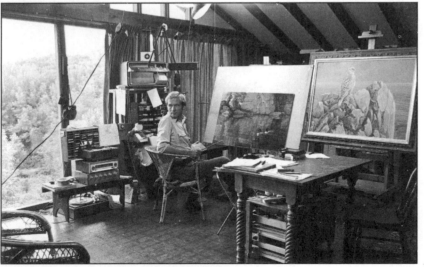

The studio. Bateman is at work on a painting of a loon family which was commissioned by the Government of Canada as a wedding present for H.R.H. Prince Charles.

Around him, held together with string and elastic bands, are gadgets to support slide viewers, sketch pads, and oddments of nature specimens, and there is a Rube Goldberg contraption that controls the volume of the television. Every flat surface in the studio is covered with paper, letters, articles, uncashed cheques, sketches, photographs. When he can't find something — which is quite often — Bob calls his wife, Birgit, who usually knows where it is.

Birgit Freybe Bateman is a beautiful woman with strawberry blonde hair and striking nordic features. She is some years younger than Bob, and is clearly a dynamic force in his life. She is a working artist as well, and specializes in abstract works in weaving and rug hooking. Originally from British Columbia, she was working as an art teacher when she and Bob met about ten years ago. It is a second marriage for both of them. Birgit enjoys the out-of-doors as much as Bob does, and she often goes along on his field trips and expeditions, whether bird- and animal-watching in various parts of the world, scuba-diving, or cross-country skiing. A good organizer, she does her best to keep the details of his career in order, but this is now a mammoth job. Birgit has ample strength of personality to withstand the inevitable pressure of an accomplished artist's ego, and she is an influential critic of Bob's works in progress as well as being his greatest fan.

As Bob paints, the telephone jangles frequently. He tucks the receiver into his shoulder and chats, still painting. The calls are from his dealers, his print publisher, his three older children who live with his first wife, his friends, or from collectors of his work, some of them calling from hundreds of miles away. He likes the calls, but is too accessible, easily drawn by casual requests and demands on his time.

He has never demanded privacy for his work. From the time he started painting as a child he was used to family and friends wandering about him and talking as he worked.

Now Bob and Birgit's two younger children, Christopher and Robbie, play in a room off the studio and run in and out, the youngest occasionally making a contributory daub to his father's current work.

The studio itself is a kind of gallery overhanging the open-plan living area of the house. This is a shouting sort of house, with everyone just within calling distance. Bob designed it himself and helped in its construction, and he is very proud of it. It is an unpretentious and seemingly casual amalgam of Swiss, Tudor, and Japanese domestic styles built on a modest scale. Its several levels include a discreetly sunken sitting area into which unwarned guests may pitch headlong with a cry and a crash. The furniture is covered in warm, earthy colours set off by some hangings woven by Birgit. Beside the dining table is a small indoor and outdoor Japanese-style garden with pools on either side of a floor-length window. Throughout the house there are exposed beams, large windows, and plenty of wall space hung with paintings and carvings, many of them African and Oriental pieces that Bob has collected on his trips. The handsomely carved front door of the house was brought back from Nigeria.

The house stands on land that Bob had bought when he was still in his twenties and then left empty until he was ready to build. The property has all the features he wanted — a few acres, a stream, a woodlot, a view. It is tucked into a declivity in the Niagara Escarpment about forty miles west of Toronto. Southern Ontario is topographically unsensational, but the escarpment, a several-hundred-mile-long cuesta of limestone topped by a layer of dolomite, rises abruptly from the surrounding farmland and extends north from Niagara Falls into Lake Huron. It is just about the only upstanding landscape feature in this part of the province and includes some of the few remaining wilderness areas. As a

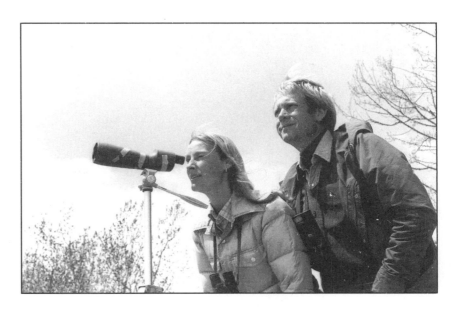

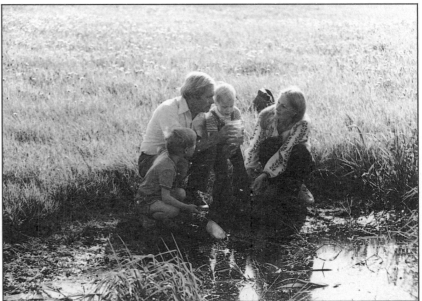

Above: birdwatching with Birgit in the early spring.
Below: Bob with Birgit and their children, Christopher (left) and Robbie.

Bob designed his house and helped build it. He combined a
variety of rural styles — Japanese, Swiss, Tudor — that
pleased him. The studio is the room at the upper left.

result, the land is protected and quarrelled over by an assortment of commissions, trail associations, landowners' groups, and government bodies. Bob, who has always been a club and organization man (especially when it has to do with nature and conservation) has served on the boards of several of these and is currently a member of the Niagara Escarpment Commission.

The escarpment's characteristic landscape and its limestone rock appear in a number of Bateman pictures, including the one of the red-tailed hawk he is now working on. Although he has been living and painting in this area for over twenty years, he has never grown tired of it, any more than he has grown tired of the country around the cottage in Haliburton, one hundred miles to the northeast, that he has been going to ever since he was a child.

Nonetheless, there are many parts of the world in which Bateman would be happy to live, and he and Birgit are contemplating a move to the coast of British Columbia, a naturalist's paradise. But southern Ontario has been an ideal base for him. He says, "I like living where my roots are and where my friends and relatives live, and I enjoy the blend of the natural world and the historical world that you get in southern Ontario." The house is less than an hour's drive from Toronto's galleries, museums, and resource material, and it is only a little over an hour from Buffalo. Buffalo's fine Albright-Knox Gallery gave Bob easy access to the exciting New York painters of the fifties and early sixties, and its zoo gave him some good live models for his paintings. He is very much a part of the community around him, having taught high school in the area for twenty years, and he is active in a variety of local associations. Moreover, two

nearby art galleries, the Alice Peck Gallery in Burlington and the Beckett Gallery in Hamilton, were instrumental in the early phase of his career, and he has a great local following of people who have been buying his paintings since he began exhibiting fifteen years ago.

These series were done when Bob was fourteen. At that time he liked to paint species of birds in a systematic way. As a teenager he was strongly influenced by the bird paintings of Major Allan Brooks, an artist for whom he still has great admiration.

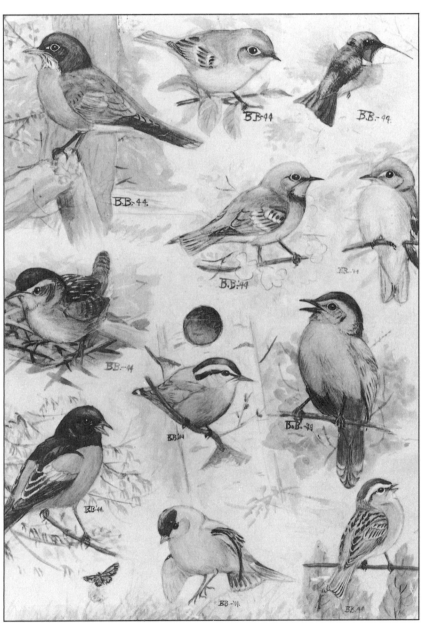

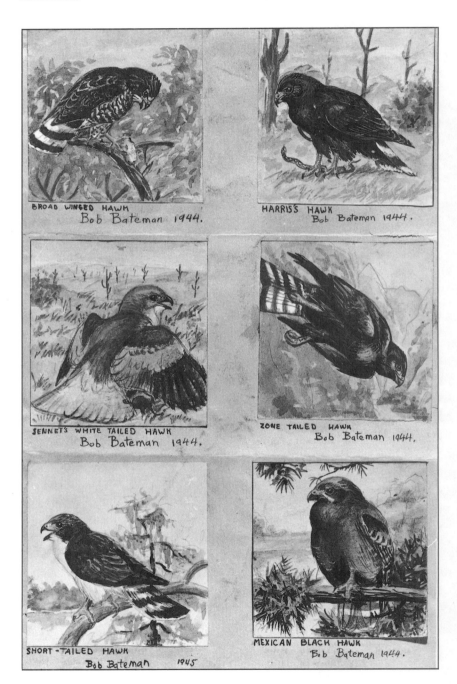

Left: "The Birds in Our Garden"
Right: "Hawks of North America"

II

Robert Bateman's public career as an artist began in 1965, for it was then, at the age of thirty-five, that he developed the style of painting animals for which he is now famous. This is a style distinguished by superb draughtsmanship and technical skill, subtle use of colour, powerful and resonant composition, all reflecting a vision of nature which is scientifically informed and personally engaged. None of these various elements evolved overnight but they all developed over the years in ways that were in themselves natural and productive.

Bob was born in Toronto in 1930. When he was six, his father had a house built on a lot in what was then the northwest quarter of the city. It was on the edge of the affluent Forest Hill Village district, and it was also on the edge of the countryside, with a garden that spilled down into one of the ravines that run through the city. Through the ravine ran a railway line — a now long-defunct suburban service called the Belt Line — but in those years there were at most only two trains a day; the rest of the time the ravine was quiet, inhabited by birds and other small wildlife, and with a stream filled with minnows and tadpoles and painted turtles. It was the perfect place for a budding naturalist. Toronto is on major bird migration routes and every May birds would funnel up the ravine in tremendous variety. During a two-year period Bob recorded over one hundred species in his neighbourhood, including, once, a flock of white pelicans spotted flying high overhead early one morning as he delivered newspapers. From his house he could walk into countryside, and west of Bathurst Street, about a quarter of a mile away, there were open fields and marshes, full of meadowlarks and bobolinks and the occasional owl.

Bob's family was stable and close. His father, Wilbur Bateman, had been raised on a farm in eastern Ontario. He became an electrical engineer and worked for many years with Canadian General Electric. Bob's mother had grown up in Nova Scotia with United Empire Loyalist antecedents and a family history of shipbuilding. Bob is the eldest of their three sons; Jack, who is three years younger, is now the Ontario Fire Marshal, and Ross, who is three years younger again, is an art teacher and designer. Neither of the Bateman parents displayed exceptional artistic gifts or had a special interest in nature, but they both encouraged their children. They recognized Bob's talent early and tolerated his perpetual painting projects, as well as the succession of owls, crows, raccoons, and the many other wild animals that he and his friends kept as pets.

When Bob was eight, his parents rented (and later bought) a cottage in Haliburton. This cottage — in fact the whole region — has been a constant factor in Bob's life. He has spent substantial parts of almost every summer there, and he goes there now with his own children. He wrote his undergraduate thesis in geography on the Haliburton region and has a ceaseless interest in every aspect of its human and natural history. As a child and a teenager there, his time was always filled. There were places to explore, specimens to catch and stuff, and pictures to complete, often to the exasperation of his brothers and parents who were occasionally ready for less single-minded recreations. If Bob has a spiritual home, it is the Haliburton cottage.

By the time he was twelve he knew that the primary interests in his life were going to be wildlife and art — although he didn't know in what combination — and he was painting systematically and regularly. He was obsessed with nature, and spent all his weekends with two friends, Alan Gordon and Don Smith (both of whom are now biologists), hiking and exploring around the edges of the city, spotting birds and climbing trees and cliffs to examine nests, sketching and noting everything he saw. Their adventures were always remembered by the variety or rarity of the species they encountered.

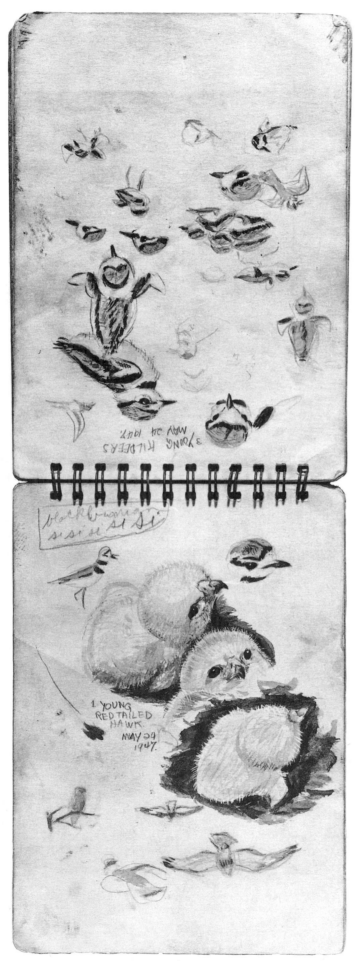

Sketchbook, May 24, 1947. Bob's birthday, was the traditional Queen's Birthday holiday at the height of the birdwatching season. On his seventeenth birthday he recorded a young red-tailed hawk in its nest, a killdeer mother doing the classic broken-wing act near her nest, and a Blackburnian warbler that Bob identified by its sound.

Most days after school Bob would go to the Batemans' sunroom and pore over all the illustrations of wildlife he could get his hands on. Among these were the drawings in Ernest Thompson Seton's *Two Little Savages,* and the work of Walter Weber and Major Allan Brooks, a distinguished bird painter of the period, whose pictures appeared in *Canadian Nature.* Roger Tory Peterson's first and revolutionary *Field Guide to the Birds* had just been published and was an important catalyst to Bob's birding activities. Then he became familiar with the work of Louis Agassiz Fuertes, the great American bird illustrator. He looked at everything, and, often chivvied and encouraged by Alan, he tried all sorts of different styles. They both loved the work of Milton Caniff, the cartoonist of *Terry and the Pirates.* A real artist, Caniff's cartoon panels were filled with detail and contained fully worked landscapes. At first the boys were not admirers of Audubon: they thought the poses of his birds were over-dramatic and eccentric, and it was only later, as they became more experienced birdwatchers, that they began to recognize his peculiar accuracy and genius.

When Bob was about twelve, his mother, with unerring good sense, sent him off with Alan to join the Junior Field Naturalists Club at the Royal Ontario Museum. He has always been grateful to her for this, for it was a turning point in his life.

The museum, a handsome stone building on the edge of the University of Toronto campus, was still in the heyday of its initial growth, with a deeply committed and often unorthodox staff dedicated to the enlargement of its collections and to the dissemination of knowledge. The Junior Field Naturalists Club was part of the museum's Saturday morning programme designed to give young people an introduction to science and art. It was run by a combination of volunteers and museum staff.

In their first two years in the club, Bob and Alan spent

much of their time learning bird carving from a retired tradesman called Frank Smith. A homespun character with an intense interest in the world around him, Smith had little formal education and no professional background in either wildlife or art. But he was a highly informed and enthusiastic naturalist who loved sharing his knowledge with young people. He was wonderfully skilled in carving balsa wood birds, including duck decoys — an art not much appreciated at that time — and the two years Bob spent with him became a fundamental part of his training as an artist. Even today it is often his habit when undertaking a painting to make a model of the subject (usually in Plasticine) trying different poses and viewing them from different angles.

As Bob and his friends became familiar with the museum they discovered that its august senior staff was surprisingly accessible. First there was James L. Baillie, the assistant curator of ornithology. Baillie had left school at sixteen and become a grocery delivery boy, but he had a passion for birds and at eighteen he got a job with the museum's ornithology section, where he had a distinguished career. He became one of the Royal Ontario Museum's best known figures and had a birdwatching column in the *Toronto Telegram* for twenty-eight years. At the museum he was determined to make himself available to the public, especially to young people. As a result his office was regularly invaded by troops of teenaged birdwatchers. Bob Bateman and his friends were regular visitors, learning about the museum's growing collections and developing their birdwatching skills and ornithological knowledge.

As he got a little older Bob began to pay attention to the quiet man in the office next to Jim Baillie's. This was Terence Shortt, the museum's chief illustrator and head of its Department of Arts and Exhibits. A modest, highly articulate, and rather elegant man, Shortt is a brilliant ornithologist and an outstanding bird painter. Like Jim

Baillie, he had comparatively little formal training, other than a brief encounter with the Winnipeg School of Art. He joined the museum as a young man and soon after went on an extended field trip to the Arctic with F. H. Varley, an outstanding portraitist and a member of the Group of Seven artists who dominated Canadian painting in the nineteen twenties and thirties. Shortt says that it was from Varley that he received his real education as an artist. Shortt's education in ornithology likewise was learned mainly on the job on many field trips and at the museum.

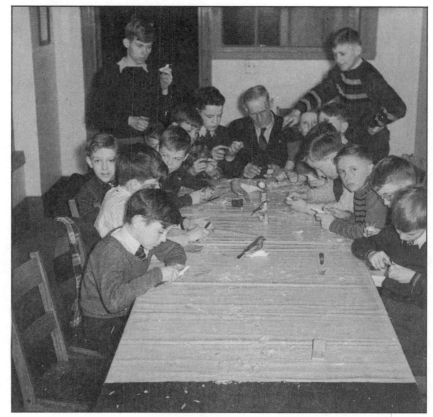

Bird carving class at the Royal Ontario Museum, 1944. The instructor, Frank Smith, is seated at the head of the table. Standing to the left and right of him are Bob Bateman and Alan Gordon.

Bob was dazzled by Shortt's knowledge of bird anatomy and behaviour. On one occasion Bob found in Algonquin Park a feather he couldn't identify. He took it back to Terry who glanced at it and said, "I'm not sure. It's either the third or fourth primary from the left wing of an immature female goshawk." The only doubt in Shortt's mind was whether it was the third or fourth. A check with the museum's specimens confirmed that it was the third.

With his encyclopaedic knowledge of ornithology, his artistic sensibility, and wide-ranging, humane imagination, Terry Shortt soon became a major and long-lasting influence on Bob Bateman. More than anyone else, he has encouraged Bob in the field of bird artistry. Shortt remembers Bob in those days as "a very personable young man, fair, clean cut, and with steady serious eyes — not that he didn't have a sense of humour — but there was a direction in them, and I knew right from the start that this was a chap who, whatever he was going to do, was going to do it very well."

By the time they were in their late teens, Bob and Alan Gordon and Don Smith had outgrown the Junior Field Naturalists and were restless without an organization to stimulate them. They found a group of like-minded people, some of them a bit older, a few recently returned war veterans. Calling themselves the Intermediate Naturalists, the new group, nearly all of them intent on careers as naturalists, continued to meet in the museum under the aegis of the museum staff. Terry Shortt remembers them as an outstanding group, and an impressive number of them today have senior positions in the world of Canadian wildlife biology, ecology, and conservation.

Although Bob is the only one of the group who has become internationally known as an artist, several of them drew and painted or were accomplished photographers, and the relationship between wildlife biology, photography, and art seemed to be a natural and comfortable one. This group was, Bob says, the most important nucleus of people in his life, and several of its members are still his closest friends.

When he was seventeen Bob had the good luck to get a summer job at a government wildlife research camp in Algonquin Park. Though much of the work was fairly menial — washing dishes and digging garbage pits and cleaning carcasses of the less delicate specimens — he also learned how to set trap lines, to catch and stuff specimens, to do a bird census and to catalogue and to illustrate the samples. During the three summers he was there he picked up an enormous amount of animal lore and he says, "It was then that I really learned my bird calls and now I can identify ninety-five per cent of what I hear in this part of the world."

The situation for Bob at the research camp was idyllic. He was able to see wildlife scientists at work and he learned how they think. He loved the give-and-take of dispassionate argument and the discussions over methodology and techniques of observation and measurement. He found it fascinating to meet people who combined an enthusiasm for nature and wilderness living with civilized and cultured thought and whose interests were not limited to their work. One of the camp customs was for the researchers to entertain each other after lunch with readings, usually out-of-doors, from non-scientific writers such as Stephen Leacock, James Thurber, and Sir Arthur Conan Doyle.

Moreover, there was the Park itself, almost a place of pilgrimage for Bob. The oldest, and still one of the largest of the Ontario Provincial Parks, covering nearly three thousand square miles, Algonquin Park is on the edge of the Canadian Shield, and has a combination of lakes, woodlands, and rocky uplands that epitomize the idea of the northland. In the years around and after the First World War, Tom Thomson and artists of the Group of Seven, such as A. Y. Jackson and Lawren Harris, had painted the north country in a style that has fixed itself permanently on the public imagination. Their

work is comparatively unknown outside Canada, but it dominates the history of Canadian art, and every young artist has to respond or react to it. Bob, who was by now paying attention to art styles, was inevitably excited by these swirling and inspiring landscapes, many of them painted right in the Park. "I idolized Thomson and the Group," he says "and I went off in a canoe to sketch and paint at every possible opportunity. I considered it a point of honour to complete an oil painting on the spot as they did." During these summers in the Park his painting style evolved swiftly from straightforward bird illustrations through a bold-stroked, Group of Seven-inspired style, and into a phase influenced by Cézanne and Rockwell Kent.

After working for three summers at the camp, Bob had developed a close affinity for the world of wildlife biology and zoology and a strong sense of himself as a scientist contributing to science. Although he did not pursue biology as a career, he has remained close to this field and has a scientific reputation as a recorder and collector of small mammal specimens. Almost everywhere he travelled in the next fifteen years, he set trap lines for different species of small mammals, stuffing, noting, and sketching the specimens for museums. While he was still working in the Park he recorded rare specimens of water shrews and bog lemming mice, and later, during a summer spent in Ungava, he made an exceptional collection of the Ungava *phenacomys,* a yellow-nosed vole of which there were previously only about twelve known museum specimens in the world. Bob presented the Royal Ontario Museum with seventy specimens of the species. Museums are voracious accumulators of representative specimens for taxonomic purposes, and Bob's contributions in this field are cited in various scientific reports.

Bob had always wanted to attend university, and in fact had been active in the Biology Club of the University of

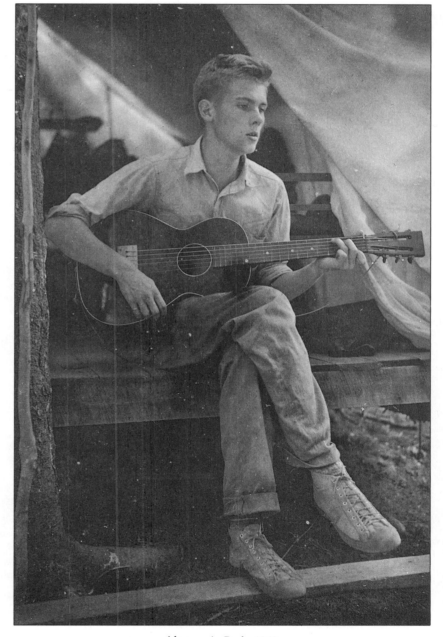

Algonquin Park, 1949.

33

Lake Boshkung, Haliburton, 1949.

Toronto while he was still in high school. In 1950 he entered the University as a student, and eventually decided on an honours course in geography. He didn't choose the fine art course because he was more attracted to the field aspect of geography. Most of his friends were becoming biologists, but Bob had neither the mathematical ability nor the inclination to join them. Theoretical science did not interest him, whereas the broad-ranging geography course reflected his own wide interest as a naturalist and gave him a good general science education, including a background in geology and landforms, and in the human and animal relationships to the environment. Geography offered him opportunities to get exciting summer jobs on field parties in remote parts of the country, and ultimately it would give him excellent qualifications as a high-school teacher.

He knew that he would continue to grow as an artist through his own reading, through looking at art wherever he found it, and through learning from other artists. He had already made a good start. When he was eighteen, he had won a Junior League scholarship for art tuition which he had used for classes with Gordon Payne at the Arts and Letters Club. Payne, a well-respected artist who painted in a traditional style, was a superb technician, and for two years Bob learned from him how to handle his materials and the basic skills of representational painting. In addition, Payne introduced Bob to the works of Cézanne and Picasso and to a highly analytical study, Earle Loran's *Cézanne's Compositions*. This book gave Bob a set of tenets in composition which are still fundamental to his work: the establishment of tensions, the use of distortion, the effect of the orchestration of forms, and overall, an approach to the picture as a whole world of its own.

Although painting and drawing were not part of Bob's curriculum at university, they remained an important part of his life. At Hart House, the university's student centre, he found he could take evening classes in drawing from Carl Schaefer, a distinguished artist who had been associated with the Group of Seven. Schaefer taught the Nikolaides method of drawing, which emphasized economy and sureness of line to catch the essence of the subject. In teaching gesture drawing using a nude model, Schaefer would at first allow his students only five or ten seconds to view and depict the model's pose. As the students became more adept they were allowed a little more time. Schaefer's most damning word was "precious" and he would sometimes say that if a thing couldn't be painted with the back end of a broom it wasn't worth painting. Bob suspects now that some of his current, richly worked paintings might be indicted as precious by Schaefer's standards; nonetheless the rhythms and strong patterns learned from Schaefer are still there.

Bob studied with Schaefer for five years and this training gave his already highly developed drawing style a strong formal base. The emphasis on speed and economy came easily to him and remains an important part of his technique. In the field, the innumerable quick sketches he makes are a kind of shorthand. "The most exciting wildlife is always on the move. You're lucky if something stays still for two seconds, let alone for twenty seconds. You aren't really going to do a painting in twenty seconds, but you can do a sketch. I can capture an image of something I've only seen for two seconds, such as a bird flying by, and I may work on that sketch for two minutes while it's still fresh in my memory, filling it out, using my knowledge of birds, their proportions, and their feathers to help me finish it off."

At university, Bob's gregariousness began to find various outlets. He sang in Gilbert and Sullivan operettas and painted sets for other theatre productions and was a member of a number of clubs and societies. He was now part of a strongly linked circle of friends. Their mutual greeting, an imitation of the complex operatic ululations of the barred owl, is

Nude, 1952.

maintained today. So, too, is the tradition they developed of collecting and singing folk songs with each other.

Bob's capacity for close and long-lasting friendships is one of his great strengths for his career as an artist. His childhood friends still remain close, and the circle of friends he developed at the Royal Ontario Museum, and subsequently at wildlife research camp and university, continue to be part of his life. He has always been strong-minded, but is healthily suggestible and responds positively to the ideas and urgings of his friends and associates.

After he graduated from the University of Toronto, Bob went to the Ontario College of Education and then began a career as a high school teacher that lasted twenty years. He started by teaching geography and art, and gradually, in the later years, turned to teaching art exclusively. Some of his friends who admired him as an artist thought he was wasting his time in the classroom, but Bob had no doubt he was doing the right thing. Although he had chosen teaching as a career partly to give himself a meal ticket as an artist and a degree of freedom to travel, he was an enthusiastic and successful teacher and he has no regrets about the years he spent at it. "I loved it. I loved preparing for classes, communicating, I loved the mentality of students, and I like teenagers." He found he was especially interested in small groups and in drawing out talented and dedicated students.

In his early years as a teacher he was tremendously active, giving talks, leading groups, and taking part in weekend workshops: he was involved in the YMCA leadership programme, taught at his old stamping ground, the Royal Ontario Museum Saturday morning club, and he taught Sunday school at the United church which he had attended as a child.

The freedom to travel was important to him and he took full advantage of every trip he made from the time he was a teenager. For someone who combines an artist's perceptions

36

with a naturalist's interests, a good journey or field trip can provide an almost overpowering array of impressions and information that must all be recorded and preserved if it is to be of any future use. Travelling well becomes in itself an important skill.

On a trip, Bob is organized, enthusiastic, and focused. He has never been a restless, wandering traveller, but rather an assiduous one, avidly curious. "I suck a place dry like an orange. I'm a professional appreciater," he says. "Since my teens, I've always tried to get everything I can out of a place at every level. I try to see and identify all the birds and trees. I try to find out about the history and politics and culture of an area. My museum experience taught me to be a one-man expedition wherever I go. I gather the anthropology and art, the botany and biology and geology. I try to take away with me a record of everything I can, whether it's photographs and sketches, samples of the habitat in plastic bags, bits of the forest floor, tape recordings of nature sounds, or native songs and talking, as well as artifacts and handicrafts. When I buy things, I try to buy as though I were buying for a museum's collection."

His first extended trip was across North America by bus when he was twenty. He went with one of his museum friends, Erik Thorn, an unusually versatile young naturalist and artist with wide interests and an infectious enthusiasm. The two travelled with a manic energy, leaping off the bus to sketch the local landscape whenever there was a rest stop, sleeping among the specimens in formaldehyde in museum labs where they had got odd jobs. They camped and climbed mountains encumbered by pounds of gear — shotguns, mousetraps, taxidermy equipment, paints, masonite boards, cameras — as well as regular camping equipment. On one glorious day after they had laboured to the top of a mountain on Vancouver Island, Bob completed six oil paintings.

This style of travel was repeated on a trip to Europe in

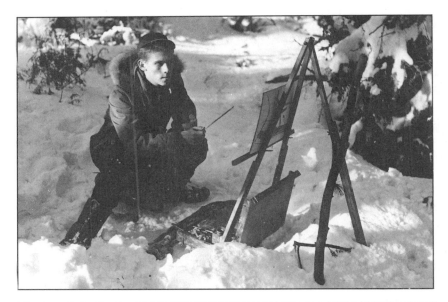

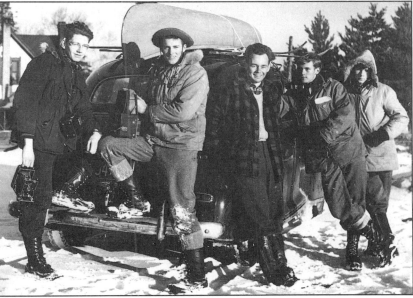

Above: Bateman painting outdoors, winter, 1950.
Below: An early spring expedition to Algonquin Park, 1948. *Left to right:* Don Smith, Alan Gordon, Bill MacDonald, Bob Bateman, Jack Bateman.

1954 after he graduated from university. Again in company with Erik Thorn, he toured England, France and northern Europe, going as far north as Lapland, visiting galleries and museums and painting and sketching prolifically.

During his university years Bob had had summer jobs working on geological field parties in Newfoundland and Ungava in northern Quebec, and, later, with a biological research party studying snow geese at Churchill on Hudson Bay. As always he trapped and stuffed small mammal specimens for museums — not always a popular activity around a busy geological camp — and he drew and painted nature specimens as well as landscapes and portraits. By now his natural science illustrations and his art were widely disparate in style, and the exquisitely executed watercolours of small mammals and a series of Newfoundland wild flowers bore little relation to the powerful, constantly evolving cubist style of his landscapes.

In 1958 he set off with another friend from his Royal Ontario Museum days, Bristol Foster, a wildlife research biologist, for a year-long trip around the world. They were accompanied for parts of the journey by Erik Thorn. They travelled as cheaply as possible, scrounging equipment and looking for sponsorships wherever they could. They had a Land Rover called the Grizzly Torque, which was equipped with gasoline jerry cans labelled "gin" and "tonic". Their route took them from England through West Africa, across to East Africa, then by sea to India, where they drove up into the eastern Himalayas and met the Crown Prince of Sikkim, then to Burma, and through Thailand and the Shan states to Malaysia, and finally to Australia. Throughout the whole trip they visited museums and research programmes, attaching themselves to the international network of biologists and natural scientists wherever they went.

In the best museum tradition, they looked at everything, recorded it all, and collected specimens for themselves and

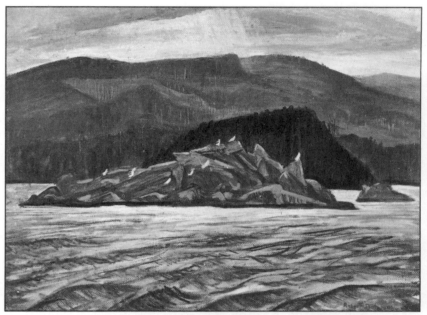

Black-backed Gull Colony, Newfoundland, 1952.

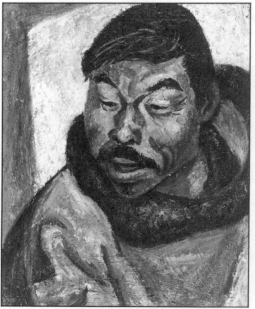

Jimmy Ematuluk, Ungava, 1953.

European sketchbook, 1954: *Top left:* a Lapp in northern Sweden; *Bottom left:* from a Paris window; *Right:* Trondheim, Norway. Two pictures done the same day at the same site, using different styles.

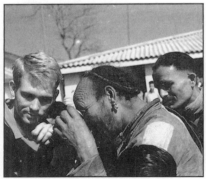 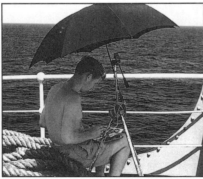

Around the world trip, 1957-58.
Top: Ghana;
Left: with tibetans in Sikkim;
Right: crossing the Indian Ocean.

for friends and colleagues. The Life Sciences section of the Royal Ontario Museum wanted specimens of a species of East African bat. These infested the attic under the tin roof of the famed Coryndon Museum in Nairobi, so the vermin of one museum became part of the collection of another. As Bob and Bristol were stumbling about in the dark trapping the bats, the man in the office below, fearing they would come crashing through the plaster of his ceiling, came up to complain. He was Louis B. Leakey, the director of the museum and the world-famous archeologist who had made the revolutionary fossil discoveries of early man in East Africa.

East Africa made a tremendous impression on them, and they knew they would return. They drove about, camping, and Bristol would photograph while Erik and Bob painted. Then, as now, Bob painted with speed and assurance and Bristol remembers the pleasure of watching him at work one day when they were near the top of the Ruwenzori mountains in Uganda. The loose-stroked landscape he did that day is still part of Foster's collection.

In Mombasa Bob and Bristol spent days looking for a cheap way to get across to India and eventually found a ship that would take them and their Land Rover and let them travel third class. They slept on deck for the crossing, and spent the days painting and talking politics with the first officer.

In Malaysia they struck up a friendship with some British soldiers still then fighting Communist insurgents in the jungle and joined them as observers on a ten-day reconnaissance. In Singapore with some of their new-found army friends they celebrated Bob's birthday at a night club. Everyone chipped in to buy Bob an almond-eyed birthday present, with whom he gallantly danced but whose favours he otherwise declined, still mindful perhaps of the teachings of his Sunday school classes.

40

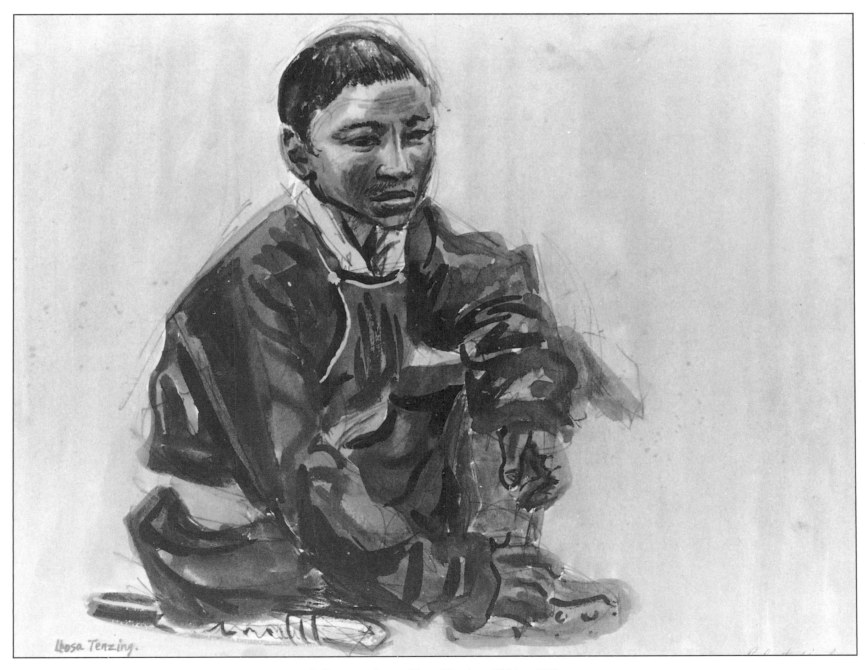

Lhosa Tenzing.

A tibetan muleteer, Lhosa Tenzing, Sikkim, 1958.

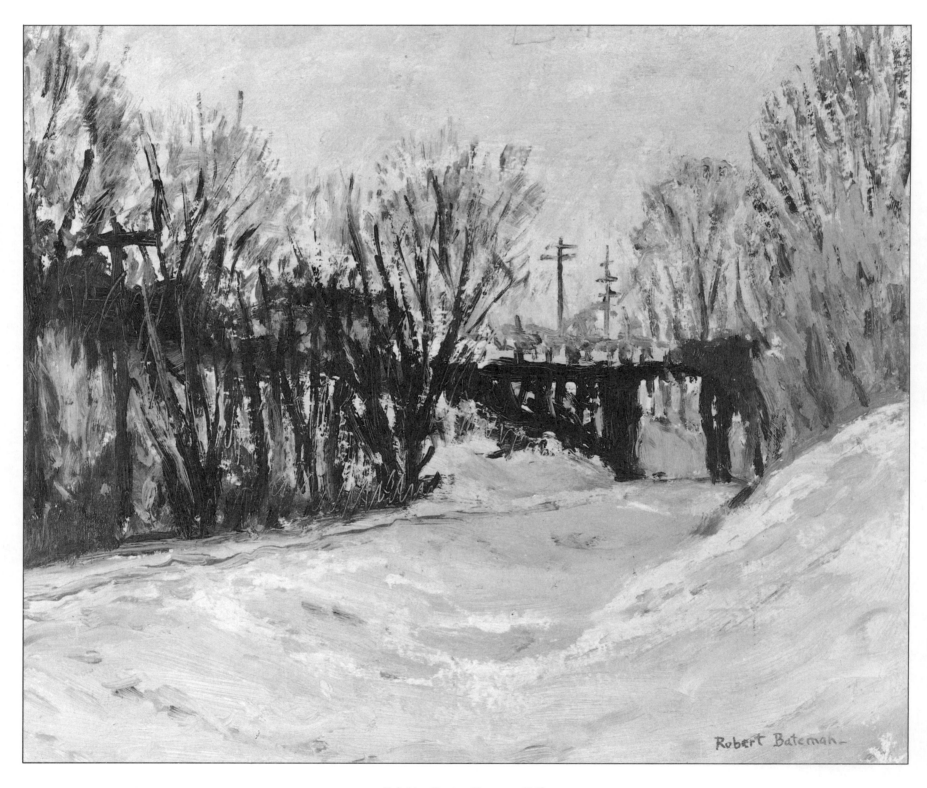

Belt Line Ravine, Toronto, 1948.

III

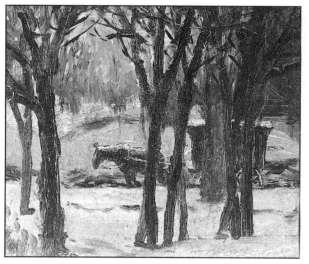

Milk Wagon, Winter Evening, Toronto, 1948

When he returned home, Bob threw himself into his teaching career. Two years later, in 1960, he married his first wife, Suzanne Bowerman, a young art student from Alliston, Ontario. Bob was still part of the North Toronto society he had grown up in, and although he didn't want to reject it, he also knew he wanted to live in a way that reflected his own interests as a naturalist, and his development as an artist.

Since he had been about eighteen, Bateman's preoccupations as an artist had split in two; his interest in wildlife and nature art went underground and did not surface again for fifteen years. It did not stop — he continued to sketch birds and animals and plants wherever he was, and he used his skills as a technical illustrator in his scientific work and for his own records. But, as he says, he no longer thought of this as Art with a capital A. "When I was in my late teens, I was influenced by my friends, particularly Alan Gordon, and by the art I saw around me, to alter my own aims and intentions in painting. My goal had been to do what in those

days was called animal or bird illustrations, and if I had kept going in that direction perhaps I would still be painting pictures that are just a couple of birds on a branch, or an animal with a bit of habitat arranged around it like a table setting. Wildlife art was illustration which appeared in books or on calendars, but it didn't hang in frames on walls. When I looked around the walls I saw impressionist or expressionist or abstract art. Besides, at that stage in my life, I thought I ought to be painting something more dynamic and exciting than just a bunch of little dickie birds.

"I first went through a phase of impressionism, trying to capture in a free, loose way a fleeting glimpse of something, not in a precious way, just capturing the moment. So I would go off on hikes with my sketchbox of oil paints and sit down in the ravines or by the lakes and in a few minutes capture what was there. I took great pride in being fast, and in being able to say a lot in a few strokes. Even though I use much more detail now, I still hope my work has that quality of capturing the moment.

"I moved from the impressionism of Monet and Degas to the vigorous and bold style of Gauguin and Van Gogh. Naturally I had been caught up by our own Group of Seven who painted the Canadian northland in such a powerful way in their lively rhythmic landscapes. I liked the way Tom Thomson looked at the world, taking a little piece of it and boiling it down to its elements, and I like A. Y. Jackson in that he showed the rhythms and power as if the landscape is alive, and the same with Emily Carr. So I started moving more in that direction, showing the power and rhythms boiling up in behind the composition and actually paring away all the frivolous externals and just trying to show the force that is behind it in nature.

"This led me toward cubism. I became interested in the work of Picasso and Braque and I found myself using these techniques of perspective and distortion to depict my own world. During this whole period, though I painted in many different styles, I generally chose subjects in nature, as opposed, say, to wine bottles or the interiors of rooms.

"I became interested in Oriental art, in particular Chinese painting of the Sung dynasty, and it still affects my approach to composition, particularly in the freer use of space. I also especially admired the Japanese woodcut artists like Hokusai and Hiroshige with their strong sense of rhythm and their ability to give the individual personality of things. My admiration for the way Oriental painters could capture things in a few strokes led to my excitement with the work of Borduas and some of the abstract expressionist painters of the New York School in the 1950s — people like Franz Kline, who is one of my great heroes, and Motherwell, Rothko, and Clyfford Still."

Bob's painting from the time he was twenty until he was in his mid-thirties was a long series of experiments reflecting his absorption of these movements in art, as well as his growing appreciation for the older masters, in particular

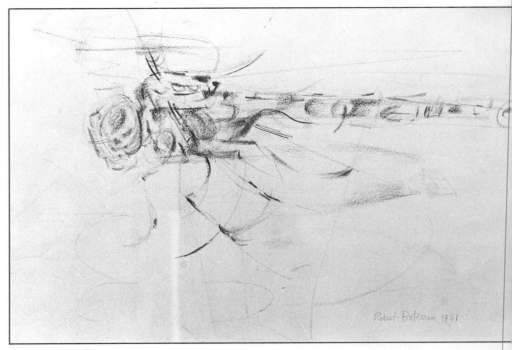

Above: Dragonfly, 1961.
Opposite: Dragonfly Country, 1961.

"I did both these pictures by a lake near Temiskaming one hot summer day when the dragonflies were at their peak. I first did the cubist drawing, showing the motion of the head, legs, and wings, and the translucent quality of the dragonfly, superimposing several poses. I then decided to do a painting of the landscape. I looked at the far shore of the lake and broke it up and then reassembled it to reflect the segmented structure of the dragonfly's abdomen. For the water, I used the image of dragonfly's wings, with their many-faceted, gem-like quality. The whole painting is a dragonfly although there is no dragonfly in it."

44

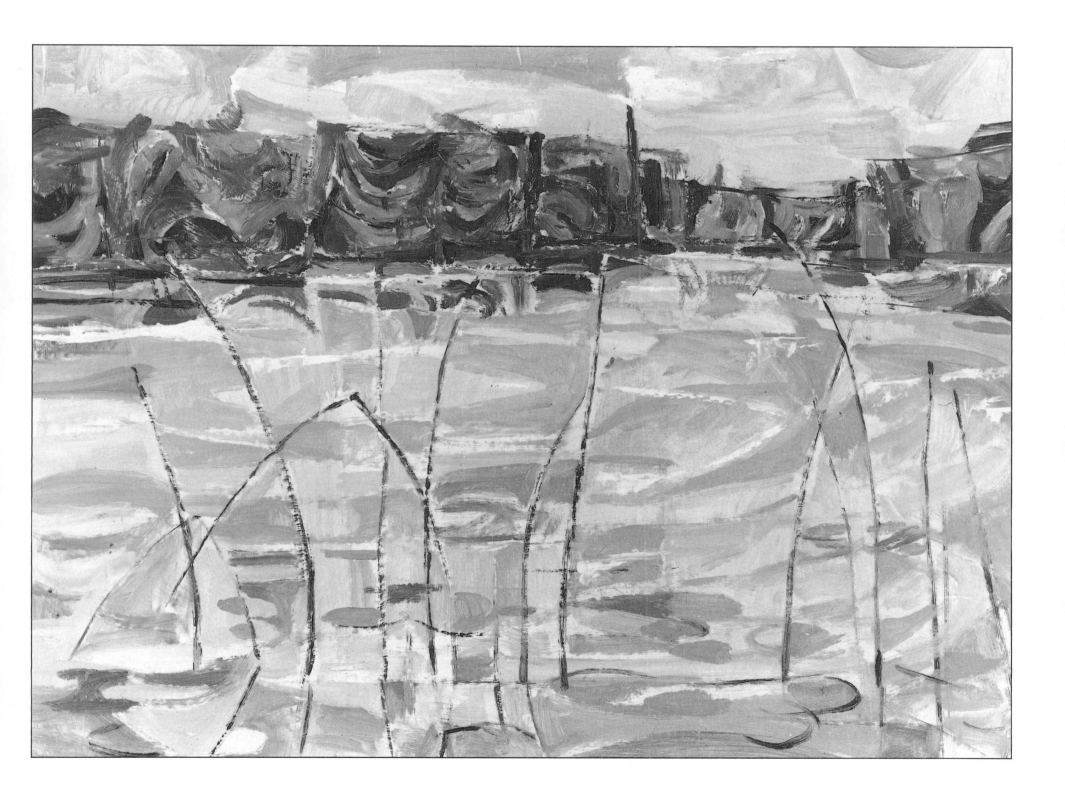

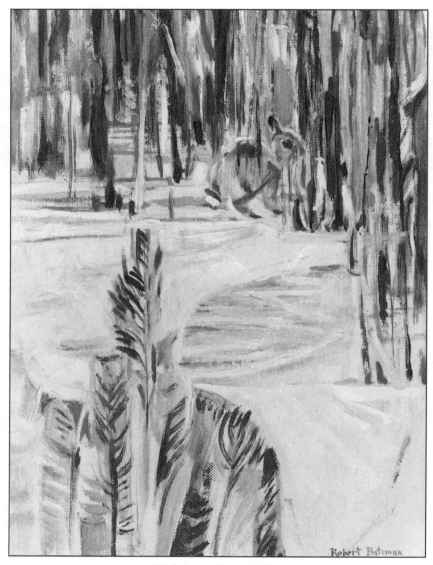

High Park, Winter, 1962.

some renaissance artists, as well as Bruegel, Vermeer, Turner and others. Besides his classes with Gordon Payne and Carl Schaefer, he was also influenced by the work of Fritz Brandtner, a strong-minded cubist artist working in Canada, and by John Hall, a professor of art at the University of Toronto School of Architecture. The Bateman pictures of these years are startling in their range, and, to enthusiasts of his present work, sometimes perplexing. Some are clearly derivative, but many are powerful and distinctive. With the benefit of hindsight it is possible to look at these paintings and say, "Here's an artist looking for a style." Bob himself says of this period, "In a sense, I didn't know who the real me was," but there is no suggestion that these were wasted years artistically. "I look back on the paintings I did in those days with a great deal of respect. I don't look on them as kid stuff, I look on them as being works of art in their own right. I look back on that period of my development as being incredibly valuable. I can't help being amazed at how almost every phase and experience has come together to contribute to the way I work now."

By the early 1960s Bateman's painting was mainly abstract expressionist in style, and his nature art was still hidden away in sketchbooks. He enjoyed working in abstract styles, but ultimately they didn't satisfy him. His own instinct was for the particular and the specific in literature and art as well as in nature, and this was at odds with the generalizing force of abstraction.

Then, in 1963, he was confronted with the work of Andrew Wyeth. A major exhibition of Wyeth's paintings was shown at the Albright-Knox Gallery in Buffalo. This exhibition made a great impact on the public as well as on many artists, for it demonstrated that, once again, realist art was acceptable, capable of expressing artistic imagination, and worthy of serious discussion. In the next decade, critical and popular recognition was given to many realist painters,

46

particularly in Canada, where Alex Colville, Christopher Pratt, and Jack Chambers became dominant figures.

For Bob, the Wyeth show was a shock and an inspiration, and it helped him to fuse his artistic instincts with his exceptional knowledge and love of the natural world: "Up until that time in the art world, the surface of the painting was considered important, and the subject was not. Wyeth was a realist whose pictures had great abstract strength. He was doing exciting painting in which the surface of the real world was important too."

Later that same year, Bob and his wife, Suzanne, left for a two-year stay in Africa, where he was to teach geography in Nigeria under the Canadian government's External Aid programme. During their first Christmas holiday they joined Bristol Foster, who had been loaned to the government of Kenya as an advisor on wildlife conservation, and who was in the process of moving there with his wife. For a month, the foursome drove around East Africa, and, with Foster's credentials, they were able to visit all the game reserves and see all the wildlife research projects.

In Nairobi, Bob and Bristol noticed in an office window a poster advertising an art competition sponsored by the East African Esso Company. Foster urged him to enter. When he got back to Nigeria, Bob looked at the research material he'd collected on East African animals, and, with the reverberations of the Wyeth show still ringing in his head, he began work on a couple of paintings for the competition. He chose as subjects the superb starling and the Thompson's gazelle, and he presented them in the lively and detailed naturalist style that has now become his trademark. He sent the paintings to Foster in Nairobi to enter in the competition. As it turned out, they didn't win, but they were extraordinarily popular with visitors to the exhibition. Biologists and wildlife experts in East Africa who saw the paintings realized that Bateman was an artist who really knew his subject.

Urged on by Bristol Foster, who was acting as his agent and research assistant for details of East African vegetation, Bob produced a number of works on commission. Meanwhile, a Nairobi art gallery run by an American couple, the Fonvilles, began to show and sell Bob's work. They soon had to press him for more paintings. Nairobi was the centre of the East African tourist traffic, and Bob's work quickly began to spread around the world.

In Nigeria, Bob was teaching in a small town. The students were keen but extremely aggressive because passing the exams meant for most of them the difference between living a subsistence existence in a jungle village or living in a modern urban culture. They wanted to be lectured on what to learn and they didn't respond to the playful, Socratic method of teaching Bob had used in Canada. They also mocked his Canadian accent and he had to adopt a West African accent in order to be understood. Bob remembers these two years as the most demanding and interesting part of his teaching career.

During the holidays he and Suzanne travelled to the north and into the interior, meeting remote hill tribesmen, absorbing everything they could, and collecting both living and dead specimens of small mammals for zoos and museums. They returned to Canada in 1965 with more than a ton of things they had gathered, and with their first child, Alan, who had been born while they were in Nigeria.

On their return, Bob resumed teaching high school, and built his house on the Niagara Escarpment, and, over the next few years, he and Suzanne had two more children, Sarah and John. Their marriage, however, came to an end. Suzanne, who has also remarried, now lives in Halifax and the three children stay with Bob and Birgit during holidays.

Bob continued to paint African wildlife pictures for the Fonville Gallery in Nairobi, and he also began to paint Ontario landscapes and rural settings in a realistic style. In

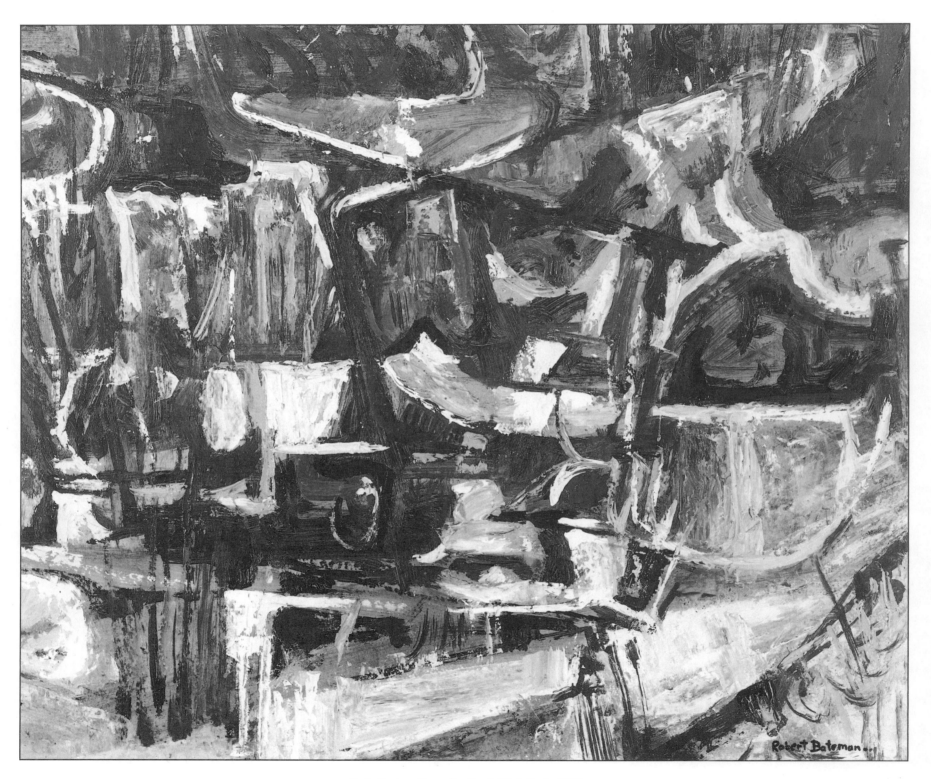

Early Spring, Grenadier Pond, High Park, 1962.

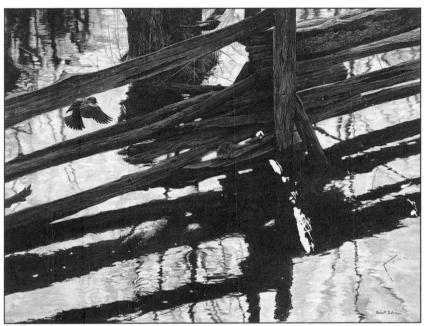

Red-winged Blackbirds and Rail Fence, 1976 (see p. 81). (see p. 81)

Grenadier Pond is typical of Bateman's abstract work, but it is not as radically different from his wildlife painting as it might at first appear. Bateman himself has no doubt of the close connection between the two styles: "I would never have painted a picture like *Red-winged Blackbirds* if I had not earlier painted a picture like *Grenadier Pond,* in which a spring landscape is reduced to powerful, dark shapes, with light, negative shapes popping through. This painting, and others like it, made me sensitive to the power of these kinds of contrasting shapes, and so, several years later, when I caught a glimpse of an old rail fence with light reflected from a pond shining through it, I was instantly excited by its possibilities for a painting. *Red-winged Blackbirds and Rail Fence* was the result."

1967, as his own Canadian Centennial project, Bob painted a series of historical scenes of Halton County, where he lives. These were exhibited in the gallery run by Alice Peck in nearby Burlington, where they sold out immediately. By now Bob was beginning to realize that he would have to make some decisions. On the one hand he had a growing international reputation for his wildlife paintings, and, on the other, had a great local following for his southern Ontario landscapes and country scenes. Moreover, he was still teaching high school. After successful one-man shows at the Pollock Gallery in Toronto and the Beckett Gallery in Hamilton, he concluded that he should concentrate on wildlife painting and he stopped teaching for half a year in order to complete paintings for a show in 1975 at the Tryon Gallery in London, England, long established as one of the foremost galleries in the world for wildlife art.

The Tryon show was a complete success and Bob's work again sold out, convincing him that he should be painting full time. Moreover, wildlife art in general was enjoying a resurgence of popular interest. *Animals in Art,* a major exhibition held at the Royal Ontario Museum in 1975, brought together notable contemporary artists with the great masters of the past and proved the current vitality of the art in Europe and North America, especially in Canada, where there are a surprising number of first-ranking artists working in different styles. It was at this exhibition that Robert Bateman's wildlife paintings, by now well-known to connoisseurs in Great Britain and the United States, became more familiar to Canadians as well. He was recognized as one of the outstanding international figures in the field.

Bob now found himself in tremendous demand. He soon could not paint fast enough to satisfy the galleries and collectors. Mill Pond Press, an art publishing house which specializes in high–quality, limited edition reproduction prints of the works of contemporary representational artists,

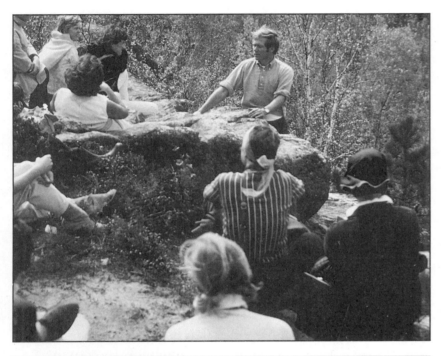

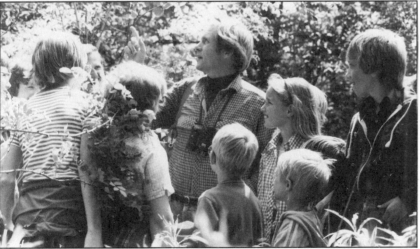

Nature talks in Algonquin Park, 1969 *(above)* and on the
Niagara Escarpment, 1981 *(below)*.

began to produce and sell editions of Bateman prints. This greatly extended his reputation, particularly in the United States. Virtually all of these Bateman limited editions have sold out and have developed a remarkable secondary market, being offered at several times the original published price.

Bateman shows at galleries became so popular that eager buyers were lining up at the doors hours before the opening. To avoid mob scenes, and to make the arrangements fairer, the major galleries that handle his work have set up draws for the paintings. The prices are established, and would-be buyers put in their names, sometimes by telephone, for a chance to acquire the pictures they want. A day or so after the opening, a draw for each picture is held, with the winner getting the first opportunity to buy it. At a recent Beckett Gallery show there were over three hundred bids for twenty paintings, and at Sportsman's Edge in New York, in 1980, a $180,000 Bateman show sold out almost instantly, the draw taking place in front of NBC television cameras.

Bob stays away from the hoopla of the draws, and he leaves the marketing of his pictures to the galleries and lets them set the prices, which he rarely remembers. But he enjoys his shows and he and Birgit often visit the galleries while they are on. He talks easily to people, and enjoys encouraging a viewer to look more deeply at a painting, to see its composition, its rhythms and echoing forms.

The popularity of his paintings has made people interested in him as well, and Bob has been in increasing demand as a public speaker. He has an easy, entertaining manner and a born instinct of involving an audience in his enthusiasm and ideas, whether he is talking about his painting, leading a nature walk, or lecturing on conservation. He is also an ideal leader or resource person for wildlife tours which has led to increased opportunities for travel in many parts of the world. He has returned to Africa many times, and, with Birgit, has voyaged as artist-in-residence with the Lindblad travel

50

organization to South America, the Antarctic, and the South Pacific. He also continues to join his biologist friends on field trips whenever he can.

But painting remains uppermost in his mind for the greater part of each day. Recently he wrote to a friend: "I am very excited by where I am. The fame and fortune is not exciting. (It is interesting, but neutral, like the weather, with pros, cons and possibilities.) It is the art part that is exciting. I find it more challenging than ever and get ten new ideas for every one I have time to paint. I have always had to paint and draw. You remember me coming home straight from school and getting into it in the sun room — setting myself goals. Later, whether it was at the cottage or in summer field jobs, I squeezed painting into every time space and spilled it over onto other things. I remember Ross moaning that it wrecked weekends at the cottage. I am still as bad as ever, whether drawing at meetings, or filling all unallocated time at home so that Birgit and I need appointments to share time together. This has never been propelled by outside forces. . . . It is more like a disease. It is not relaxing, and it is not even usually comfortable. I can't explain it."

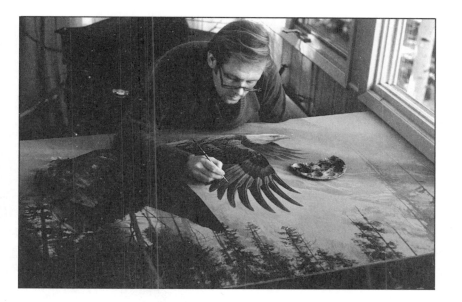

In the summer, the works in progress, along with all his equipment, move with Bob to the cottage in Haliburton. Despite the inconvenience of lugging a painting and all his paraphernalia about, he loves working outdoors. "I like the light and the air and being able to get a good distance back from the picture. I feel much freer and seem to have more energy and to accomplish more."

51

IV

In making wildlife the main subject for his art, as he has done for the past decade, Robert Bateman would seem to be doing the most natural thing for him, given his exceptional combination of talents and interests, but he is well aware of the *cordon sanitaire* which surrounds this field of painting. Wildlife art, to use a term he is reluctant to use, has tended to be segregated by critics and galleries from the main body of fine art. An artist who distinguishes himself in this field is not likely to find his works discussed in the same articles or hung in the same galleries as his contemporaries who paint less specific subjects.

This is partly because much of the best known animal art has reflected the growth of the natural sciences and appeared as illustrations in books or portfolios. Audubon's work was issued in this way and so was much of Fuertes'. However, there are a number of nineteenth- and early twentieth-century artists for whom wildlife was an all-engulfing subject and who painted full-scale canvases.

Leo-Paul Robert specialized in small birds, while Wilhelm Khunert and Carl Rungius are known for their paintings of larger animals. Bruno Liljefors of Sweden is generally regarded by experts as a genius who brought an artistry to the presentation of both birds and mammals which has never been surpassed. His work has never been well known in North America. Bob Bateman was introduced to Liljefors's painting by Erik Thorn when Erik and Bob were travelling together in Europe in 1954. Liljefors became Bob's idol, and he and Birgit made a pilgrimage to see the Liljefors collection in Sweden a few years ago. "He is my favourite artist and absolute hero," Bob says. "He was able to capture the whole feeling for a subject with flair and economy." Liljefors was strongly influenced by the impressionists. His paintings, like Bateman's, reflect a powerful and informed artistic imagination responding to a vast body of naturalistic observation.

Francis Lee Jacques, best known for the spectacular natural history dioramas he painted for American museums in the 1930s and 40s, also brought a distinctive style and artistry to his wildlife painting that Bob Bateman particularly admires. From the current, and very full, spectrum of animal artists, there are a few with whom Bob feels a special kinship in terms of artistic purpose. Bob Kuhn in the United States, George McLean in Canada, and Raymond Ching, a New Zealander, all seem to approach a wildlife painting first and foremost as a painting, in which the idea of the work is more important than the species depicted, and which contains a strong sense of time and particularity.

One perennial issue in the world of wildlife art is that of anthropomorphism. Does the artist attribute a human personality to the animal or a human emotion or sentiment to the picture? If he does, is this a false representation of nature? If he does not, can the picture move us and have an emotional appeal and power? Anthropomorphism is a dirty word to most natural scientists, although Terry Shortt, whose ornithological knowledge and artistic sense are universally respected, says he is not disturbed by the suggestion of anthropomorphism in his own art or anyone else's. "If you're dealing with anything in which the emotions and your personality are involved, how can the work of a human being be anything but anthropomorphic? I love a bird when I paint it. I paint it with loving attention. In my own paintings, somehow, without my intending it, my birds turn out to look like humans. I don't believe you can be a good artist and observe well unless you have a depth of emotion and sensitivity to many things and the capacity to convey this."

It is not surprising then, to hear that Shortt's general response to Robert Bateman's paintings is a thoroughly human one. "There is," he says, "a lyrical quality in them. One could write a little poem to many of them, or they remind one of a poem by Wordsworth or Coleridge.

There is a hint of nostalgia and yearning. Even in an action-filled picture like the one with the wrestling elephants there is a lyrical quality, a rhythm, and an atmosphere that is free, from harshness."

David M. Lank, an outstanding critic of wildlife art, responding to the question of anthropomorphism, distinguishes three philosophic approaches an artist can take in treating animal subjects. "One way is to de-animalize the animal — to make it an object for human observation and examination. If it is a bird, it can be examined feather by feather. A second way is to paint animals in terms that flatter ordinary human ideas about them, such as the sentimental appeal of baby animals, or the fierceness of some predators, or the prettiness of some birds. The third way is to present the animal from its own point of view. That is what Bob Bateman is doing. For instance, in the painting *Heron on the Rocks* you are there with the young heron. He is looking up the river for his benefit, not for ours."

The empathy with the animal subjects that Bateman's paintings evoke is a direct reflection of his own approach to nature, which, even when he was a child, was one of affection and scientific curiosity, not one of sentimentality or fascination with the pleasing appearance of the animals. "The scientific aspect and the behavioural aspect have been what attracted me to wildlife from the first," he says. "It was an interest in life cycles and ecology and bird behaviour rather than a colourful image that got me painting birds. Certainly some birds have an exciting appearance — not necessarily the most colourful ones — but it has always been an interest in the bird itself that attracts me, not the colour combinations.

"I grew up reading Sir Charles G.D. Roberts and Ernest Thompson Seton. Their best work is unanthropomorphic, and has everything from dragonfly larvae to grizzly bears doing whatever they do with deliberateness and impassivity — with faint flickerings of joy and anger and fear, but this is

very far from a sentimental Disney-style approach. I've been close to wildlife biology and biologists all my life, and I think about nature as a scientist does. When I paint a baby cottontail I am not trying to convey any kind of sentimental feeling about it. I want to convey its emotions of fear and resignation and instinctive trust in its own camouflage. I respect the baby killdeer or a bald eagle that I paint, but I don't idolize them. I think of them living their own lives as part of a whole environment."

Bateman's exceptional quality of conveying the emotional world of an animal (which is based on a close knowledge of the biological and behavioural details of the animal and its environment) makes his pictures very exciting for biologists and natural scientists who sometimes may know a great deal about the subjects. William Whitehead, a former research biologist who is now an award-winning writer of films and television documentaries on the natural sciences, says, "There is in Bob's paintings a tremendous emotional involvement with the animals which is quite different from a purely technical representation of their appearance. What I get from a Bateman painting is not the suggestion that an animal thinks or feels in human terms, but an affirmation that it does think or feel or imagine in its own way, not as a human but in a way which may not be all that widely separated from me and which is also quite distinctive.

"When I look at the painting of the lioness with wildebeest on the horizon there are moments when I suddenly think I know what it is to be a lion, and to see sharply, without sentimentality but with emotion, my mate, my food, and my home. The loons among the reeds, the mouse on the branch, the winter cardinal — these are not entirely human views of the subjects, but rather the kind of view available to members of their own species.

"Birds have extremely sharp vision. In Bob's bird paintings he conveys the tremendously focused expression of the

bird – for example, in *The Great Blue Heron*. Also, through the level of detail he achieves in the picture, he makes us feel we are seeing the world through a bird's eyes. Many birds are practical botanists, or practical entomologists, and when he paints a song sparrow in a thicket and draws as much attention to the plants as to the birds, I feel as if I am, for a moment, seeing the plants as clearly and as importantly as the birds do."

Bateman's paintings are those of a man who is always delighted by his sightings of wildlife in nature. Despite the care with which he may have examined hundreds of museum and zoo specimens to understand better what he sees in the field, the primary mood he creates in any picture is the freshness and excitement of a glimpse of a wildlife subject seen living its own life.

The sensation of a special, captured moment is most obvious in pictures in which a bird is in flight, or an animal in action. But even in paintings where an animal is at rest, such as the American elk in *Evening Snowfall* or in paintings that have no bird or mammal in them, there is a quality of a seized, fleeting moment. It is there in *Reeds*, where the placid moment may soon be altered by a change of weather or light or an intrusion of some form of wildlife. In *Haliburton Farmhouse* the singularity of the moment is held by the monarch butterfly just visible in the field.

In an article about Bateman's art, David Lank compares this fleeting quality with the sense of eternity that is characteristic of Andrew Wyeth's work. Wyeth's pictures, he writes, "exude a sense of timelessness: his tattered lace curtains will always billow against that window which will never close; the old woman still sits in her doorway, and the empty windows of the weathered farm house stare blindly into an unchanging infinity. But Bateman's swallow and sparrow will leave, his barn owl will only fleetingly be framed in the open church door, and the pheasant will

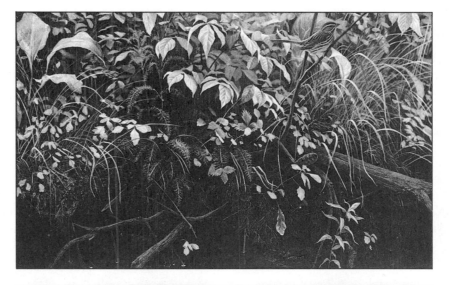

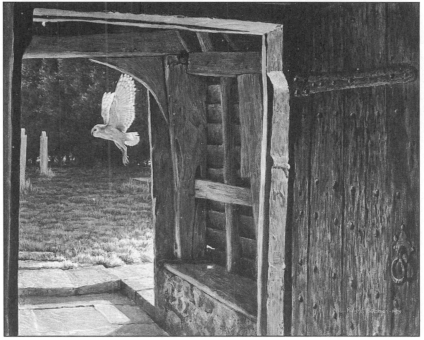

Above: Streambank – June (p. 9).
Below: Barn Owl in the Churchyard (p. 156).

55

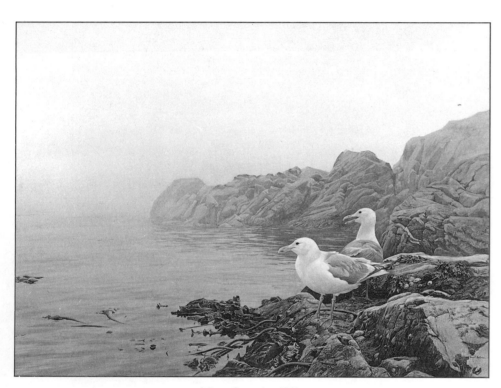

Misty Coast (p. 133).

disappear into the brown stubble of the dormant field. . . ."

Lank develops this point in an illuminating analysis of *Misty Coast.* "From the highly detailed foreground, Bateman brings the viewer into the composition through the two gulls, which, by the turn of their heads, further force the viewer towards the increasing mystery of the receding coast beyond which sky and sea blend into one. Try as you might, you cannot keep your eyes or your attention focused on the birds; they lead you to explore the whole composition. It is the setting which dominates, not the birds.

"The lack of symmetry in the painting adds to the magical illusion. The visual centre of gravity and the mathematical centre are two totally different points. Through the composition of the various elements, and the skillful use of differing intensities of colour, Bateman has created a painting whose focal point is the void between the rocks in the foreground and the jutting rocks behind. Both birds are looking at that void. Our eye is also forced to that spot but, finding nothing there, moves again to search for more. The optical balances force our own eye movement to supply the motion in a basically static scene. We can imagine that, should we look away for a moment or two, the two gulls might hunch forward, spread their wings, and as silently as fog, lift on into the unseen beyond. This potential for change adds a profound touch of nature to Bateman's portrayal."

In all Bateman paintings there is a highly informed love for the richness and variety of the whole natural world. He has a pantheistic reverence for all of nature and he wants it all to be treated with respect.

This pantheism includes a broad view of human civilization and its declining variety, or what Bob describes, in one of his most popular and contentious lecture subjects, as The Disappearing World. This is his highly personal account of the increasing homogenization of world culture — the phenomenon described by the French anthropologist

Claude Lévi-Strauss as monoculture and by Marshall McLuhan as the Global Village. Bob calls it "instant pudding." "All over the world," he says "we are replacing our human and cultural heritage with things which are smooth, bland, agreeable, artificial, and above all, convenient, and made with ingredients with which we have no connection and over which we have no control." Thinking about his world travels over the past twenty-five years, he has come to realize that the variety of human cultures and societies, with their unique art and architecture and social structures, is being drastically reduced.

He challenges his audience to claim an affection or emotion for their local shopping plaza or for most apartment buildings or a highway strip of fast-food stands and used car lots. The idea is more laughable than repellant. But then he goes on to remind his listeners that these are the characteristics that are being spread all over the world at the expense of unique and irreplaceable indigenous cultures and cultural accomplishments — things as different as African tribal life, Japanese folk songs, and handsome old Ontario farmhouses.

He laments the losses and he is an ardent preservationist — of culture as well as of nature — but his attitude is not one of relentless pessimism or gloom. He is cheerfully capable of appreciating the opportunity he has had as a comparatively lucky North American to travel about the world and to experience the enormous variety of things there are to see, even as they are disappearing.

Bob believes that the visual aspect of modern western life for the past twenty years has been relatively unchanged in terms of the style of day-to-day perceptions and lifestyle, whereas in the preceding decades we moved swiftly from the remains of the old rural society which he can remember from his youth, with the horse-drawn vehicles still evident in city streets, the small shops, and the easy access to countryside and rural life.

Above: Bob and his children, Sarah, Alan, and John, on a pack-horse trip in Montana
Below left: Galapagos, 1980
Below right: Balua, New Guinea, 1981

Antarctic Elements, 24 × 29½″, 1979.

The notion of progress in art, he thinks, is dead, a view shared to some extent by Robert Hughes in *The Death of the Avant Garde* and Tom Wolfe in *The Painted Word*. He thinks that the extreme movements of the last fifty years of art history are the final twitchings of the progressive notion in art. "This is a challenge to art curators who are still looking around a little desperately for the new and the shocking which has characterized contemporary art from the 1890s into the 1960s.

"In art and science we are now in a delta, at the end of the long flow of progress. In a delta there is no clear direction but there may be many choices. The best we can do is to enjoy the choices that we have and to be genuinely and creatively eclectic. I don't mind at all when people suggest that one of my paintings is like a Japanese woodcut or has a lot of cubist influence or reflects the shapes of some primitive art. I think these are all legitimate sources for an artist to draw from and to reflect in his work.

"What I really like about being in this delta is that a great collector can have on his wall a Kline or a Rothko and beside it a Wyeth and beside that a seventeenth-century miniature and next to it some African tribal art. They can all work well together; they are all art and have their own merit and can be judged by their own standards. This is what is exciting and promising, not only for art but also for mankind. As we move through the delta, we can pick and choose from Eskimo and Sioux Indian cultures or from the flower children of the sixties or any number of other cultures which are floating around us. We have unlimited choices, more than any individual can make use of.

"I can't conceive of anything being more varied and rich and handsome than the planet Earth. And its crowning beauty is the natural world. Whether it's here in Ontario or in the Antarctic or in Africa, I want to soak it up, to understand it as well as I can, and to absorb it. And then I'd like to put it together and express it in my paintings. This is the way I want to dedicate my work."

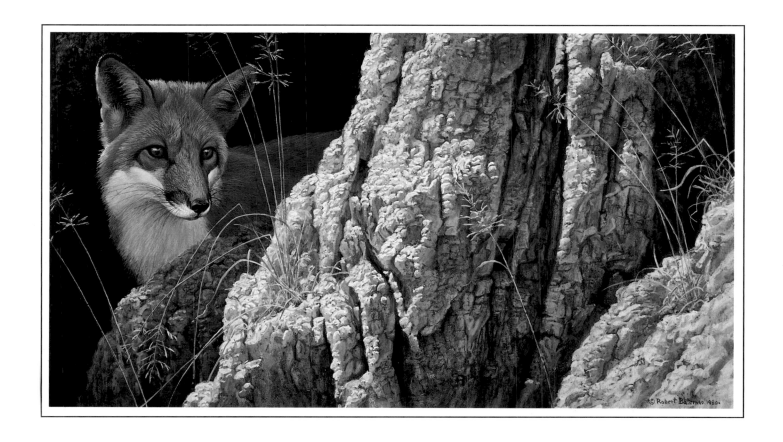

PLATES
AND COMMENTARIES

Killdeer

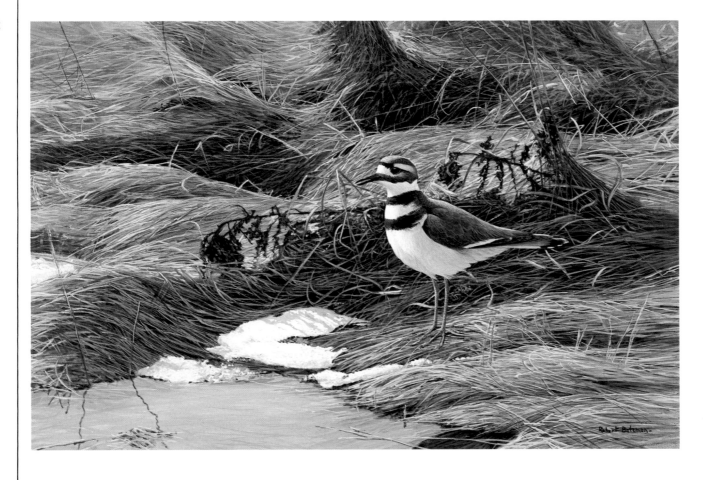

For me, the killdeer is the harbinger of spring. There are other species — the horned lark, or the robin, for instance, that may arrive earlier, but hearing the call of the killdeers and seeing them moving north to their territory as the snow melts are the real signals that spring is here.

At the end of winter all the grasses and all but the woodiest of weeds in a meadow have been mushed down into hummocky lumps that feel like wet shredded wheat underfoot. All my life I've been an inveterate hiker, and spring is the best time for hiking, when the new vegetation hasn't grown up and the temperature is cool. I wanted to get the feeling in *First Arrival* that you could make your way across the field, hearing your boots squish and feeling the lumps and bumps of earth and matted vegetation.

First Arrival was painted not long after I had moved away from an extended period of painting abstracts, when I was still resisting the idea of a strong central subject, preferring subtlety and a certain austerity in composition. These feelings also coincided with my conviction as a naturalist that you can find beauty and variety in small or apparently unspectacular aspects of nature.

▲ Spring Thaw — Killdeer; acrylic, 15 × 24″, 1970
▶ First Arrival — Killdeer; acrylic, 30 × 40″, 1970
◀ Curious Glance — Red Fox; oil, 14 × 24″, 1980

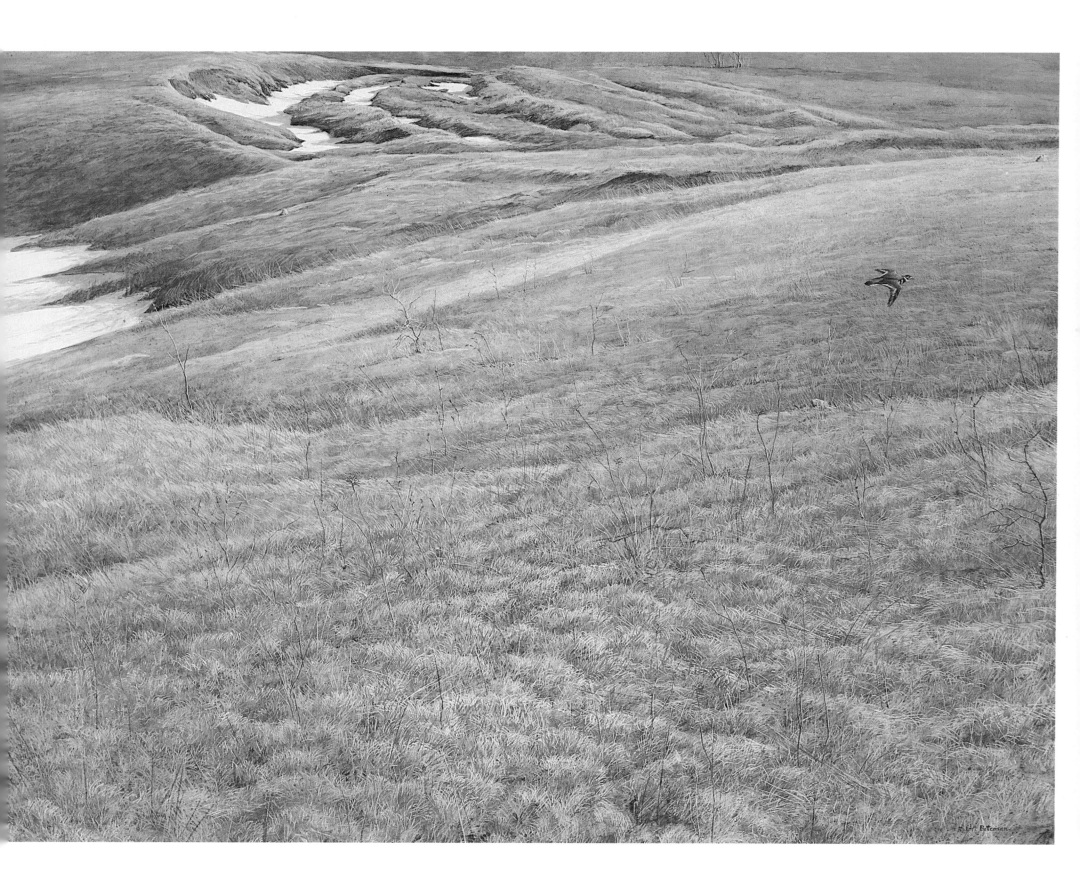

Courting Swans

In any courtship there is some conflict and commotion. In this picture of whistling swans courting in the early spring that commotion is going on compositionally as well. The dynamic rhythms are moving in several directions and are conflicting with each other. The other interest for me in this painting was playing with the whites — the excitement and challenge of making the most out of a very limited colour range.

▶ Courting Swans; acrylic, 35⁷/₈ × 48″, 1976

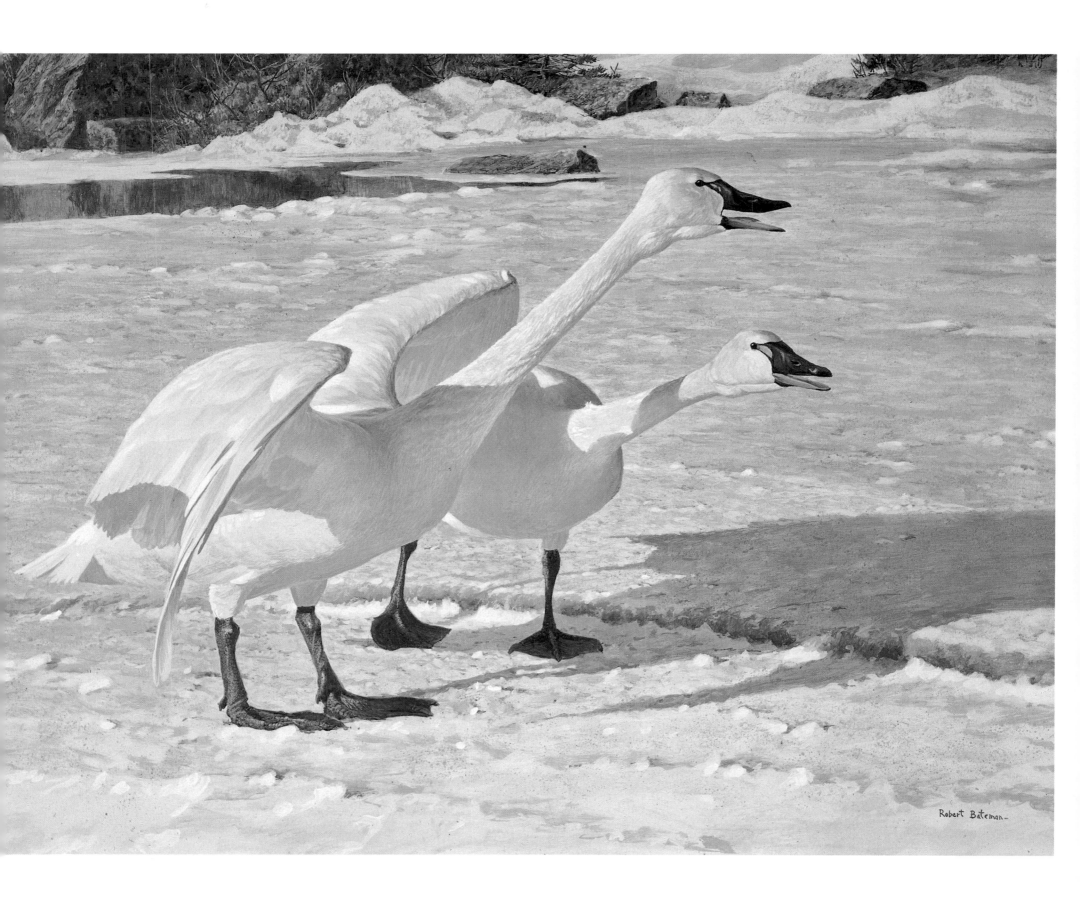

Robert Bateman

Nesting Geese

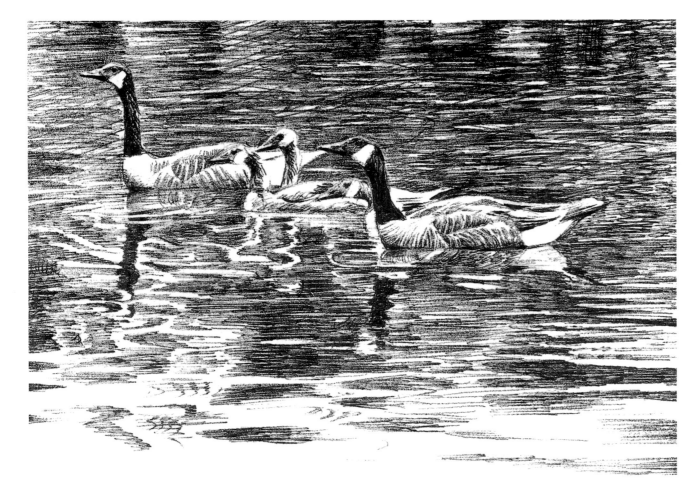

Canada Geese, for me, are symbols of fidelity and territoriality. I see them as forceful, direct birds. This pair used to nest near where we lived, and I knew the male well for about two years and had fed him by hand. But when I tried to come near their nest in a rubber raft they both charged me with their necks outstretched. The male almost jumped into the raft with me, tried to beat me about the head with his wings, and got me completely soaked. In this painting I was thinking about the bond between the two and have shown the male on guard, watchful and alert and the female on the nest.

I was also interested in the different textures of the feathers. On a goose's neck the feathers are little sheaves, velvety and overlapping, almost like sheaves of wheat, whereas the wing feathers are very hard and shiny like sheet metal.

▲ Canada Goose Family; pen drawing, 1974
▶ Nesting Geese; acrylic, 36 × 48″, 1978

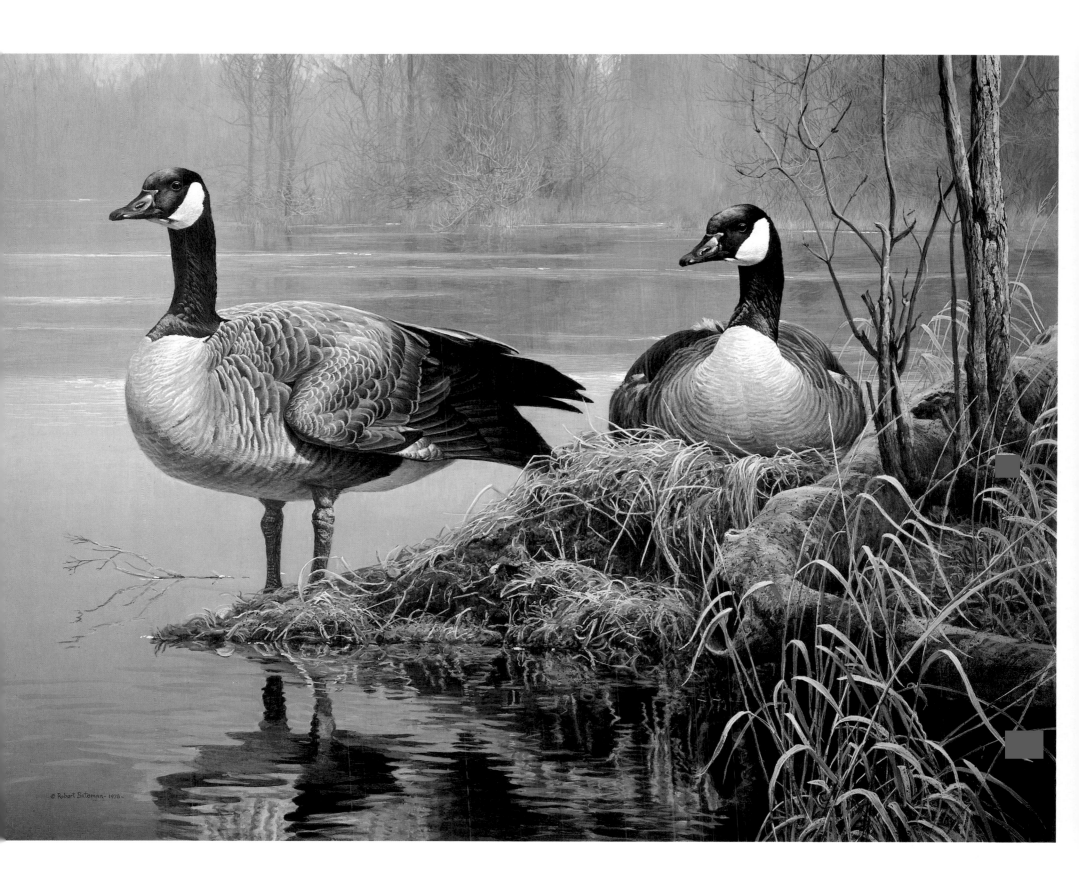

Whistling Swan, Lake Erie

I like contemplating empty space in nature and also in art. When I'm standing in front of one of Mark Rothko's great canvases, a big piece of space that says simply yellow, or orange, I get a spiritual feeling, a sense of great presence. I enjoy the emptiness and lack of texture and rhythm and balance, and I connect it in my own mind with Zen and Oriental art where the presentation of the unstated and a striving for empty space and nothingness are valid pursuits.

In painting I like to play with empty space, but my Western mind wants to rivet it a little bit, which is very un-Zen. Here, I cracked the edge of the emptiness with the swan and the brilliance of the gold and dark blue shadows. Then I lightly hinted at a jet vapour trail at the top which sets up a tension across the space, like the gap in a spark plug. The vapour trail also echoes the form of the swan's wing (as do the snow banks) as well as suggesting the faintly disturbing presence of man.

▶ Whistling Swan, Lake Erie; acrylic, 36 × 48″, 1976

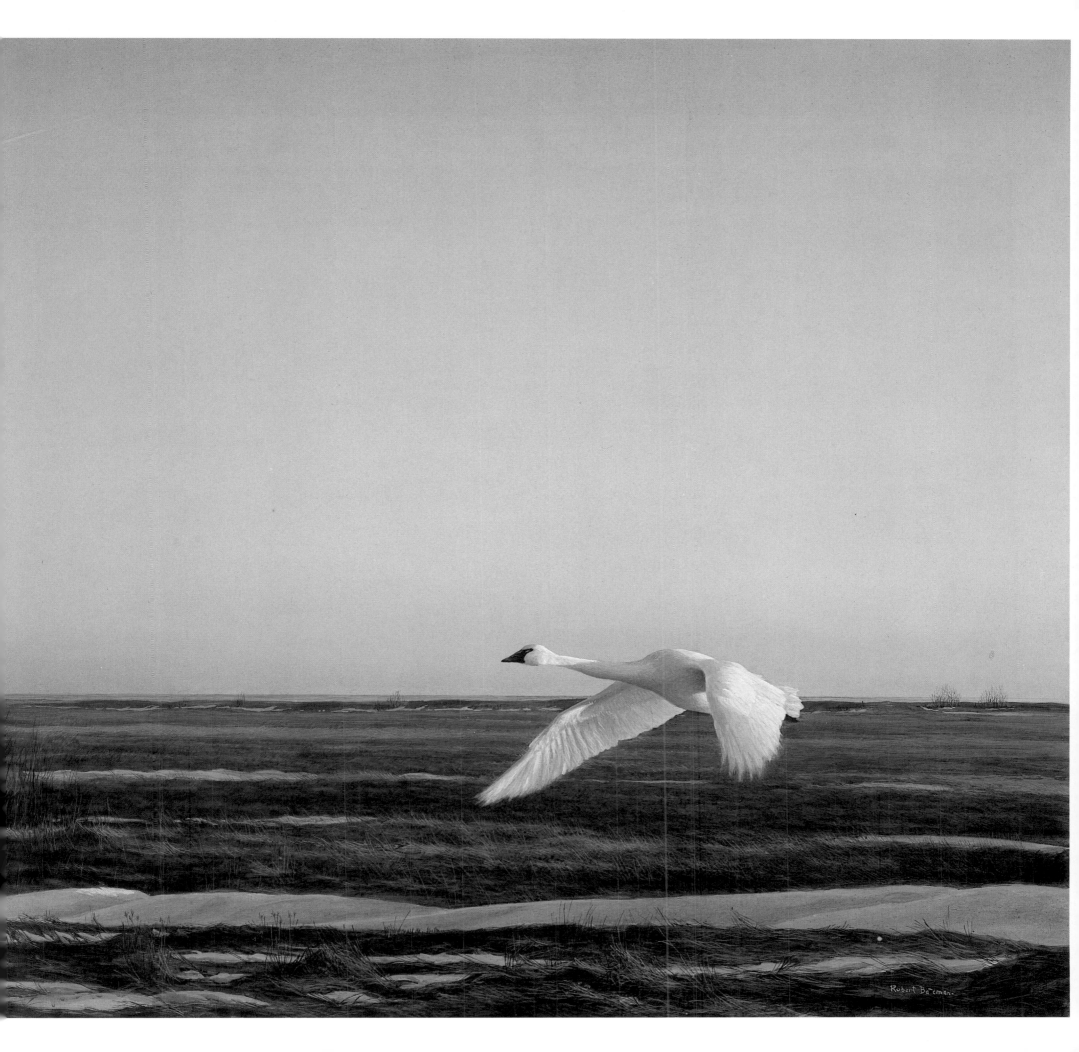

Herons

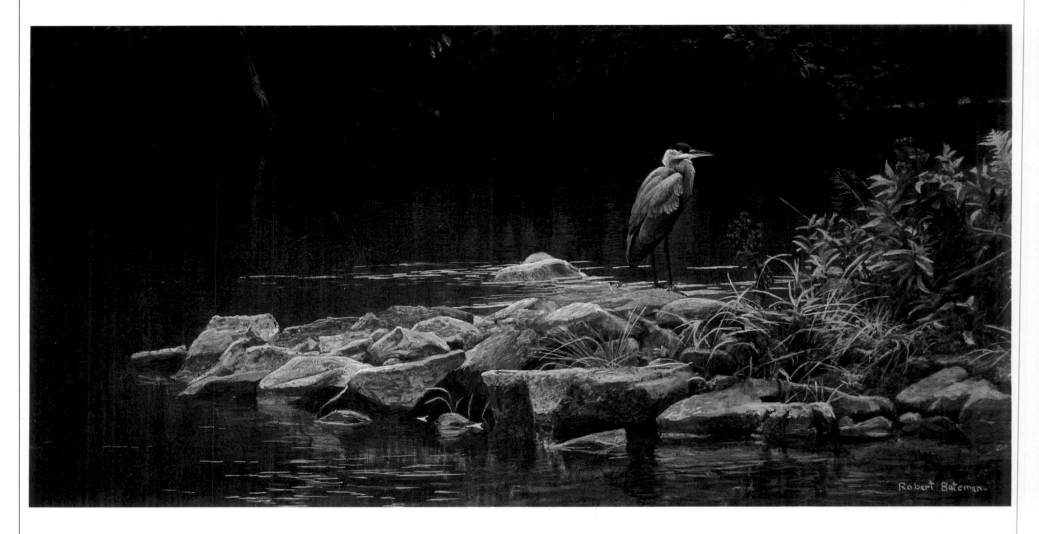

▲ Heron on the Rocks; acrylic, 12 × 24″, 1976
▶ Great Blue Heron; acrylic, 30 × 40″, 1978

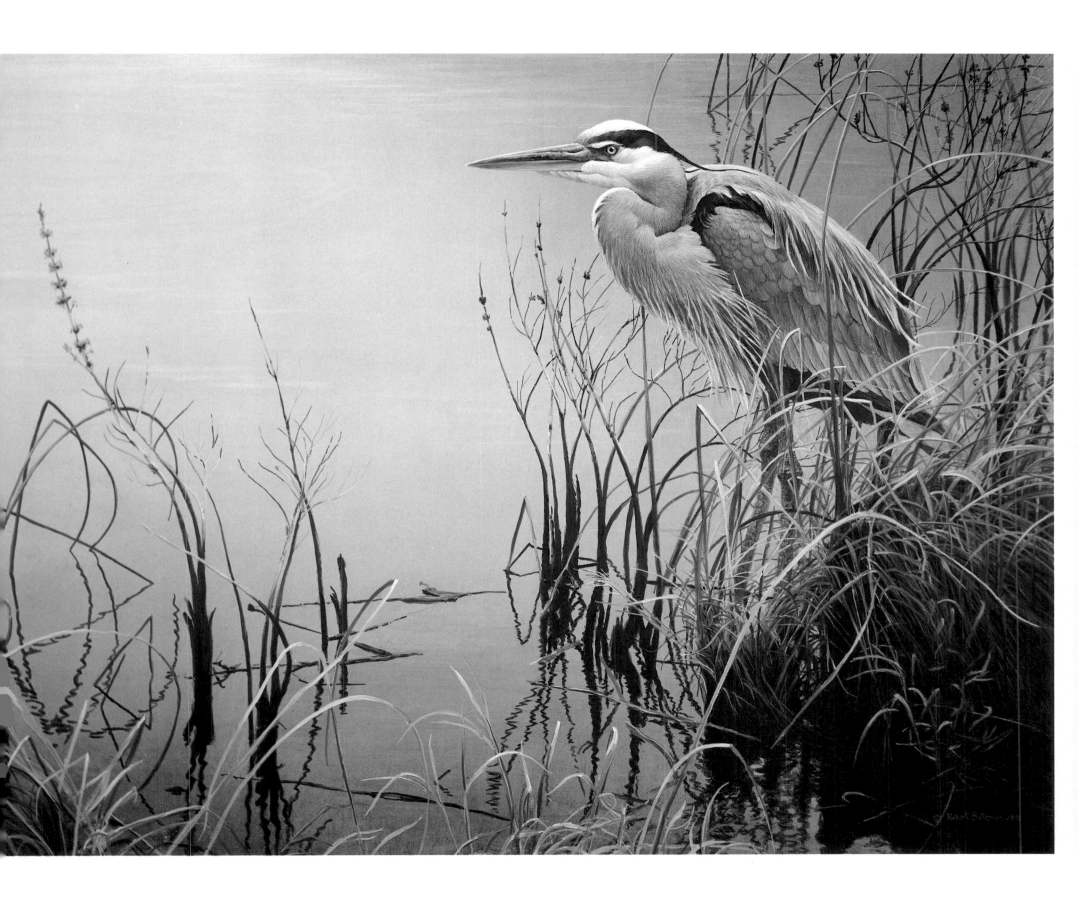

Loons in Morning Mist

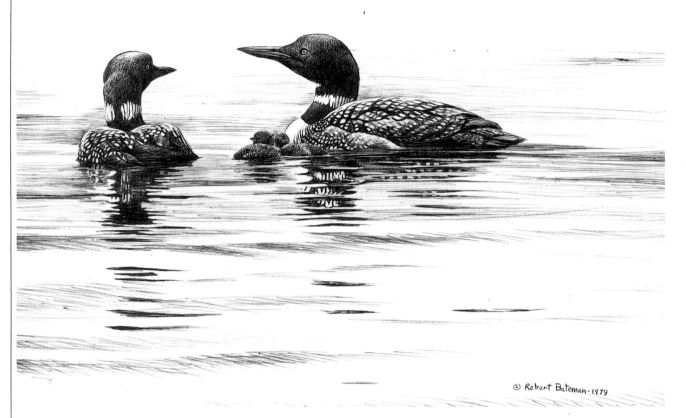

I wanted atmosphere and space in this picture, but also a veiled, flat look, like a Japanese screen. I wanted the loons to be very calm and stately, not thrusting out from the picture the way the nesting Canada geese do.

I enjoyed playing with all the rhythms in the reeds, and as I was painting them I was reminded of a period in Mondrian's work when he would paint little lines that intersected, inviting you to take an excursion into space and back again.

Technically this was a difficult painting to do, with its gradual modulation of light and the interplay of the reeds, and I set it aside for long periods of time before finally completing it. I was originally inspired to use the soft gold colour by a beautiful photograph in the book *Canada: A Year of the Land,* but the painting might be equally effective in a number of other colours.

▲ Loons; pen drawing, 1979
▶ Loons in Morning Mist; oil, 32 × 48″, 1980

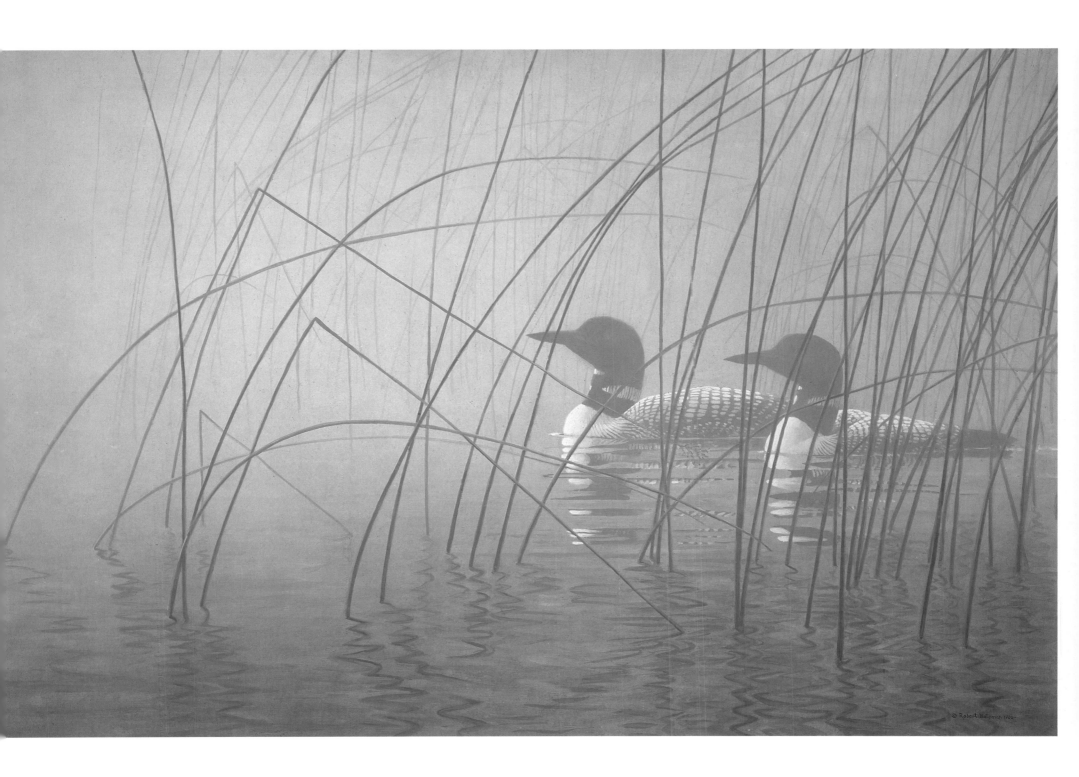

Among the Leaves — Cottontail Rabbit

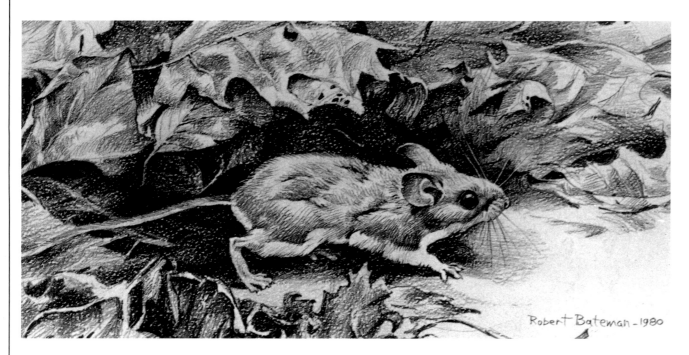

The challenge in this painting was that young rabbits tend to be cute and spring flowers tend to be pretty. I wanted to avoid a painting that was too cute or too pretty, so I did what nature does — I hid the rabbit among the leaves. I emphasized the crispness and transparency of the leaves and put washes of darker colour over the cottontail to push him back into the picture. The trilliums relieve the otherwise brown colour scheme, and distract the eye away from the rabbit. When I cut the trilliums off at the top of the picture I was reminded of Degas' painting of a hat shop, in which a rack of ladies' hats goes up at an angle and out of the picture.

▲ Mouse in Leaves; pencil drawing
▶ Among the Leaves — Cottontail Rabbit; acrylic, 13 × 18″, 1977

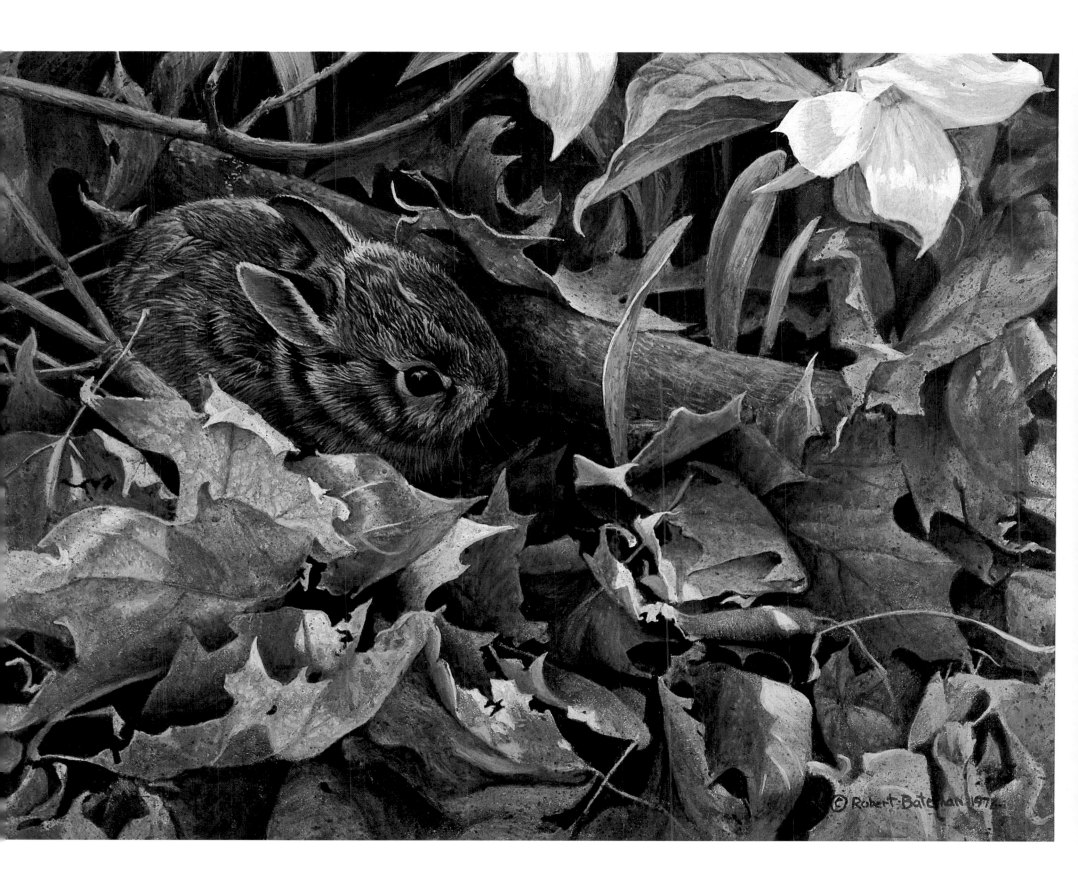

Swallow Banks

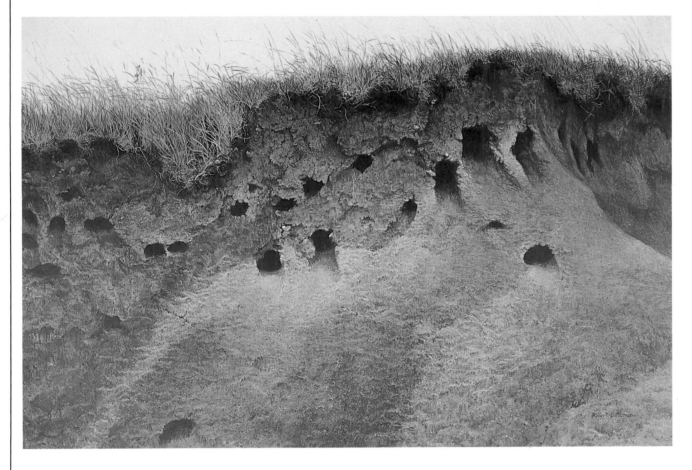

A small piece of nature can often reveal an amazingly rich history, unique in its combination of animal or insect or human activity, of vegetation growing and decaying, of rock formations and of weathering, the effects of freezing and thawing on rock and earth. In the picture of the bank swallows' nesting colony in the fall, the birds have migrated south and their holes are all empty but still quite firm. This colony was on the northern edge of the deciduous forest where the nutrients of the soil are leached out — a process known as podzolization — and the result is a distinctive, ashy-gray band of soil.

Looking at the bank from top to bottom, you can see that the first layer has a particularly crumbly texture, rich in organic matter from decomposing grasses and vegetation. Below this is a more heavily mineralized layer where the various organic compounds have reacted and the iron oxide shows up better. Finally you get down to the subsoil which is very sandy and was probably an old sand bar during the Ice Age. Driven into the bank are the swallows' holes which have also become part of its evolutionary history.

The second picture, *After Winter,* shows another bank with slightly different soil. A pair of bank swallows are preparing to in-habit an old colony and are hovering in front of it, sizing it up. The winter has weathered the bank and caused the holes to collapse. You can also see the effect the winter has had on the surface of the soil, breaking it up into sections that are almost collapsing. These forms are to me very exciting — their textures and shapes, and the scientific reasons that explain them.

▲ Swallow Bank, Fall; acrylic, 24 × 36″, 1968
▶ Swallow Bank, After Winter; tempera, 31 × 50″, 1970

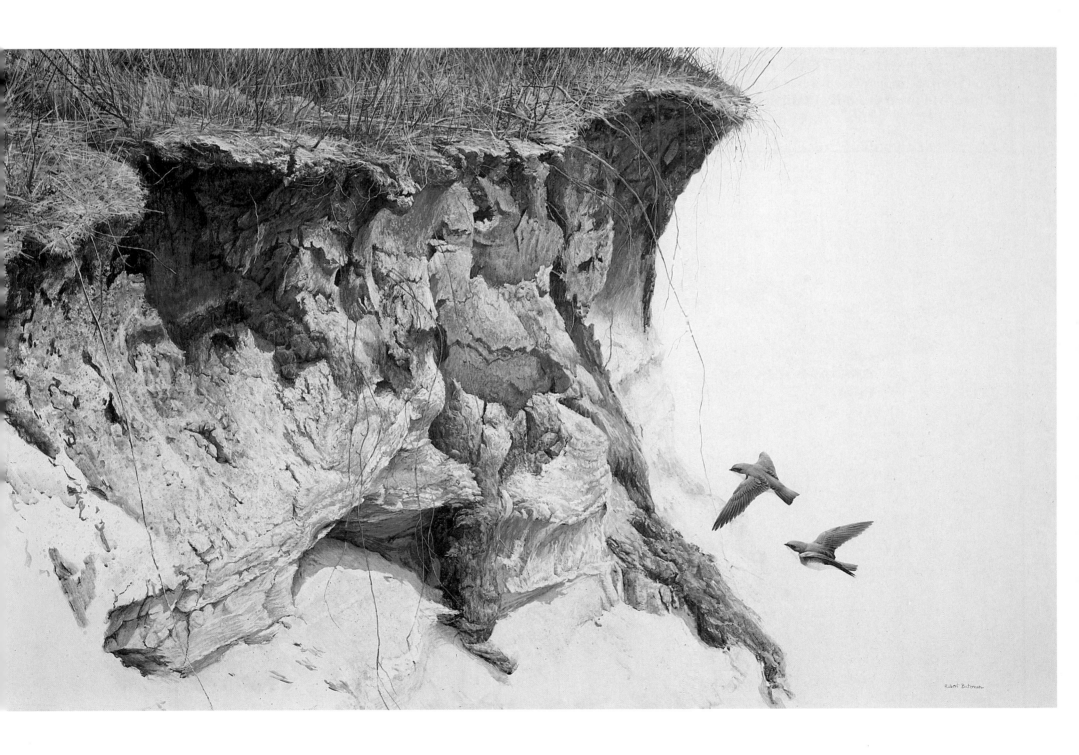

Reeds

There are many small areas of our natural world — not just endangered species or spectacular mountain ranges — that ought to be treated with more consideration and respect. It was that feeling that attracted me to this unremarkable but lovely reed bank — the perfect place for a red-winged blackbird. I actually intended to include a female in the picture and painted one on a little card, but when I tried to find a place for her somehow she disturbed the tranquility of the scene.

▶ Reeds; egg tempera, 25 × 44″, 1970

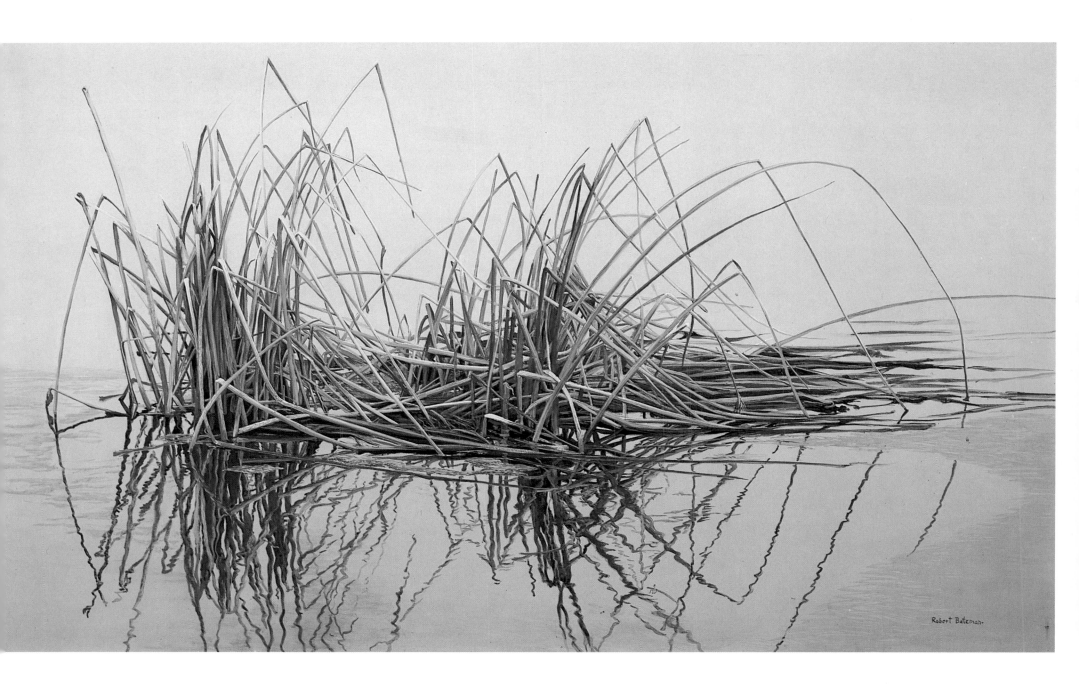

Red-winged Blackbirds and Rail Fence

Here, two male red-winged blackbirds are fighting to control the territory, and the composition reflects their conflict. The fence rails, which were the inspiration for the picture, seem to me like the slashing of a samurai sword or a piece of very bold Japanese calligraphy. They should be the positive spaces here, but they are fighting for dominance with the shimmering white negative space of the swamp behind them. I knew I wanted red-winged blackbirds in this landscape, because they have a military look, with their sharp bills and red epaulets, and they are very active in the swamp at this time of year.

Once the slashing shapes were established in the picture, I went back to the scene to look again at the split cedar fence rails to understand their characteristics in detail. Every rail of a cedar fence is an incredibly sophisticated series of planes and hollows, as individual as a fingerprint, and I made numerous drawings and notes and diagrams to paint each one of these in detail. I try to imagine what it would be like to be a snail crawling along these rails, feeling every bump and knot and ridge.

I also spent many hours watching red-winged blackbirds in the swamp and sketching them in a variety of positions to capture their gestures and characteristics. The males arrive early in the spring, a week or two before the females and start singing around the perimeter of a territory in order to claim it. To establish dominance, they fly up and down and hunch up to show as much of their red as possible. Here, the male on the right is fleeing from the one on the left. From my sketches I made sculptures of both birds and from these I made preliminary cutout paintings of them to find the right position for them in the picture.

An artist recreates the world and so can make his own rules, but he must pay the price of his rules. In terms of composition I think I placed these birds successfully, but after the painting was finished an ornithologist friend pointed out to me that a dominant red-winged blackbird would never let himself get below another male that he is driving from his territory. This bothered me but here I decided to let the artist's world prevail over the natural world.

▶ Red-winged Blackbirds and Rail Fence; acrylic, 36 × 48″, 1976

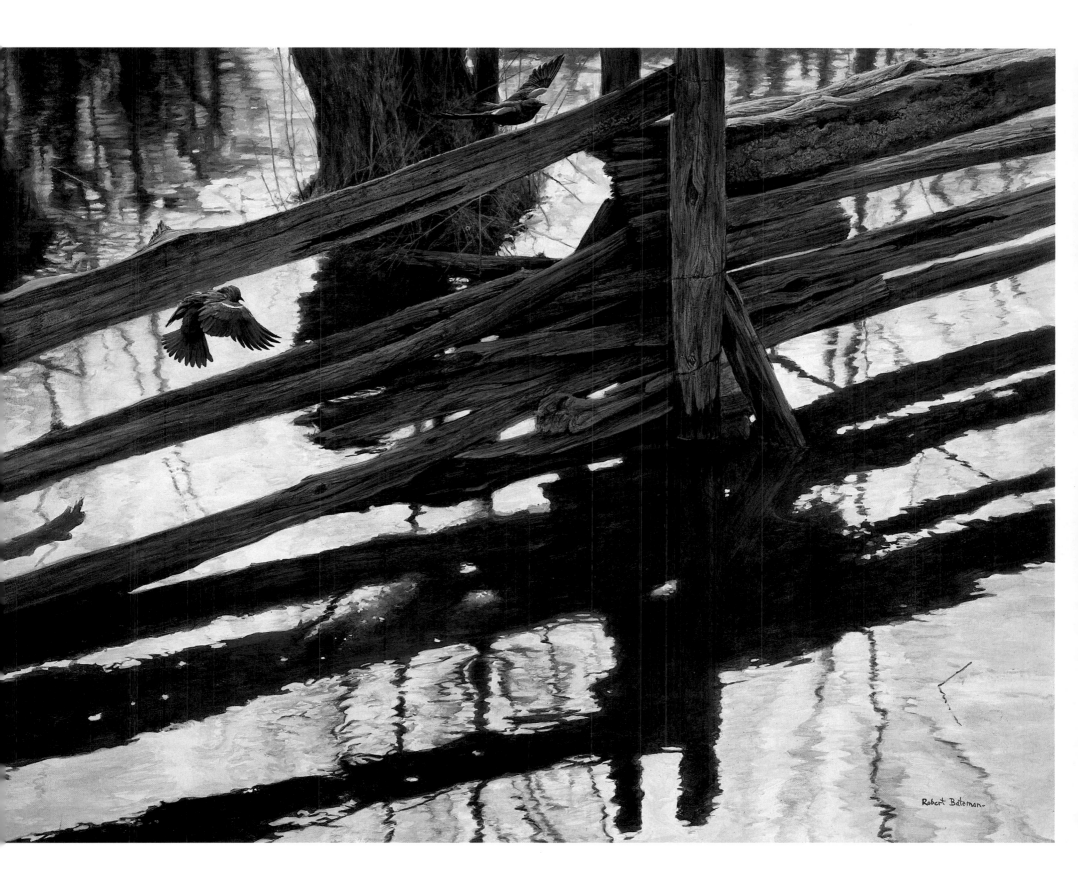

Robert Bateman

Black Bear

This bear is lying on a rock outcrop topped with white pines, a place I have known since I was a child. It is a sunny day, but the bear is well protected and is able to have a good look around before he comes out and starts foraging. He is a fairly amiable bear with an interested expression.

I enjoyed painting the rock, a kind of granite called gneiss, using little trickles of turquoise and pink and yellow and gray. When I paint rocks I like to convey their characteristics and to make sure that they belong in the landscape and are recognizable geologically.

▶Watchful Repose − Black Bear; oil, 20 × 25″, 1980

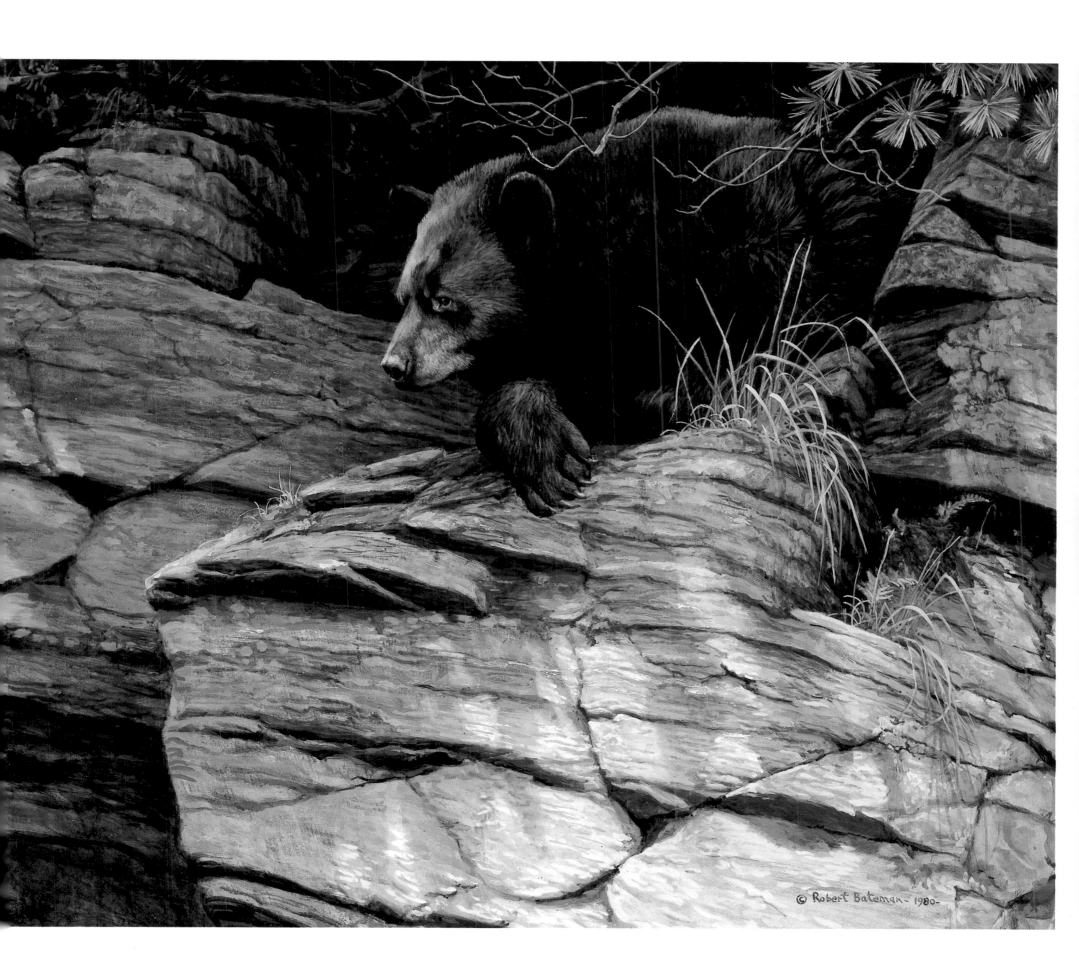

© Robert Bateman – 1980–

Haliburton Farmhouses

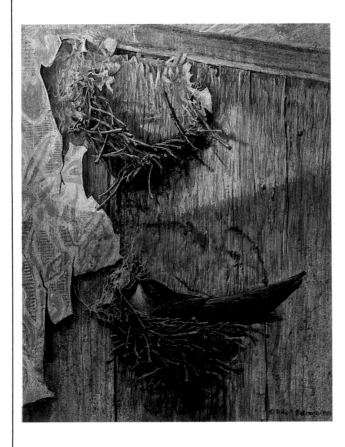

In the Haliburton region of Ontario, which I know so well, I get a poignant sense of natural growth and decay. I have spent most of my summers there since I was a child, and, as a geography student, I studied it in detail. People first settled here in the 1890s, clearing the land and farming, and for a few years they had good crops and a ready market, feeding the lumber workers in the area. But soon all the lumber was cut off, and the crops failed too, for this was marginal farmland and the settlers were cultivating topsoil which had no depth and was soon leached out. Gradually the communities which had been built up — some of them quite elaborate — were abandoned. Now, fifty or sixty years later, many of the buildings have almost totally vanished and nature has taken over again. You can walk through the woods and find an unexpected apple tree, or a lilac bush that some woman had planted by her doorway perhaps to remind her of an English garden and to bring some gentility and beauty into a rather harsh life. Now the woman is long forgotten and what remains of her house is a shelter for other creatures. Mice scamper along the window sills and outside on a hot summer day a monarch butterfly floats through the milkweed that has grown up around the long-abandoned plough.

Chimney swifts have taken advantage of these old buildings and are among the species that have flourished since the time of the original settlements. Their nests are made from their own saliva which acts as a glue. (The famous Chinese birds' nest soup is made from swifts' nests.) Here the mother is sitting on her eggs, and higher up on the wall are the glued rings of an earlier nest staining the wallpaper.

▲ Chimney Swift in Nest; acrylic, 16 × 12″, 1978
▶ Haliburton House; acrylic, 37½ × 29″, undated

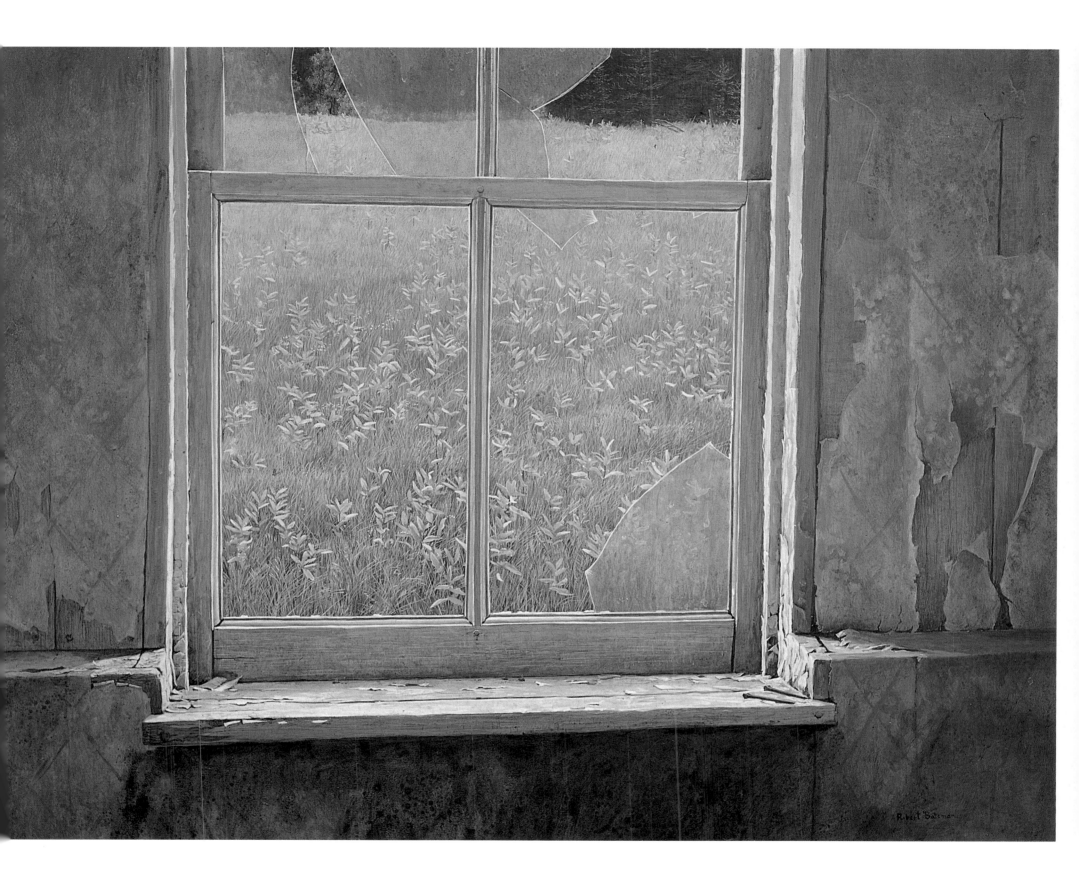

Young Barn Swallow

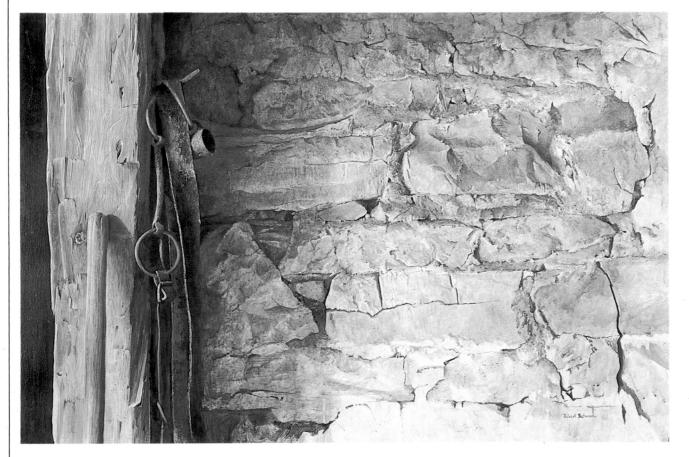

Despite its realism, *Young Barn Swallow* has many abstract qualities. I was attracted by the shapes of the stones and plaster on the wall. The old stable is man-made, but it has an organic quality and a sense of history in its elements. The stones in the wall were created by primeval forces in the earth and shaped by Ice Age glaciation before they were picked up by a farmer clearing his land and then piled up in a way that made a unique pattern. Then the plaster, probably a kind of homemade lime, was put on and white-washed, and now it has flaked off, making another pattern. The window sill has been rubbed by the chins and necks of horses until it has a patina like the steps of an ancient castle.

This is a young barn swallow whose nest was in the stable. His wing feathers are fully grown and he's ready to fly, but he still has bits of fluff sticking to him. He has probably taken some flights around the stable and is now getting ready to fly outside. There is a sliver of the outside world on the right-hand side which gives a fresh accent to the dun-coloured interior.

▲ Harmsen's Place; acrylic, 24 × 36″, 1971
▶ Young Barn Swallow; egg tempera, 23 × 17½″, 1969

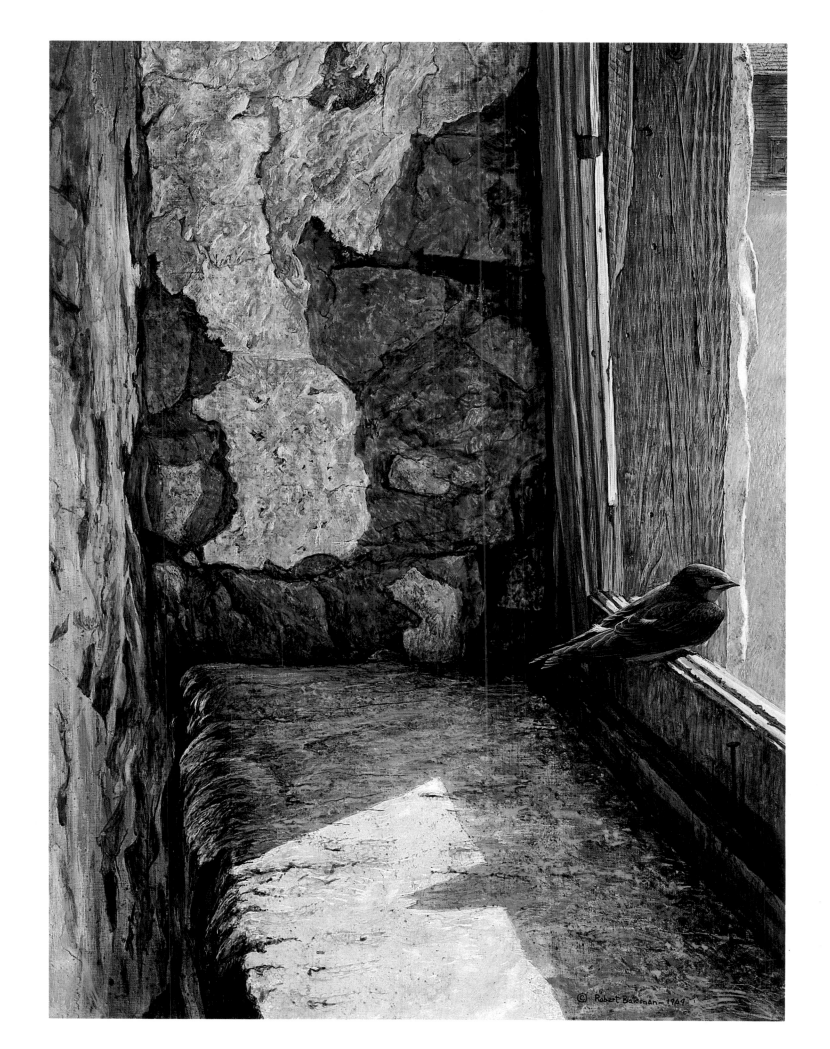

Marginal Meadow

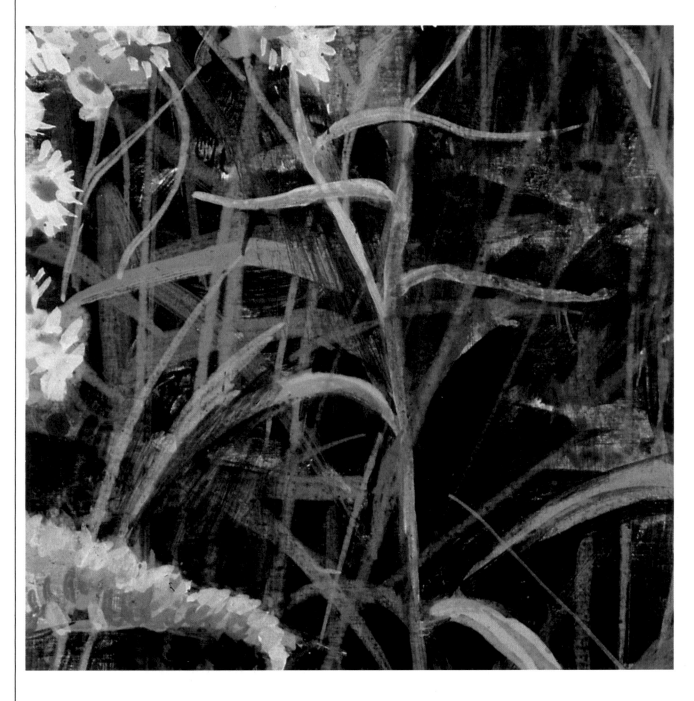

Everyone must have enjoyed the childhood fantasy of becoming some tiny creature who has Lilliputian adventures in a world where ordinary things have become gigantic. I often relive these fantasies when I'm painting a small complex piece of nature like this old meadow, now overgrown with goldenrod and everlasting. In working to convey the idea of air and space and depth around all these plants, I imagine that I'm a field mouse running in and out through them or an insect buzzing around them. Although it is on a small scale, this is still a landscape and is based as much on rhythmic patterns and impressionist and cubist techniques as on meticulous detail.

▲ Marginal Meadow (detail)
▶ Marginal Meadow; acrylic, 35½ × 23¾″, 1970

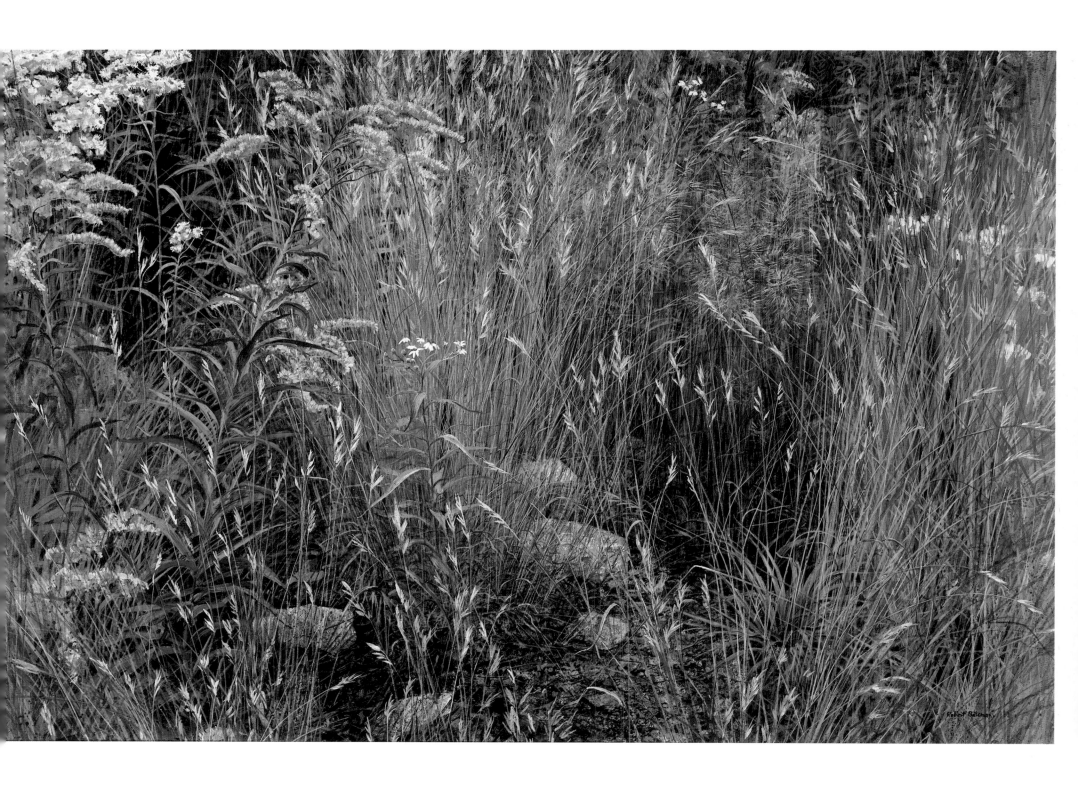

Aspen and Kingfisher

Here I have put the kingfisher within a very patterned picture, similar to *Marginal Meadow,* in which the entire image is the subject of the picture. Within the pattern there is a structured gradation of colours, a bit like Victor Vasarely's hard-edge op art, where different colours gradually deepen or lighten in intensity in opposite directions across the picture, and the exciting area is the cross-over point. In *Aspen and Kingfisher,* the water is very dark at the bottom and fades to light at the top, and the leaves are light at the bottom and modulated to dark at the top.

The leaves also follow rhythmic trails which I have emphasized by making some leaves yellower than others. There are also rhythmic variations in depth which are developed by the skeleton of twigs and branches behind the leaves. I had to do a lot of field drawings of these twigs after the leaves had fallen in order to sort out where each one originated and where it went.

▶ Aspen and Kingfisher; acrylic, 40 × 48″, 1977

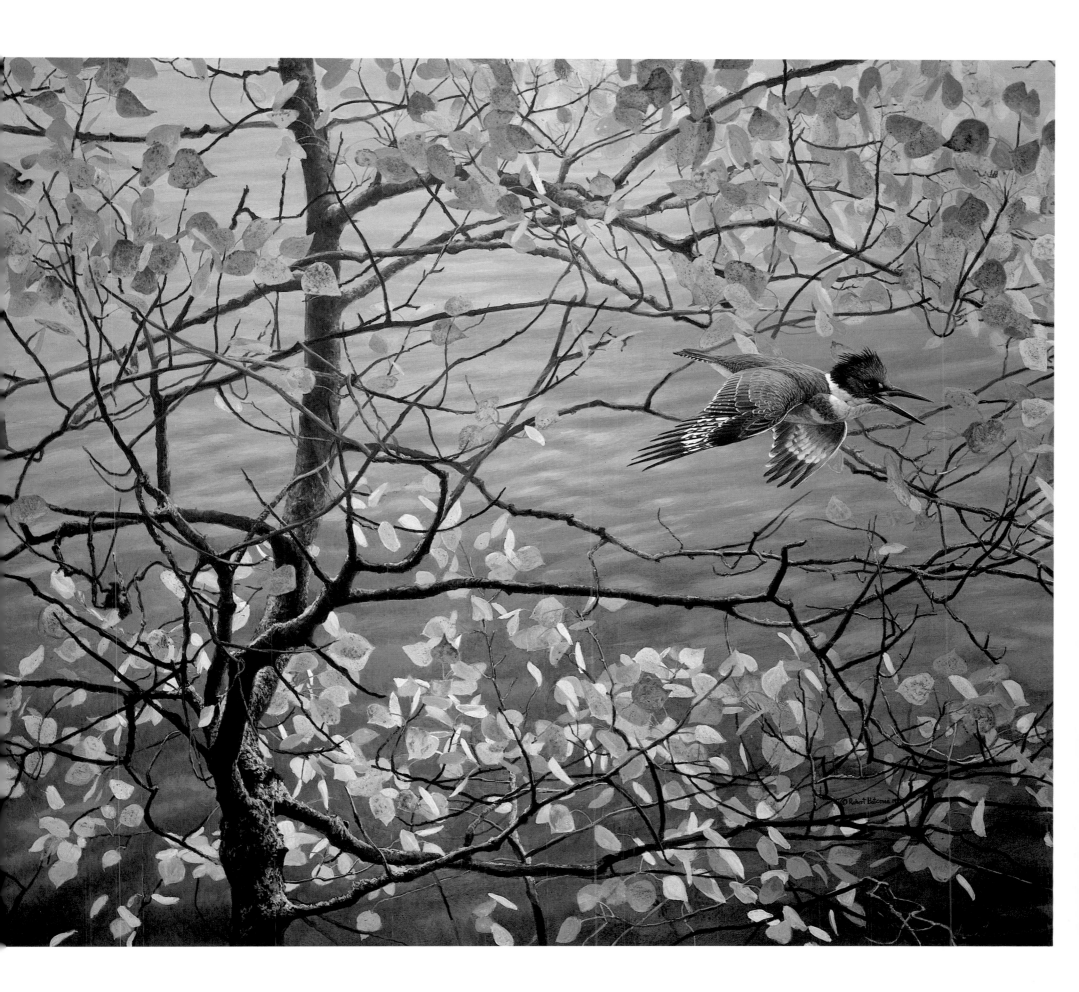

Snipe; Short-eared Owl

In nearly all my pictures I am interested in the relationship between a wildlife subject and its natural environment. Just as important to me is the relationship between the subject and the overall composition and theme of the picture. Neither of these two pictures has a horizon which would act as a dividing line, and in each one I have again let the bird's natural surroundings become a pattern that fills the whole picture. In both of them the composition is developed from the shape and markings of the bird.

The markings of the snipe are reflected in the rhythmic weaving and bending of the marsh grass around it, and the strong diagonal line of the snipe's long bill sets up the diagonal composition of the picture, which is reinforced by the direction of the blades of grass and the low angle of the light from the sun.

The short-eared owl is surrounded by a setting of prairie grasses, sagebrush and other plants, and rocks and lichen. The rolling composition is based on the shape of the owl and reflected in the rocks behind and in front of it. Here the low angle of the sun hits the tops of the rocks leaving the rest of the picture dark and rich.

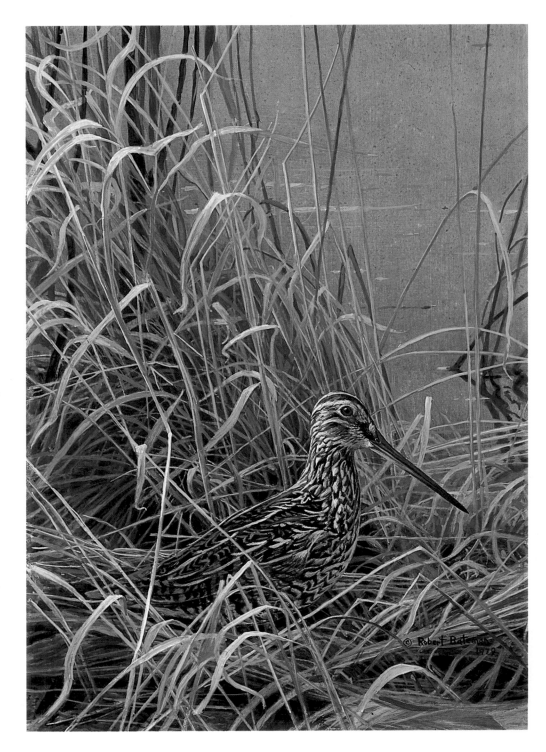

▲ Snipe; acrylic, 12 × 16″, 1979
▶ Prairie Evening — Short Eared Owl; acrylic, 24 × 36″, 1976

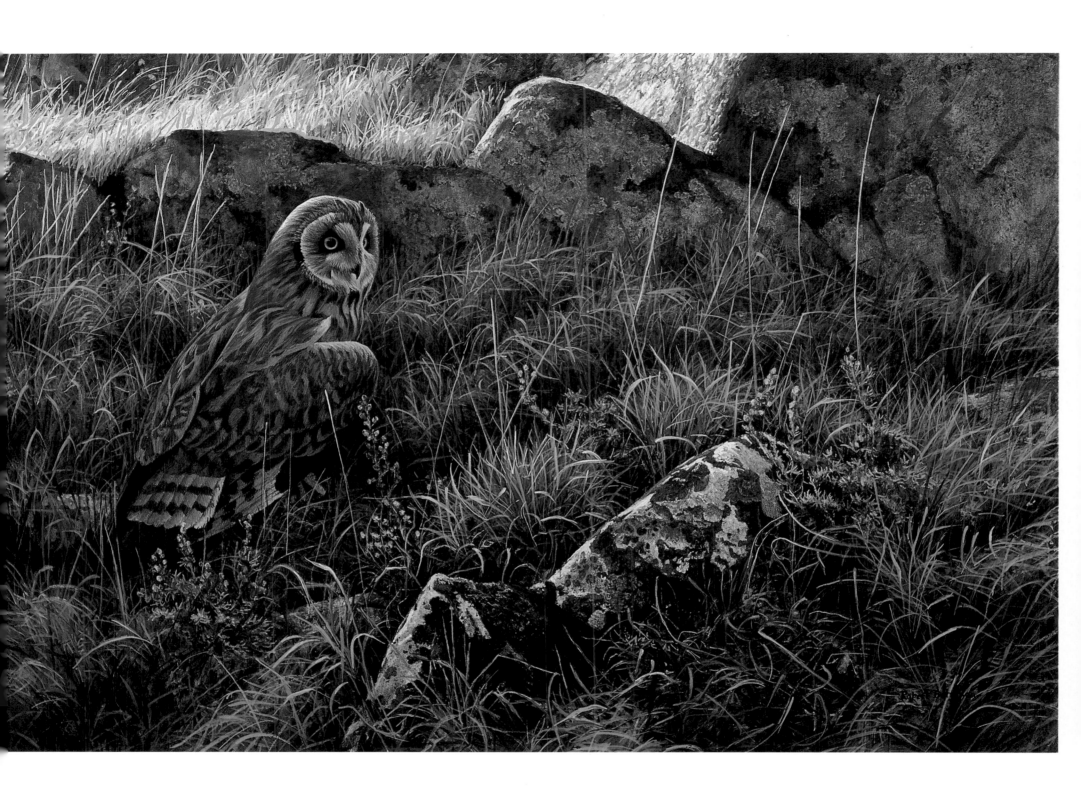

Autumn Overture

This beaver dam and beaver pond near our cottage in Haliburton is a favourite place of mine, especially in late autumn after the bright fall colours have passed and only a few leaves are left on the trees. I love the rich velvety purples and blacks mixed with grays and flecks of gold that seem to predominate in this season.

This is perfect moose habitat, a big swampy pond with lush vegetation the moose can duck for, surrounded by a thick woods giving plenty of protection. I wanted to show the bull moose as a dark, menacing presence, but with his attention directed towards the cow. She is in an ungainly pose with her head lowered and with a somewhat reptilian demeanour. Neither of them are very beautiful by human standards but they are at their prime in rutting season, and, presumably, are very appealing to each other.

▲ Cow Moose; pen drawing, 1979
▶ Autumn Overture; oil, 30 × 48″, 1980

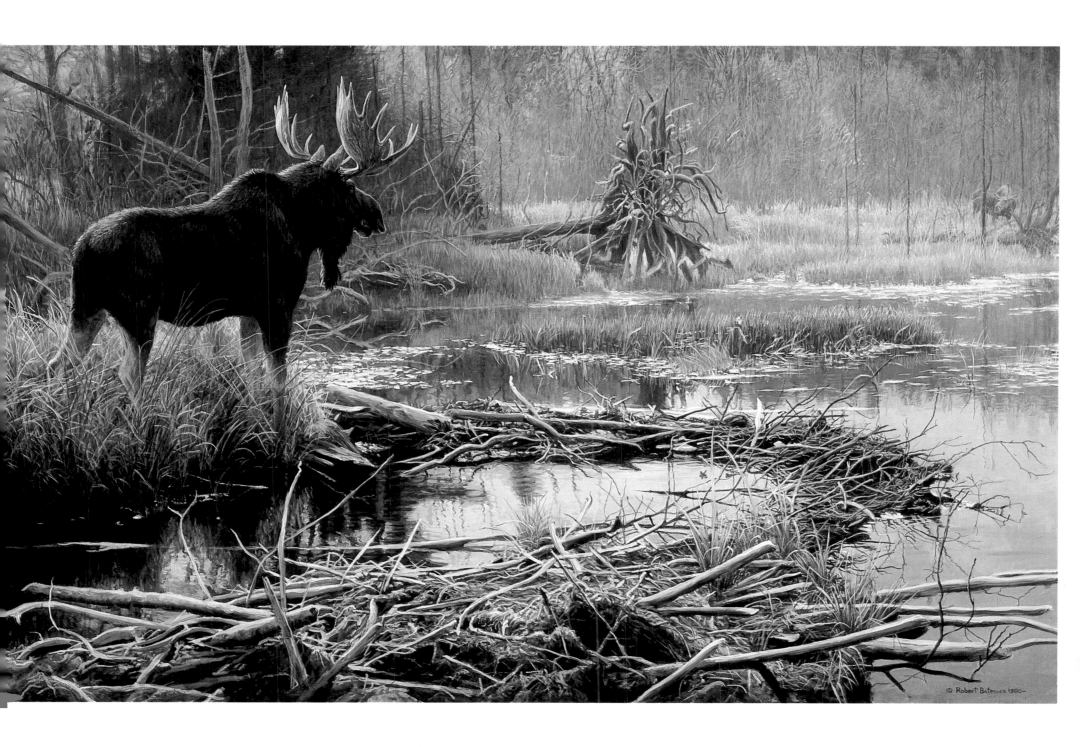

© Robert Bateman 1980

Bull Moose

The splintered, bashed alders in the foreground and background are an indication of the careless and dangerous power of a bull moose. He is still in prime condition and in a fighting mood at the end of the rutting season after the first snows have fallen. Some of the trees are knocked down to be chewed, while others have been broken off by antler cleaning or in temper tantrums.

The moose's face, pushed forward in the picture so that the top of the antlers and the rest of his body are invisible, presents an immediate threat, rather like the face of a large and enraged man whose fender you have just hit, and who is now glaring in at you through your car window.

▶ Bull Moose; acrylic, 30 × 40″, 1978

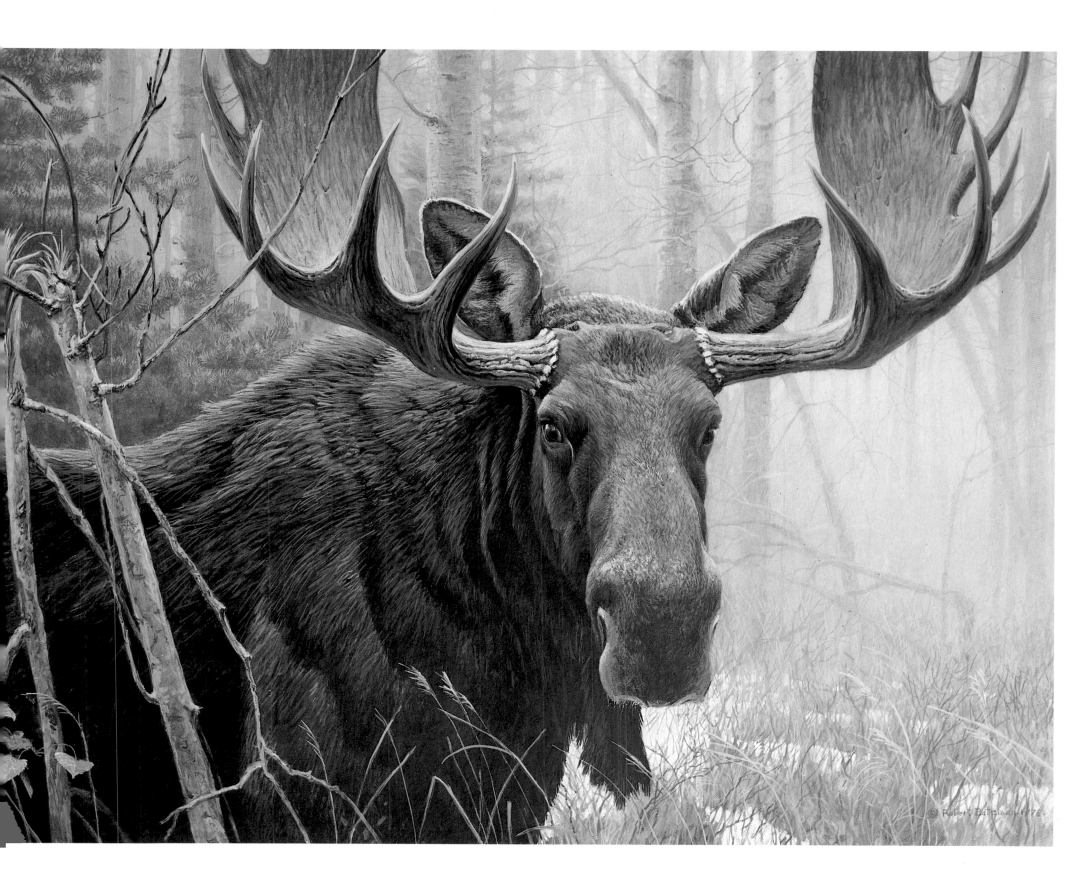

Robert Bateman 1976

Goshawk and Ruffed Grouse

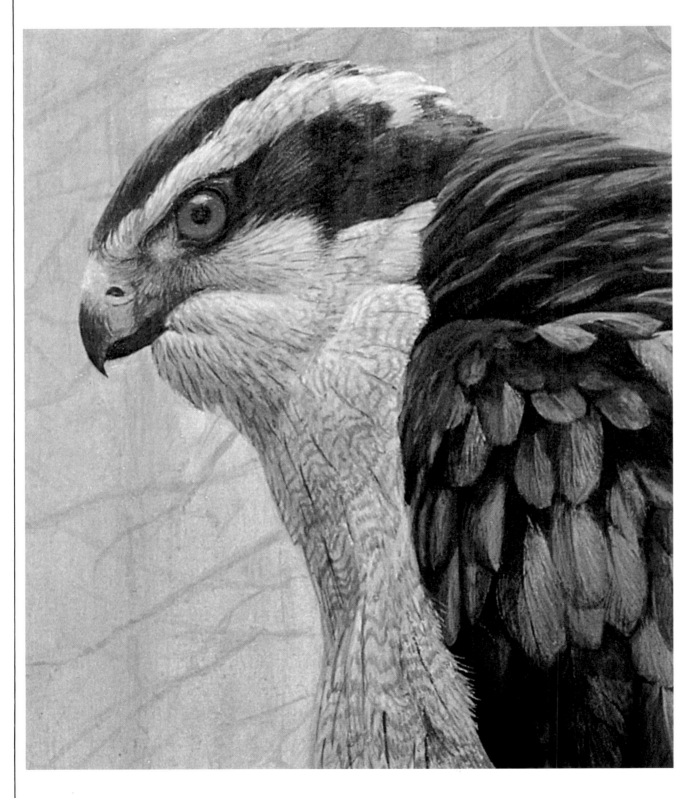

A bird's feathers are beautifully modulated in colour and tone. They also change in size from small and rounded to bigger and more pointed. And they are set up in every species in a distinctive way that is surprising and full of interest.

I had often seen goshawks in the field, but I was able to get an understanding of the modulations of their feathers by looking frame by frame at a film a friend of mine had made. In the film a goshawk ruffled up all its feathers, gave them a kind of shiver and then let them slowly descend. This was so exciting visually to me that it became the originating idea of the picture. Later, I saw a freshly killed ruffed grouse whose feathers would open and close showing something of the same modulation. Ruffed grouse are an important prey for goshawks and so this completed the subject of the picture.

▲ Goshawk (detail)
▶ Goshawk and Ruffed Grouse; acrylic, 24 × 40″, 1973

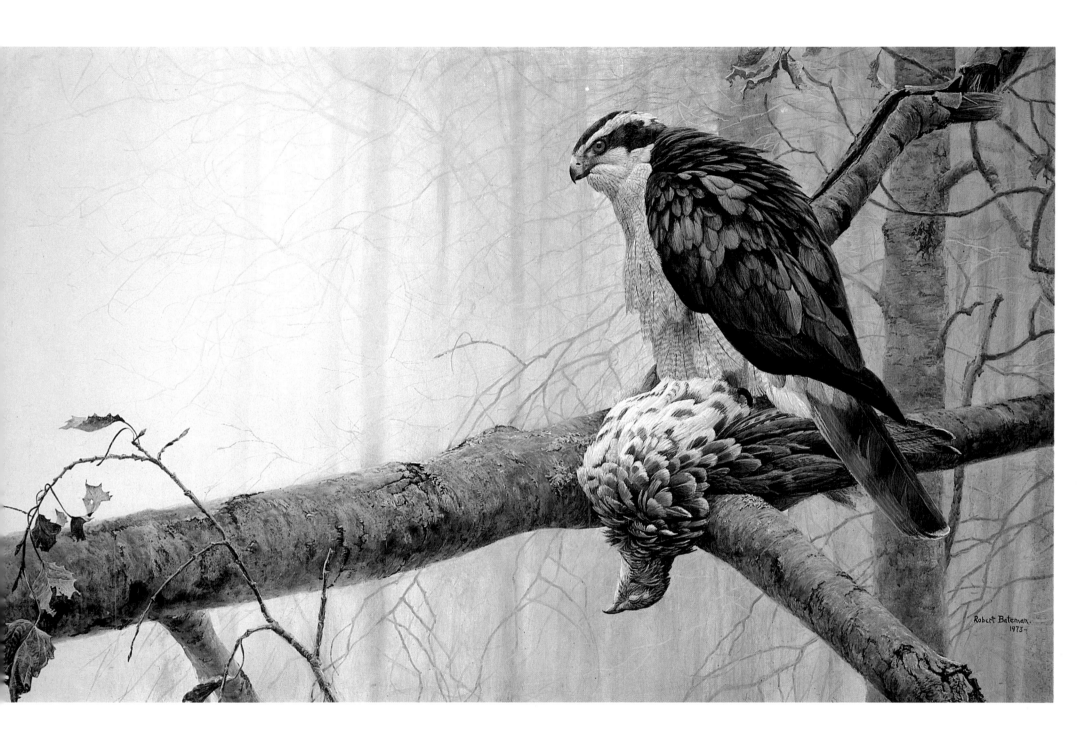

Great Horned Owls

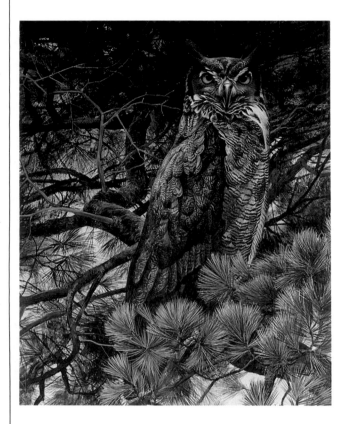

As a teenager, I was constantly looking for owls. My friends and I would ride our bikes around the outskirts of Toronto exploring woodlots, especially ones with white pines that great horned owls liked to use for shelter from the weather and marauding crows. By listening for their hooting at night and scanning the ground for the pellets of fur and bone they regurgitate, I gradually learned to identify their roosting places. The only way you really can see an owl in a pine tree is to look straight up through the branches. I used to spend such long periods of time gazing up into pine trees that my neck would barely straighten and I would see big pine boughs in my sleep.

Later in life, when I became familiar with the paintings of abstract expressionists such as Franz Kline and Pierre Soulages and their bold loose strokes, I began to see my own world in a different way. I discovered a new potential in the dark rhythmic branches of the white pine and they appear in quite a number of my pictures.

▲ Great Horned Owl; (detail) acrylic, 48 × 30″, 1970
▶ Up in the Pine; acrylic, 32 × 48″, 1971

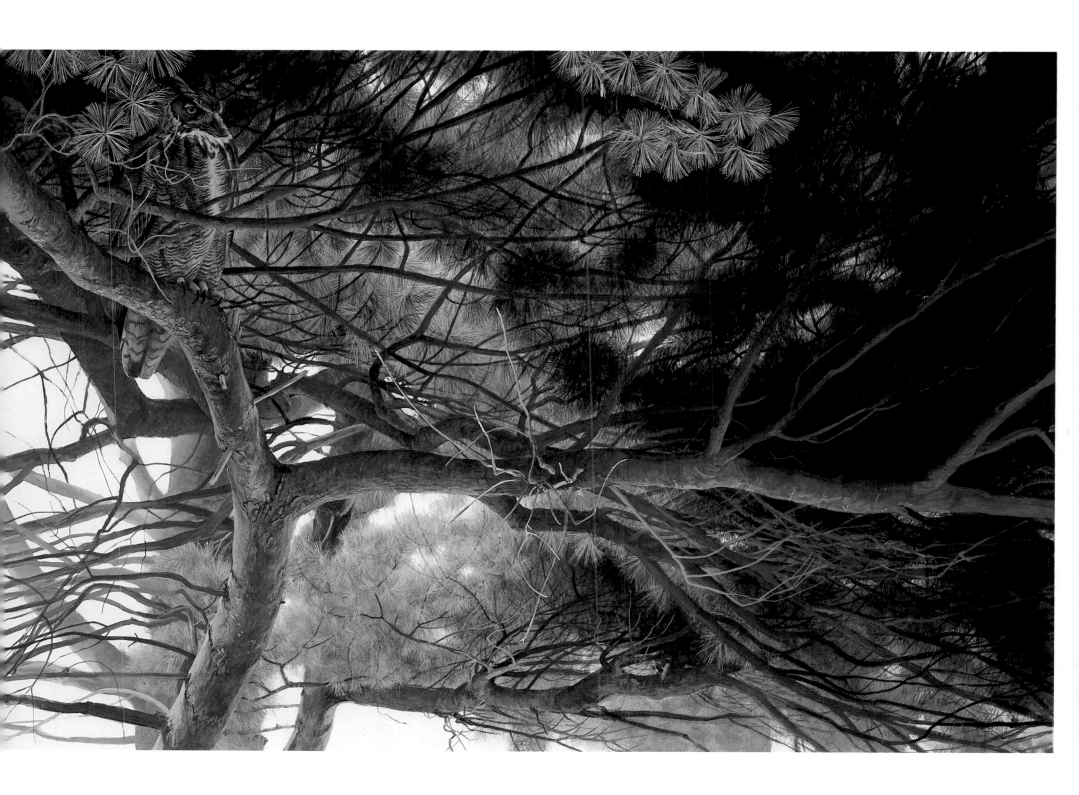

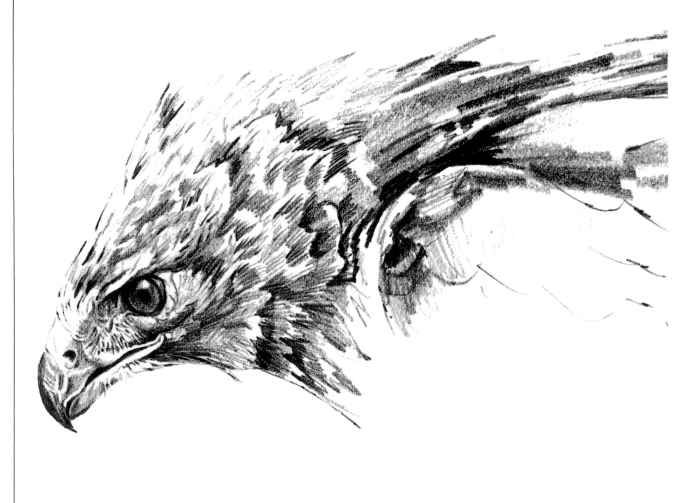

For me, the first thing a painting of an animal must convey is the distinctive personality of the species. Technically, this can be analyzed in terms of proportions and relationships. The emotional effect is harder to analyze, but is equally important if the picture is to be a success.

The expression of a red-tailed hawk has a combination of docility and fierceness and a certain serious dignity, rather like a handsome dog. This is because of the relationship between the eyebrows, which make the hawk look hard and fierce, and the deep brown of the eyes, which suggest softness. In contrast, eagles or vultures have a relentlessly fierce expression. The feathers of red-tailed hawks also have a soft quality; they are not hard and armour-like, like the feathers of eagles, or fussy like those of goshawks.

I'm also very conscious of making sure that the identifying field marks show clearly. This is especially important for hawks and other birds of prey which are hard to distinguish one from the other. However, I don't feel obligated to show all the field marks, nor necessarily the most important. This is where the artist's imagination and power of selection is important. A fellow-artist and friend of mine, George McLean, once had the courage to do a painting of a red-winged blackbird from an angle at which practically all of the red on the wing was obscured.

In this red-tailed hawk, I didn't show much of the red tail, but I did show such distinguishing marks as an overall buffyness in the upper breast, and a light line in the scapular feathers covering the upper part of the wing.

▲ Red-tailed Hawk Head (study)
▶ Red-tailed Hawk on Mount Nemo; oil, 24 × 36″, 1980

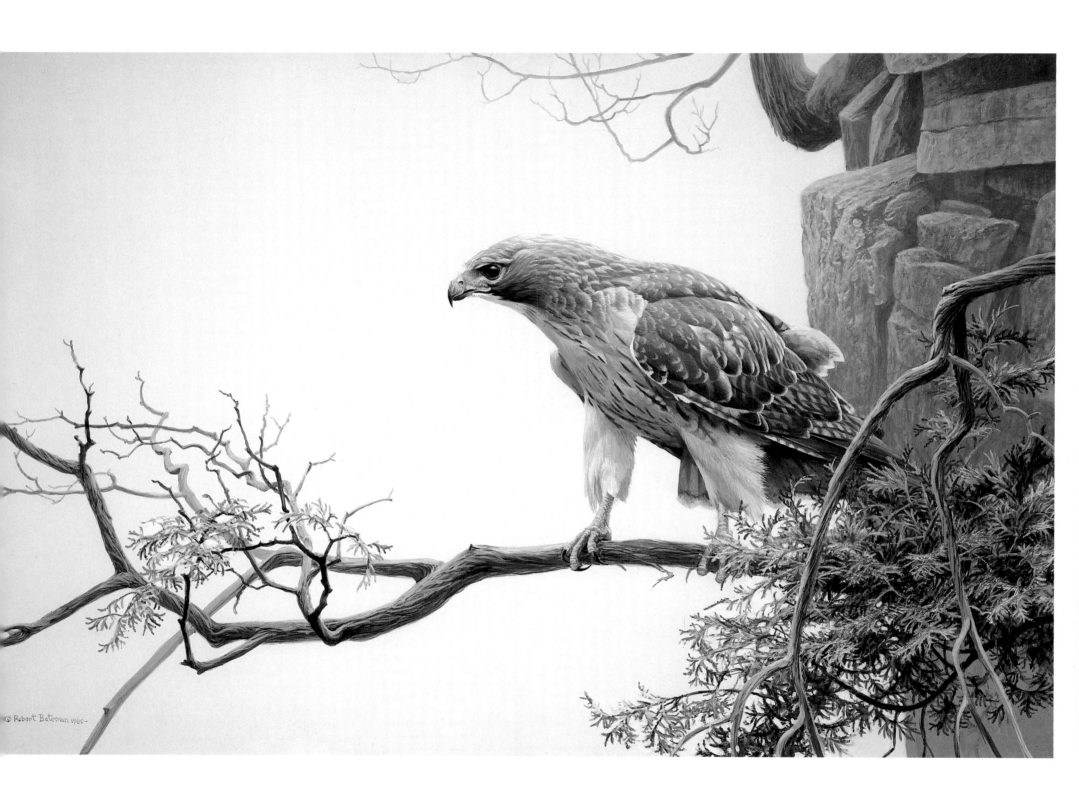

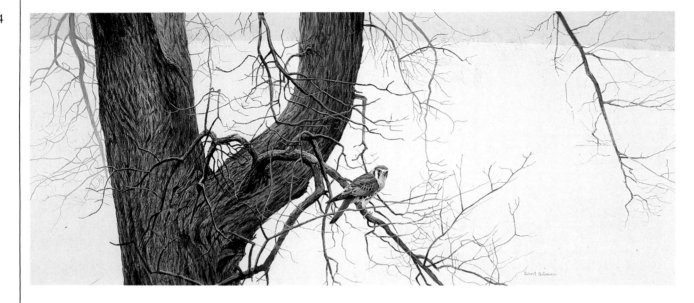

104

Rough-legged Hawk in Elm is an important picture for me because it represents a turning point in my work. The picture began life in 1962 as an abstract expressionist painting of an elm tree. At that time I was strongly influenced by the work of Franz Kline and I was painting pictures that presented strong positive and negative spaces. When I came to paint this elm tree, instead of standing back and drawing the beautiful parasol shape of the whole elm, I looked right at the heart of the tree and saw an explosion of big, black, out-thrusting trunks. I found a second-storey window in a house which looked right into this tree, and there I made a bold, slashing abstract painting which at the time I was quite pleased with.

Then, in 1963, I went to an Andrew Wyeth exhibition in Buffalo, and soon after I went to Africa for two years. There, I began to paint realistically again and to concentrate on wildlife subjects. When I came back home and saw my abstract elm I still liked it but I thought it would be more interesting if it were re-worked. I kept the dynamic forms, but built up the texture of the bark of the trunks and eventually introduced the rough-legged hawk. Thus, in a very real way, this is a transitional picture.

Winter Elm — American Kestrel is a later picture in which I again used the strong rhythmic lines of the dark elm branches to divide up the white space of the snowy hillside into some interesting shapes.

▲ Winter Elm — American Kestrel; acrylic, 15 × 36″, 1970
▶ Rough-legged Hawk in Elm; acrylic, 36 × 48″, 1966

Window into Ontario

This picture, the largest I have ever painted, contains symbols of the early inter-relationship between man and nature in Southern Ontario. Maple is the landmark tree of the area — maple syrup was one of the original industries — and here young sugar maples are regenerating at the edge of the woods. The field, first cleared a century and more ago, has the classic split rail cedar fence. This has the advantage of being made entirely of local material and of being self-supporting, but it takes up a lot of space, so it only survives now in places where the farmland is not too valuable. The blue jay is a boisterous winter bird not too much intimidated by humans. I have echoed the blue and white pattern of its wings in the shadows on the snow.

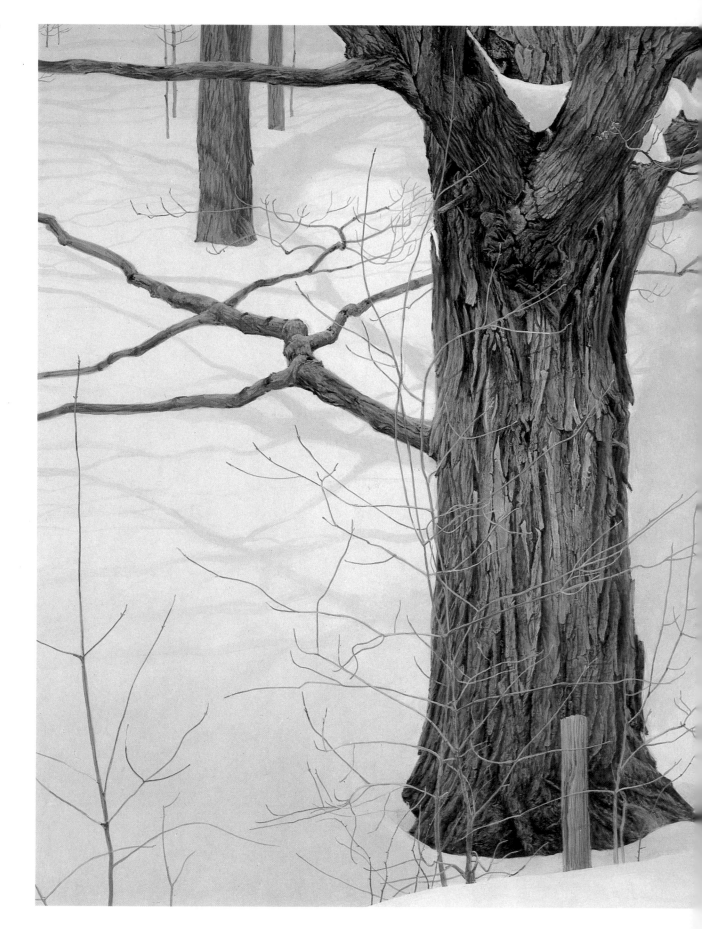

▶ Window into Ontario; acrylic, 48 × 96″, 1977

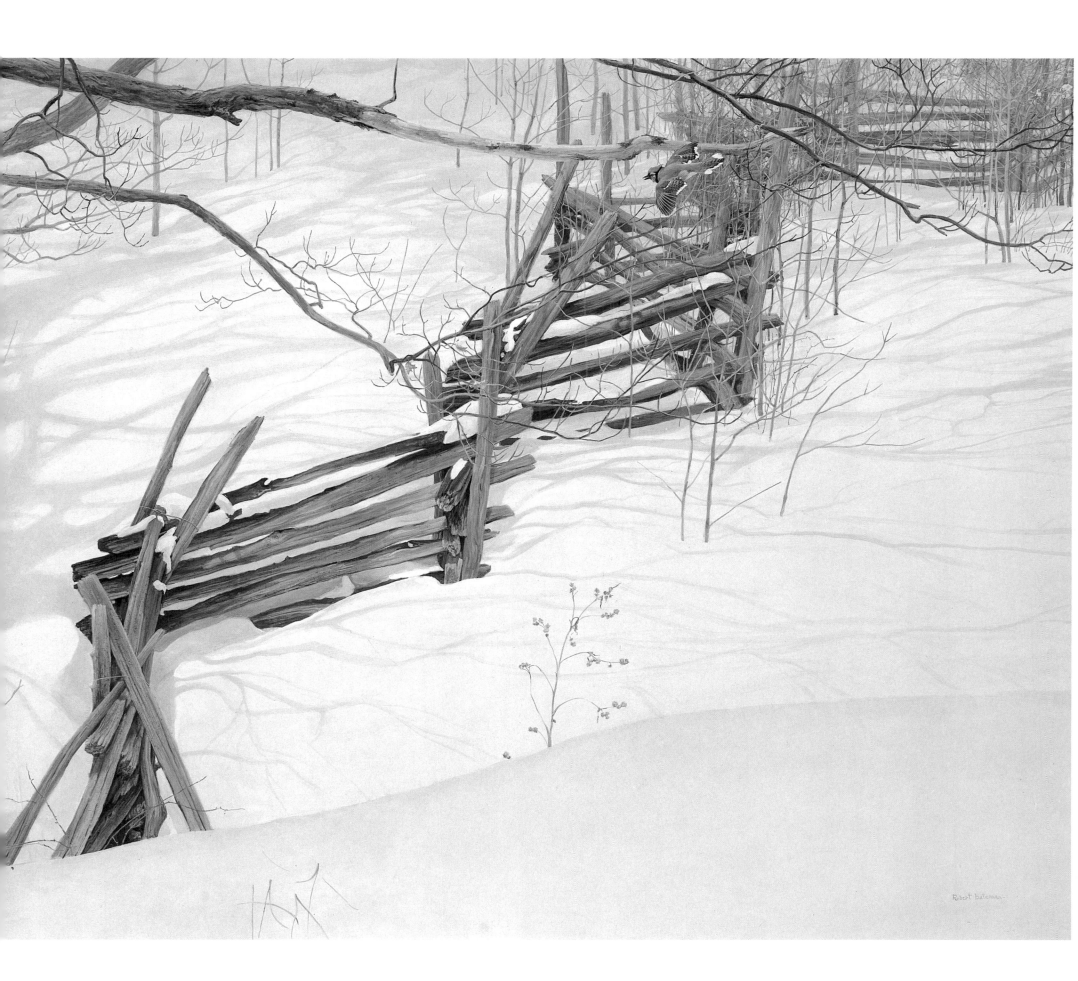

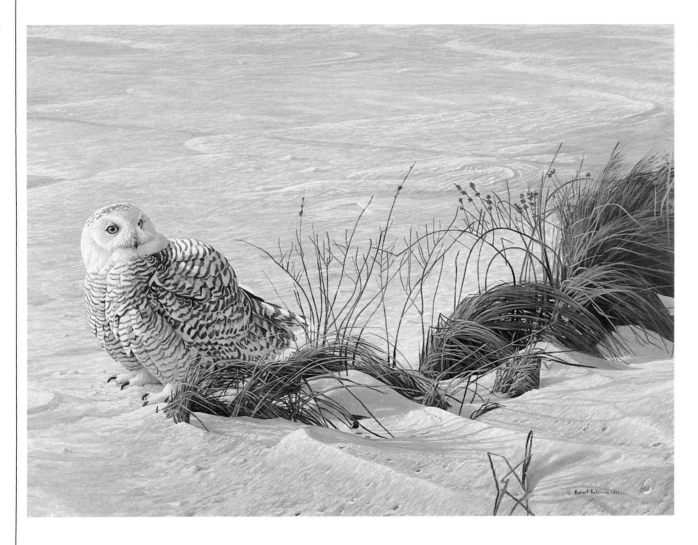

Every winter since boyhood I have seen snowy owls when they travel south from their breeding grounds in the Arctic tundra. I have lost count of the number I have seen, yet each time I see one is a special occasion. I watch for the characteristic white form in farm fields or on trees or fence posts. There is an electric feeling when, through my binoculars, I see the round head turn and the yellow eyes recognize my presence. Sometimes I can approach closely, but inevitably and without a hint of fear the owl drifts away to another perch within sight, as if my proximity is not threatening but a bit rude.

In *Afternoon Glow* I have portrayed the owl at the end of the day in the rich light that precedes sunset. White light is made up of all the colours of the spectrum, and on a winter afternoon these colours seem to separate and radiate a shimmer of every hue. In the picture I have echoed the bounds and curves of the grasses in the form of the bird and in the wind-sculptured snow.

Usually these owls hunt by day. In *Fallen Willow* the snowy owl looks for prey — probably weakened waterfowl or meadow mice — from a willow branch that has fallen down and then rerooted itself.

▲ Afternoon Glow − Snowy Owl; acrylic, 36 × 48″, 1977
▶ Fallen Willow − Snowy Owl; acrylic, 29 × 48″, 1970

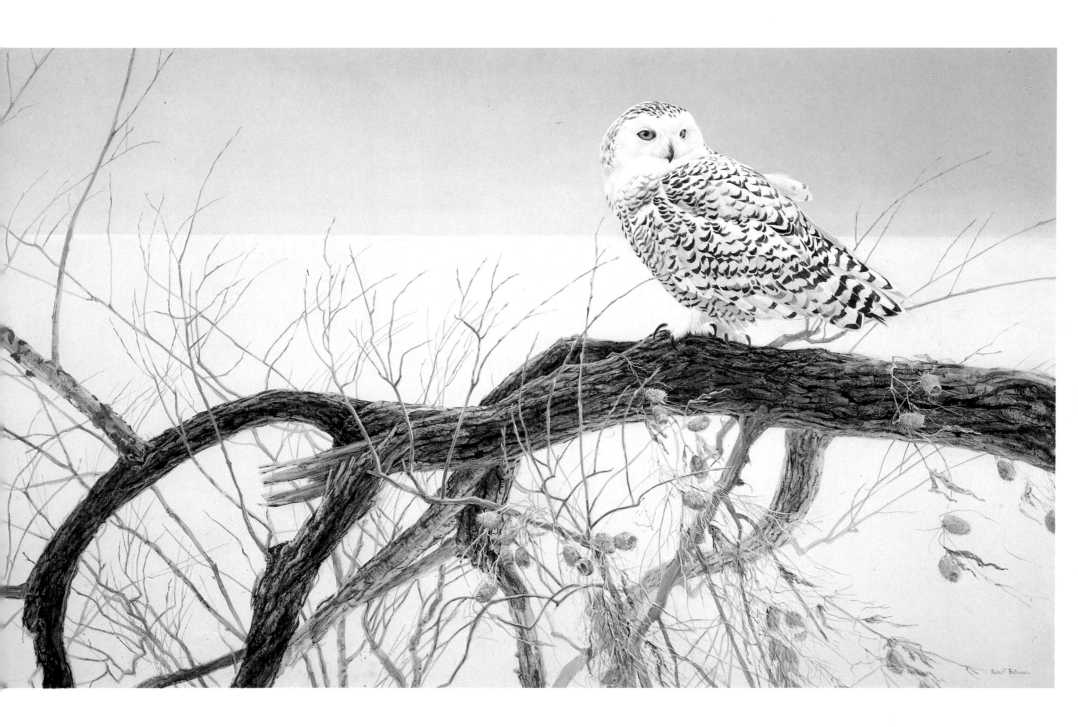

Chipmunk; Snowshoe Hare

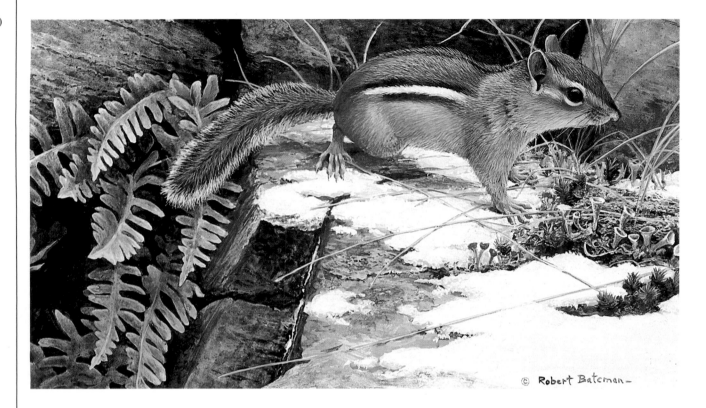

▲ On the Alert − Chipmunk; acrylic, 8 × 13″, 1972
▶ Winter − Snowshoe Hare; acrylic, 20 × 32″, 1978

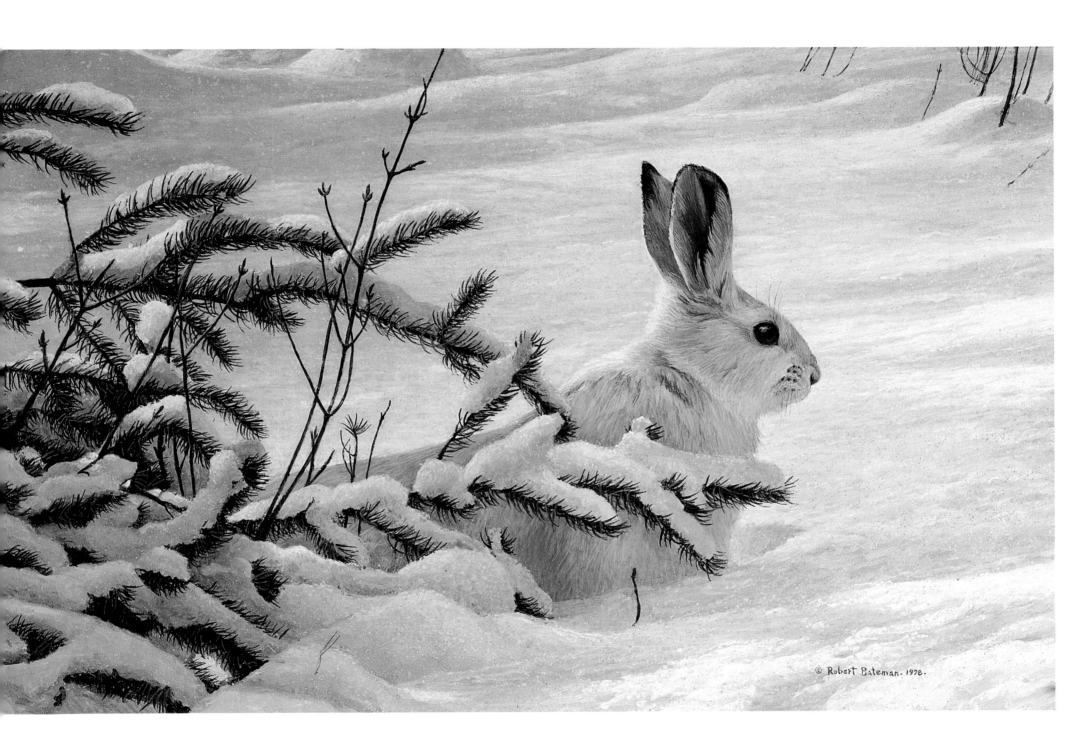

Kingfisher in Winter

For me shape is probably the most important element in a picture. I'd like all my pictures to be made up of shapes that are interesting and strong in themselves, regardless of their content. The idea for *Kingfisher in Winter* began with a particular piece of landscape near our cottage that I began to recreate in my mind. Once I had made a sketch of the basic composition, I began to develop the shapes, the powerful, interlocking, light and dark, positive and negative shapes of the water and snow. I knew I wanted a bird in the picture, and eventually chose a kingfisher. They are not usually thought of as winter birds, but can often be seen in the snow, provided there is some open running water where they can fish.

Within each of the major shapes I began to build in forms, and, as often happens, a theme emerged which I instinctively repeated in a variety of ways throughout the picture. In this case it is a sort of drooping letter P. It appears in the snow at the top of the picture, a little in the position of the bird, then in the tree trunk where the main branch comes out, and then repeatedly in the overhanging snowbank at the bottom.

Once the big, negative shape, the water, was established, I began to introduce the turbulence and rhythmic swirls that provide the action of the picture, again using the drooping P theme in a large, opulent pattern with smaller decorations overlying it. By putting a thin, whitish-gray glaze all over the water, but more thickly at the top, the water lay back and by comparison became richer and deeper toward the bottom. By graying the upper part of the water in this way I was also able to bring out the foreground of the picture which includes the kingfisher and the branch.

Pure black and white and strong contrasting colours are the high cards to play in a painting. I use them very carefully and deliberately for the strongest effect. Here on the left side, the water gets very dark, though not pure black, so the tree in front of it stands out. Then on the right side, where the water is grayed, the black twig jumps out for the reverse reason. I used rust very selectively for the female kingfisher's characteristic flanks, and also on the underside of the peeling birchbark. The other accent is the golden yellow of the few leaves remaining on the tree.

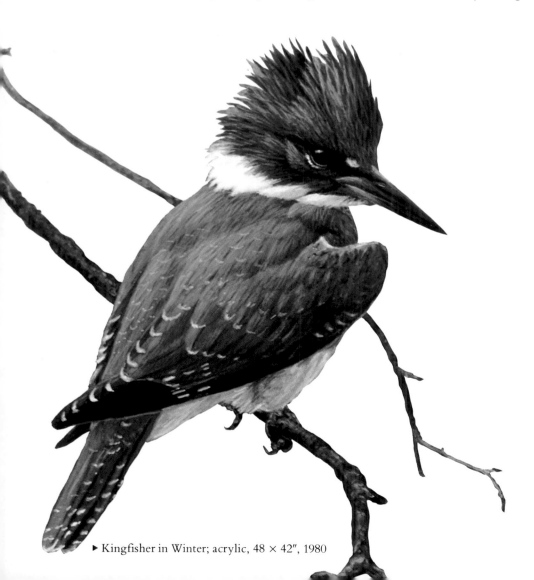

▶ Kingfisher in Winter; acrylic, 48 × 42″, 1980

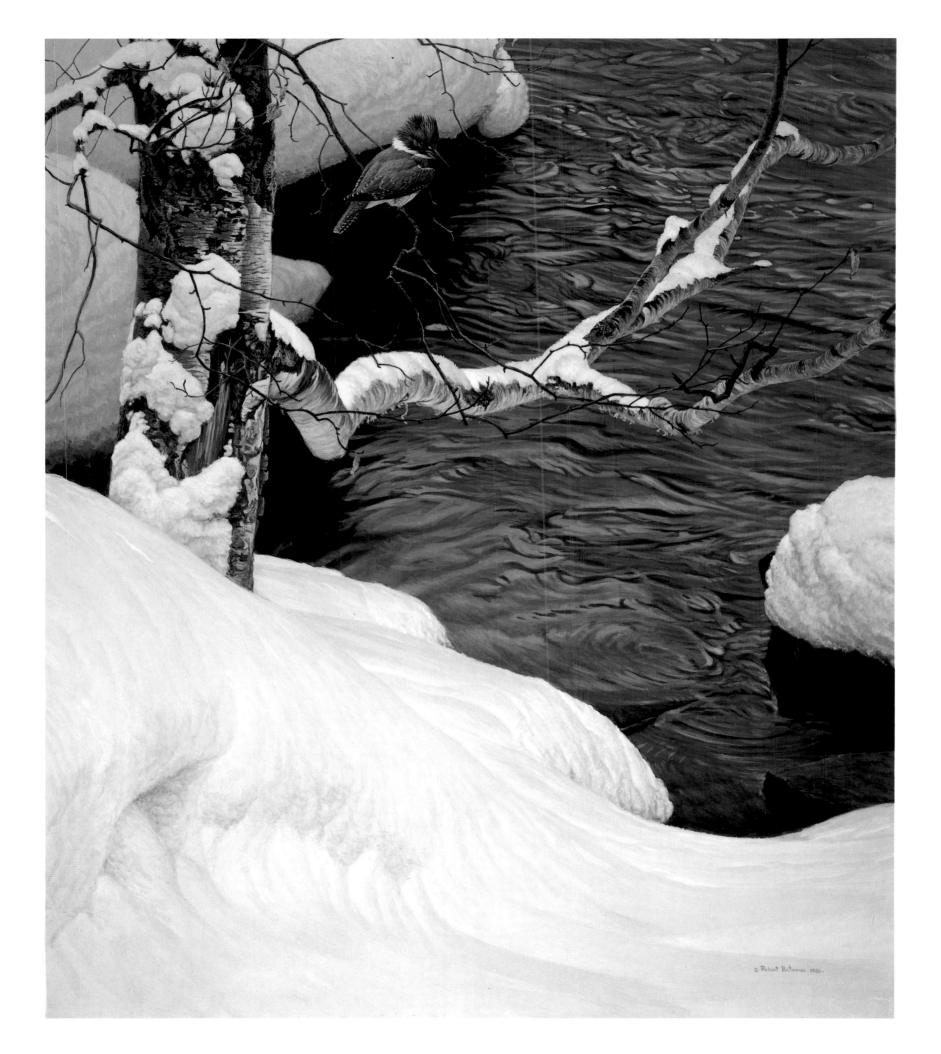

Edge of the Wood

When the great white pines of Ontario were cut down and the land cleared, the stumps were pulled out to the edge of the fields and used as the first fences. Because they were solid, tangled and resinous, they lasted a long time. Some of them are two hundred years old and still going strong. In this fence, some cedar rails have been added. A fence like this one on the edge of a typical farm woodlot gives good shelter for wildlife.

A deer is usually alert but in seclusion during the day. Here, one is seen gazing out over the open field where danger might threaten from the nearby farm or from the snowmobile whose track is just discernible. The glazed, nubbly texture on top of the drifts in the foreground indicates there is a thick crust on the snow, strong enough to support the doe, so the elegant lines of her legs can be seen. The snow has drifted in behind the fence making curving shapes on which the abstract forms of the fence are reflected.

▶ Edge of the Wood – White-tailed Deer; acrylic, 23½×36″, 1976

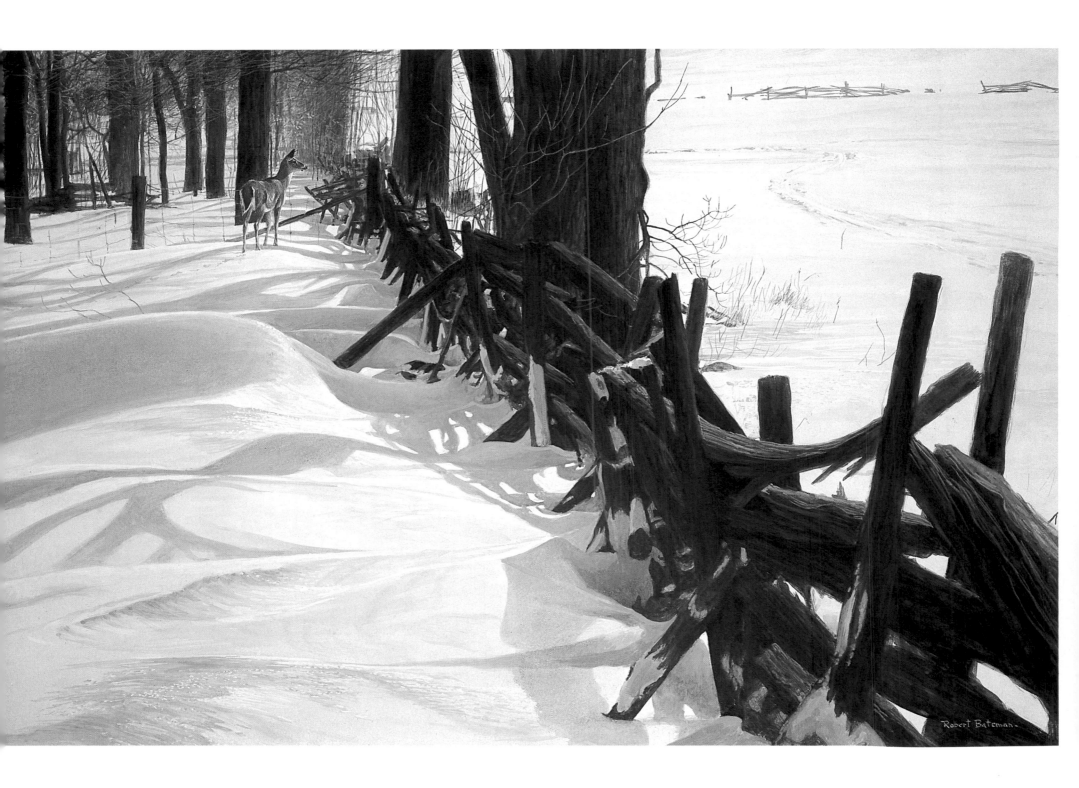
Robert Bateman

Downy Woodpecker

Huddled in the blowing snow, a male downy woodpecker has found a morsel of food in a goldenrod gall. These galls are formed by the plant as a protective coating around a small parasitic fly which lays its egg in the stem. Sometimes the fly larva is parasitized by a certain species of tiny wasp which lays its egg on top of it. The fly larva provides nourishment for the developing baby wasp. There are also other wasps which parasitize the wasp larva, which is feeding on the fly larva feeding on the goldenrod. Finally, in the winter, the downy woodpecker makes a hole in the pulpy gall and devours the pupa of the winner.

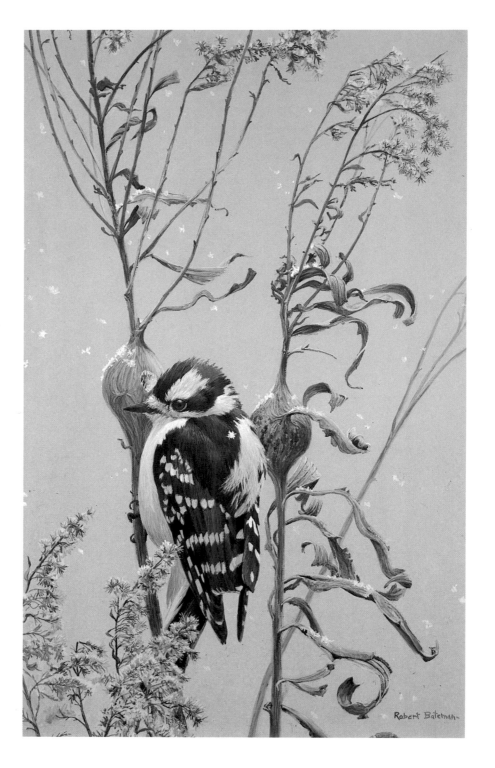

▲ Downy Woodpecker; acrylic, 13½ × 21¼″, 1974
▶ Winter Cardinal; acrylic, 15¾ × 10″, 1978

Cardinal

Cardinals have been moving north in recent years, and have now become familiar winter birds. They have no migrating instincts, and have learned to survive successfully, finding seeds and berries in thickets and hedgerows and gardens and also on bird feeders, where they are usually especially welcomed. In the spring they are boisterous and whistling, but in the winter they are quieter and more reclusive, usually feeding at dusk. Here, a male shelters among the rootlets and grasses of a road bank, fluffing his plumage for warmth in the weak winter sun.

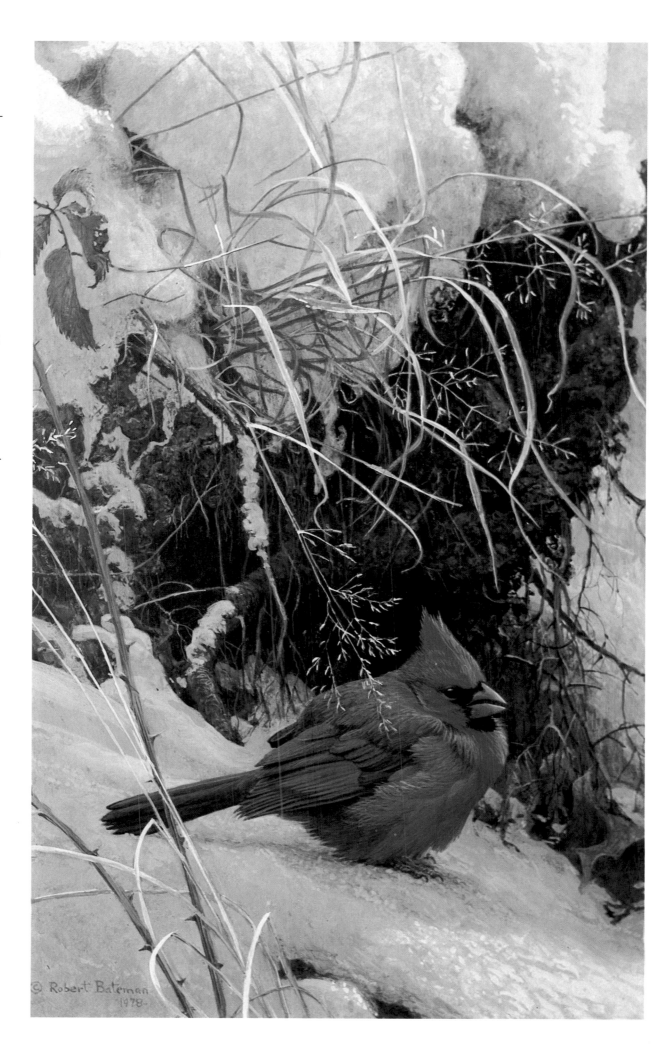

Wolf Pack in Moonlight

Wolves are powerful, handsome animals, and in a pack they can easily kill something as large as a moose. They travel swiftly and silently, roaming the river valleys looking for prey. I wanted the composition of this picture to have a strong, unstoppable, driving force, but I also wanted to give a feeling of ghostly transparency and a sense of the wolves appearing everywhere. I used a lot of colour in the wolf's fur and the same colour in the snow behind to make him more transparent, and to make him more ghostly I gave him virtually no shadow.

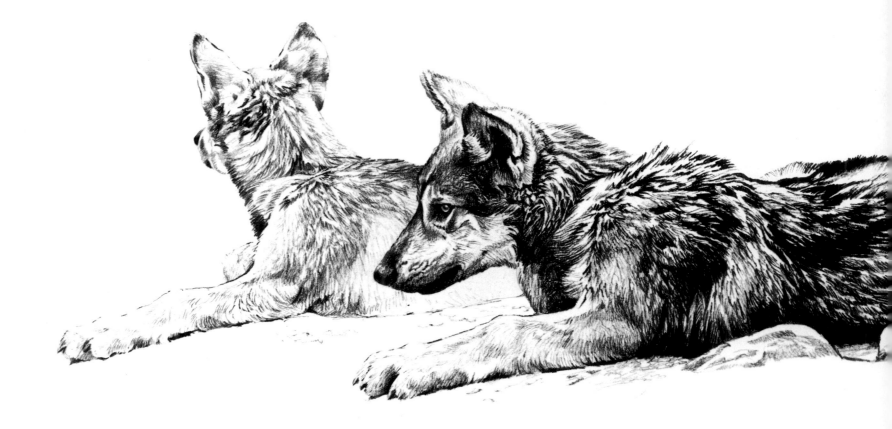

▲ Wolf Pups; pen drawing, 1980
► Wolf Pack in Moonlight; acrylic, 24 × 36″, 1977

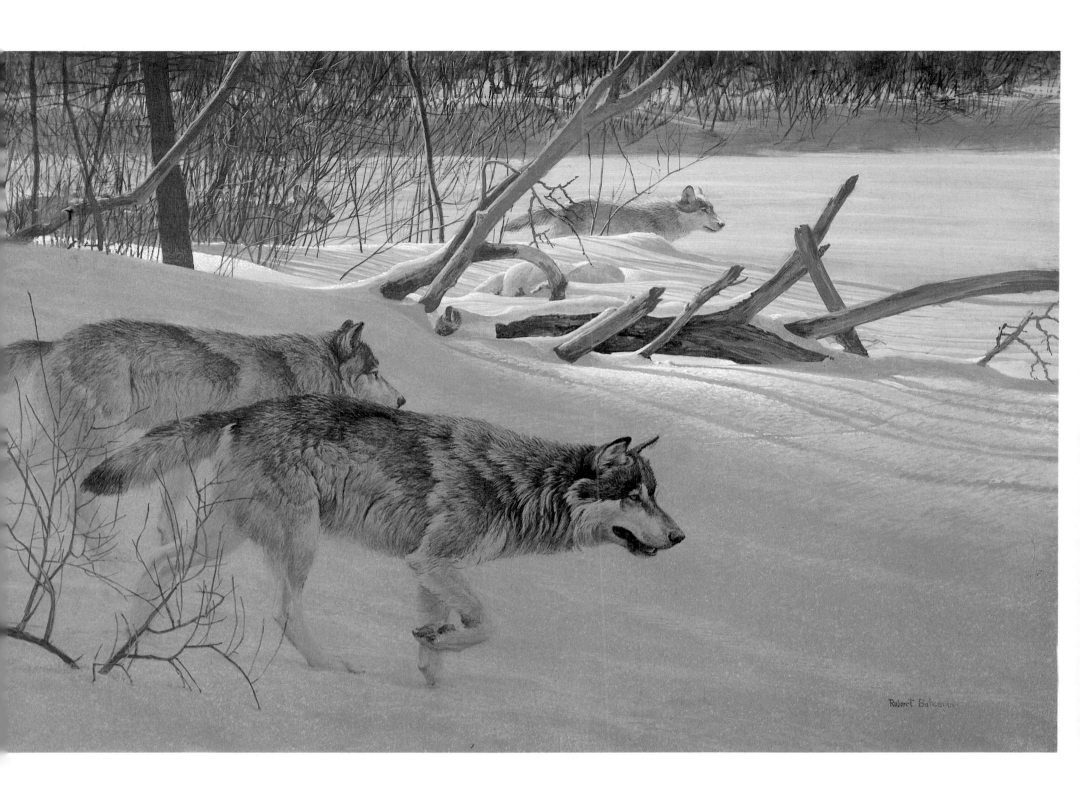

Robert Bateman

Evening Snowfall — American Elk

A big bull elk, surrounded by his harem, is bedding down for the night. The elk is like a monument slowly being covered by snow; his face is quite emotionless and his eyes are almost glazed over. The aspens in the fading light present almost church-like shapes and serenity.

The idea for this picture originated with a handsome bull elk I had seen in just this position on a winter day, with the snow outlining the pattern and fracturing of the fur. I spent a long time thinking up the right setting and composition for him and gradually pulled together in my imagination the landscape and point of view and then introduced the additional members of the herd.

I also tried to convey a feeling of air and space through the trees behind the elk by making the left side of the picture dark and moving across to a light, airy feeling on the right side, almost as if the woods were opening up towards a clearing.

Then I was concerned about the snow which takes up almost half the picture. At first I assumed that the top surface would be lighter and the sides of the tracks darker, but I found that looked artificial. So late one snowy afternoon I went out into the snow and made an elk-like track. To my astonishment, the interiors of the tracks were lighter than the tops — it seemed as though light was emanating from inside the snow.

▶Evening Snowfall — American Elk; acrylic, 28 × 48″, 1979

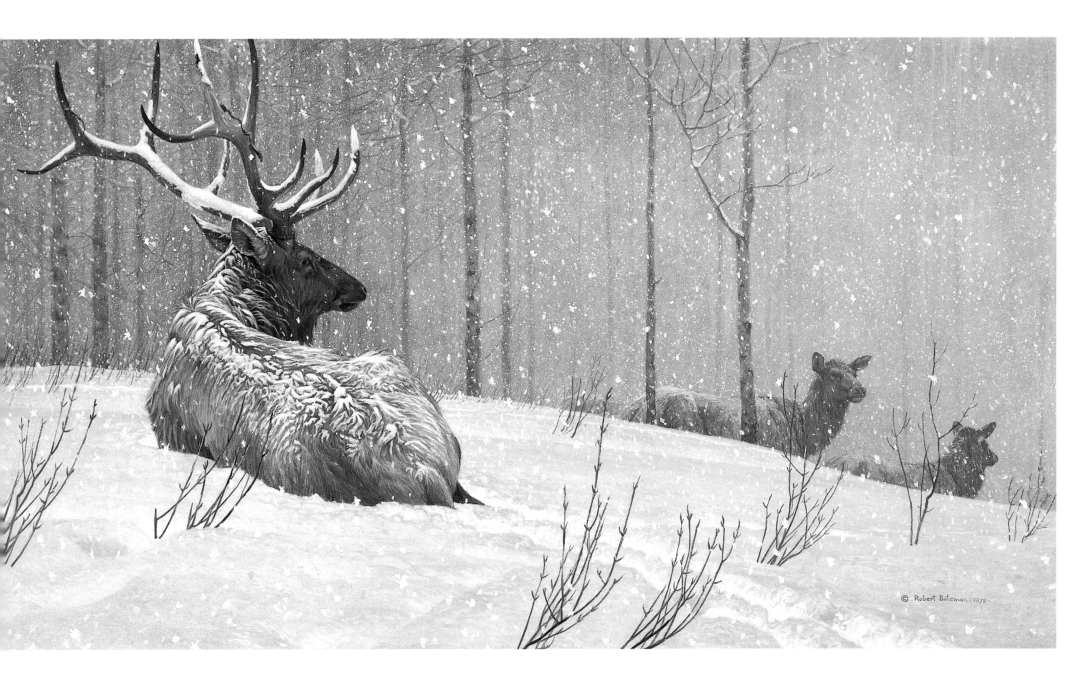

In the Mountains

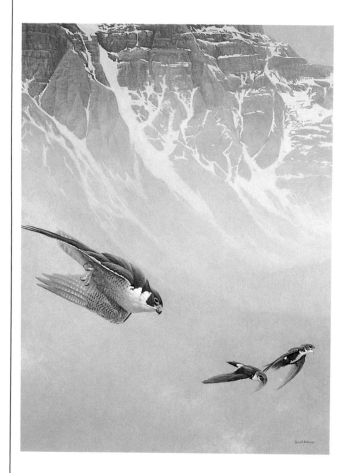

The air is the eagle's domain, and in *Majesty on the Wing* I wanted to capture the presence of the atmosphere. The wings seem to seize volumes of air. I have orchestrated the shapes of the snow patches to echo the strokes of the wing feathers and to emphasize the thrust of the bird through the air. I have usually observed bald eagles in a landscape of sombre power and that is the mood I sought to portray.

Snow can be used in paintings to reveal shape and structure, whether on the back of an elk or in the declivities and clearings of a mountainside. In *Peregrine Falcon and White-throated Swifts* the picture is structured to have thrust and force and motion and again the snowfields are created to add to that thrust.

▲ Peregrine Falcon and White-throated Swifts; acrylic, 30 × 40″, 1976
▶ Majesty on the Wing; acrylic, 36 × 60″, 1978

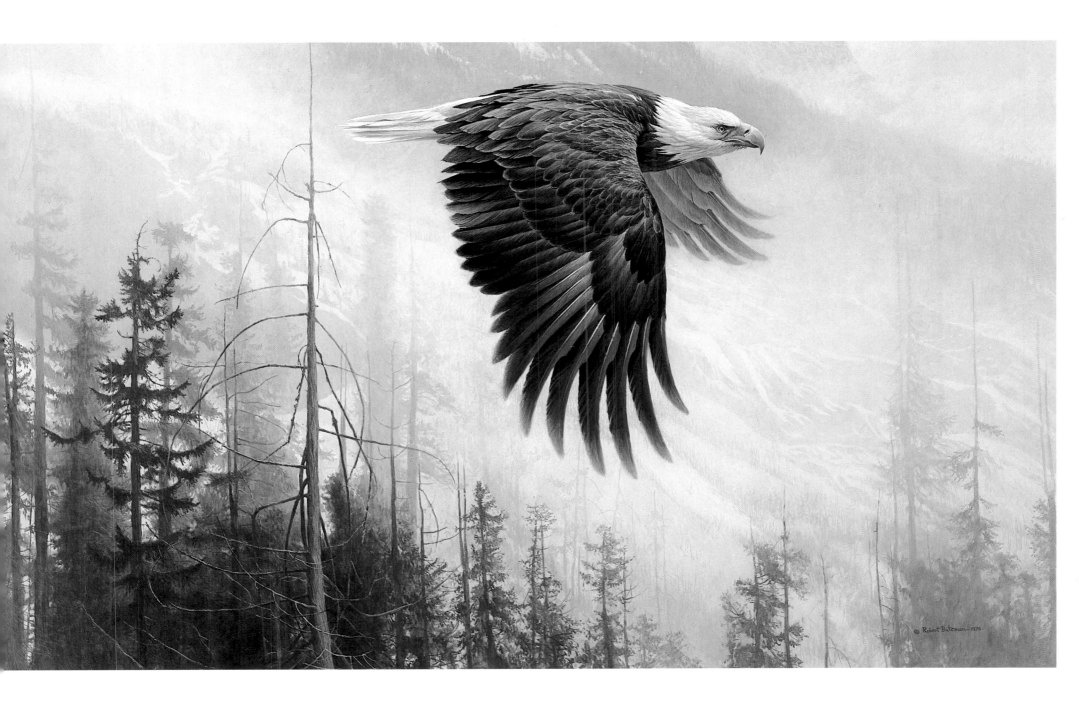

Mountain Goats

The inspiration for this picture came from two quite different sources. In the spring of 1980 I saw a very powerful show of Clyfford Still's work in New York. Walking through his huge abstract canvases — big, organic shapes with slashes cutting across them — was a bit like walking through the Grand Canyon. Later that summer my family and I took a packhorse trip in the West, among great rock faces and plunging waterfalls. These two sources of impressions worked together strongly on my imagination.

The original composition of the picture was an abstract form with a slash and two white blobs. It could have been horizontal or vertical, but by making it vertical it became a natural home for mountain goats, with the slash becoming a mountain torrent. The rock forms were created with abstract strokes that fitted the precipitous feeling and reflected their crystalline quality.

When the goats were first established in the picture there appeared to be no way for them to move on, which made some people nervous. So I introduced an escape route for them, although they are such amazingly surefooted animals that they wouldn't really need any help from me.

▶ Sheer Drop — Mountain Goats; oil, 48 × 36″, 1980

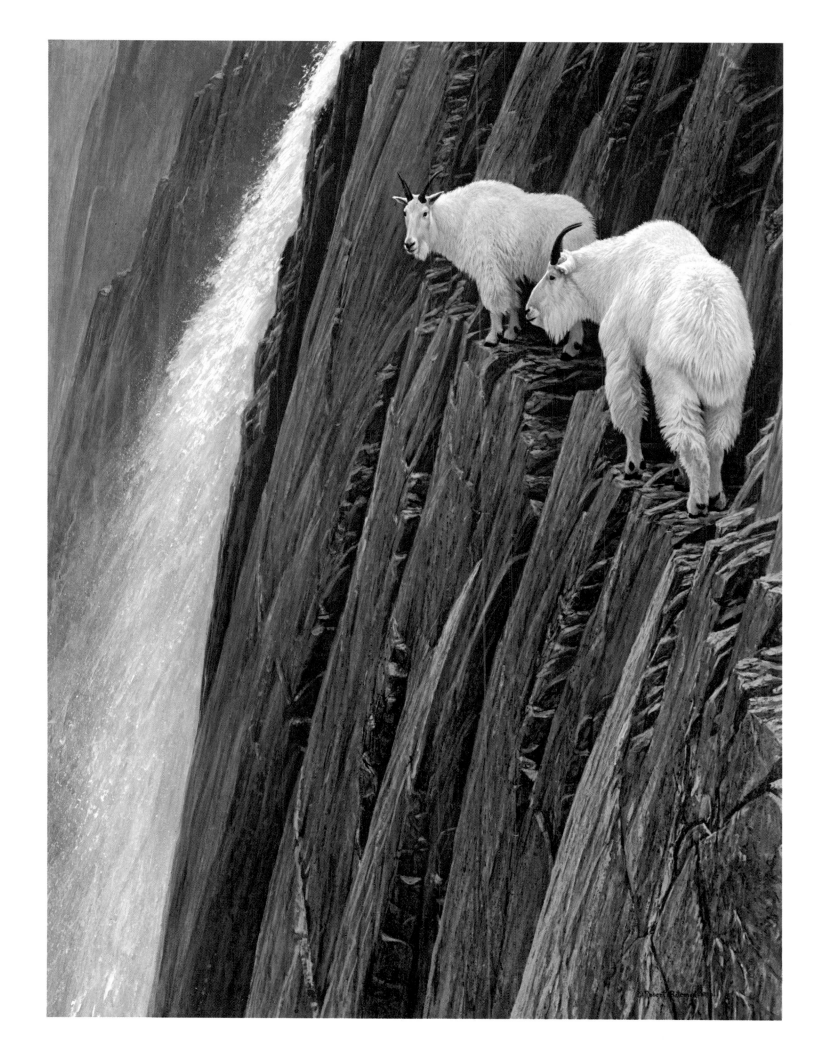

Coyote in Winter Sage

I don't often paint pictures with messages, but when I came to paint this coyote for the Cowboy Hall of Fame, in Tulsa, Oklahoma, I decided to show a really magnificent male I had once seen, and to put him in a noble stance. Coyotes are thought of as slinking, skulking animals, and are often reviled as vermin, particularly in the West, but they are a successful, resourceful species, and should not be discriminated against.

Coyotes live in semi-wilderness areas near towns and villages — the sort of areas that get littered with beer cans and other garbage by snowmobilers and casual hunters. The beer can in the picture may bother a few people enough to remind them to take their beer cans home with them. Curiously, I was told that the only people who had actually objected to the beer can were a couple of "typical wilderness litterers."

► Coyote in Winter Sage; acrylic, 48 × 72″, 1979

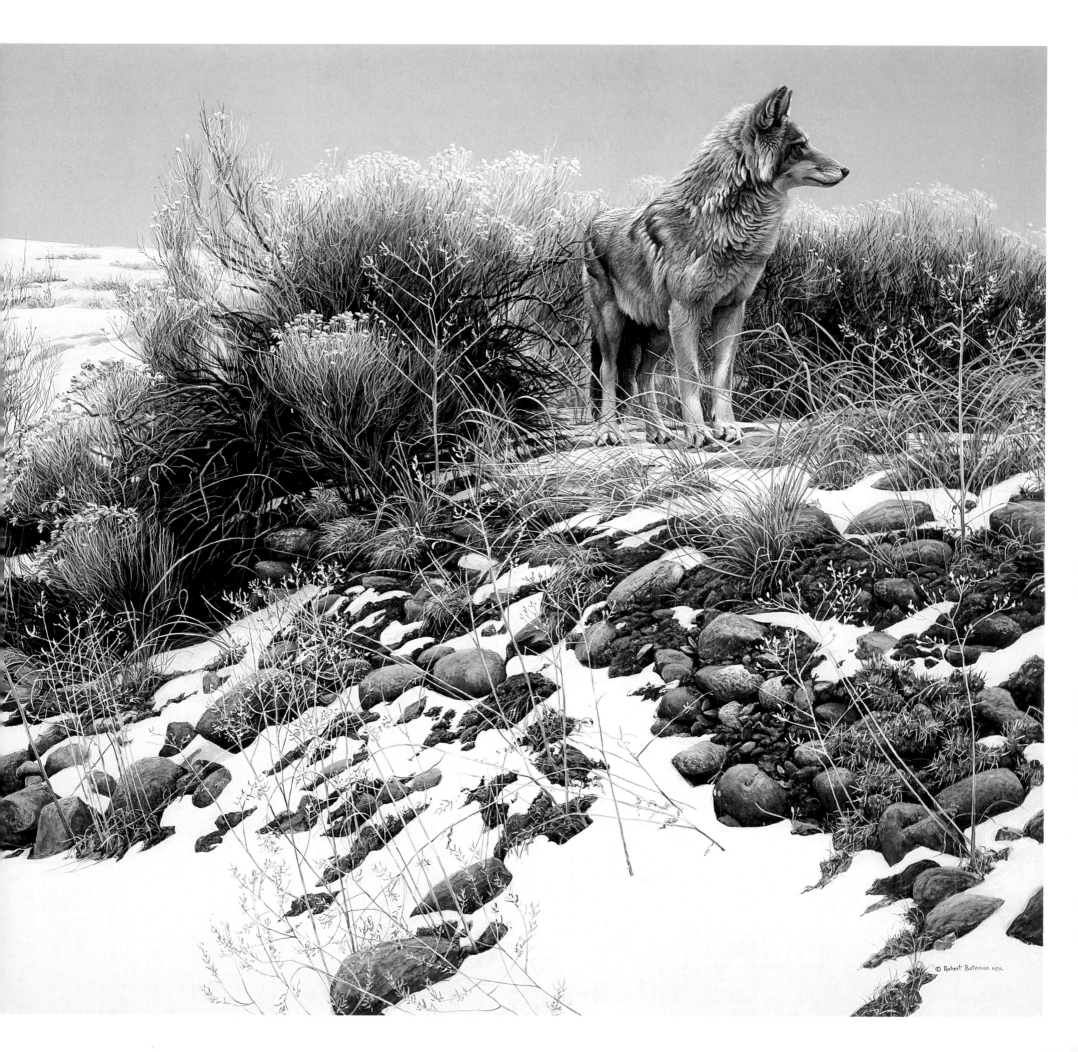

© Robert Bateman 1979.

Polar Bears

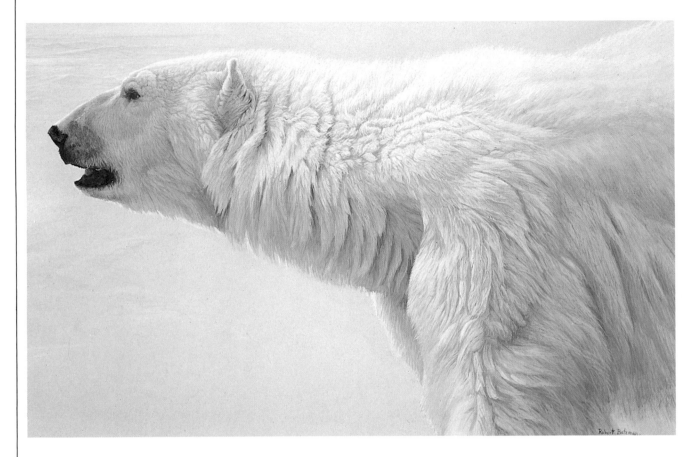

The physics of fur — the way it breaks, the richness of its texture, the effect of space between the individual hairs is fascinating, and every square inch is full of interest. In *Polar Bear Profile* I have treated the fur as landscape. In *Arctic Family* I again became fascinated with the fur, but here allowed a landscape in the background to echo the shapes of the bears. The cubs gave me great difficulty. Once again there was the challenge of avoiding the cuteness of young animals, and I made many models of their heads to find the right position and expression.

▲ Polar Bear Profile; acrylic, 24 × 36″, 1976
▶ Arctic Family; acrylic, 20 × 30″, 1978

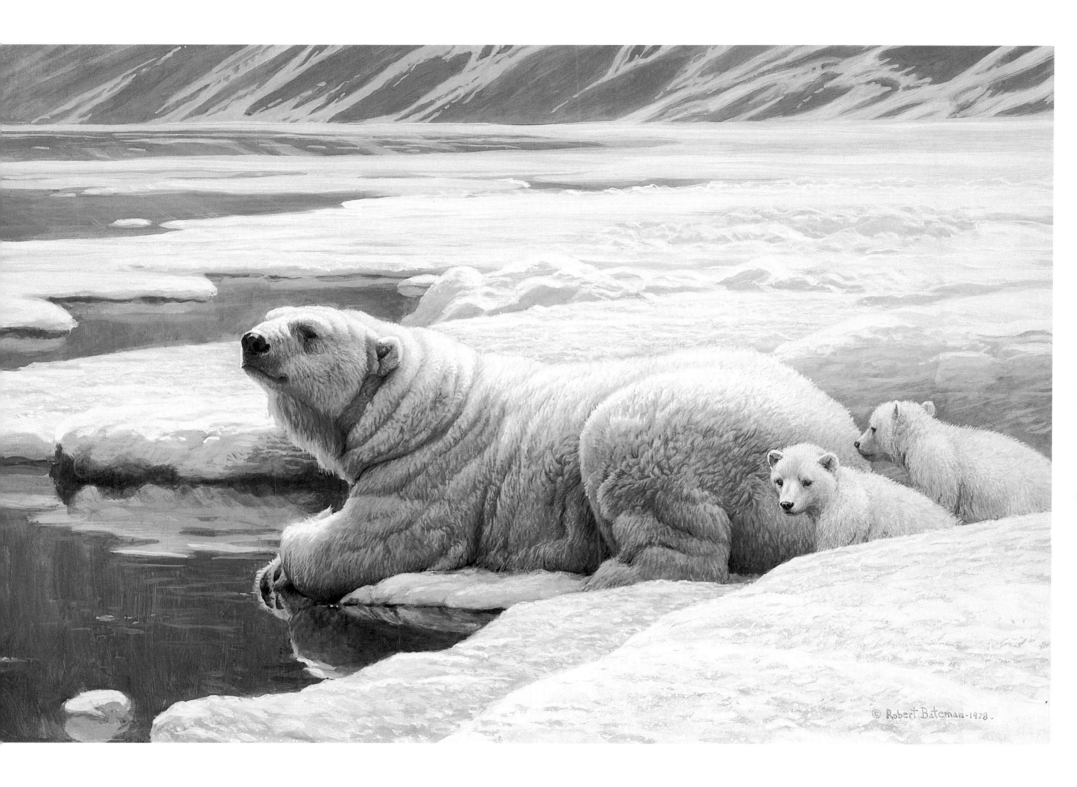
© Robert Bateman 1978

Gentoo Penguins and Whalebones

I originally sketched this scene sitting on a toilet-shaped whalebone at the old whaling station of Port Lockroy in the Antarctic. I loved drawing the huge whitened whalebones; they are a wonderful exercise in form, with every variety of depth and shadow, and are very reminiscent of the sculptures of Henry Moore. These bones have a poignant quality as well, for they seem like a monument to the tragic, wasteful slaughter of the great whaling era.

The Gentoo penguins, which have adopted the whalebones as their shelter, are huddled in the lower quarter of the picture. They are moulting and miserable, quite unlike the usual notion of them as natty little creatures.

▲ Penguins and Whalebones; sketch
▶ Gentoo Penguins and Whalebones; acrylic, 30 × 48″, 1979

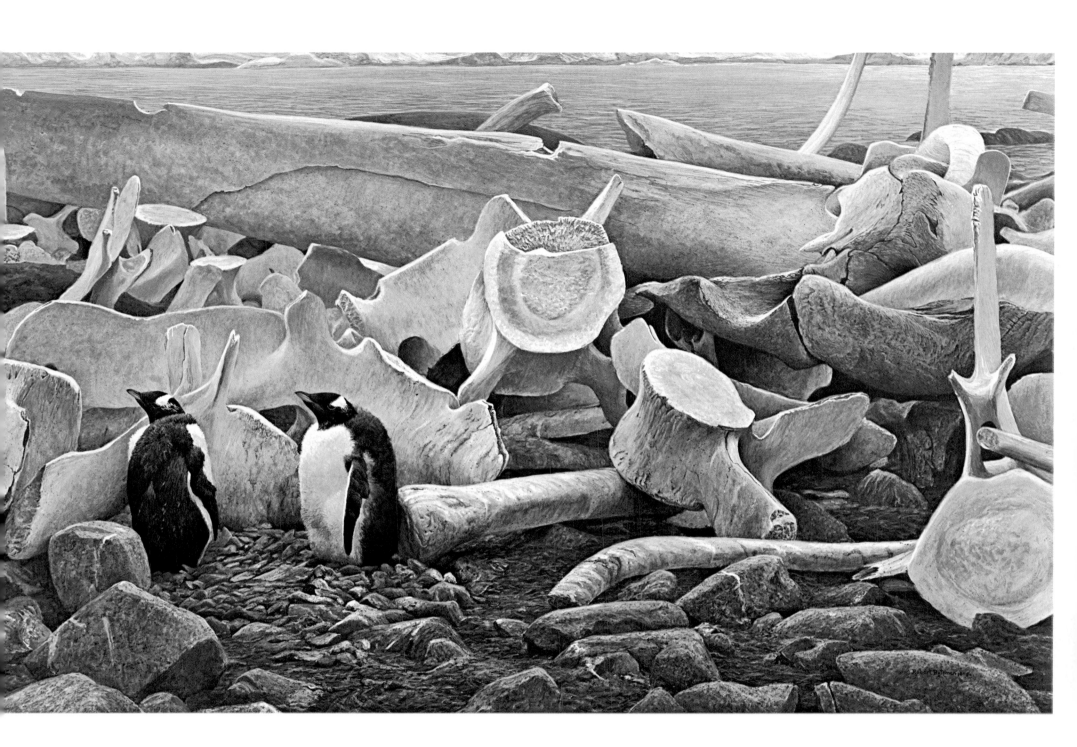

Misty Coast

The edges of contrasting environments always seem to have an exceptional variety and richness of natural life, whether it is the overlapping edges of two ocean currents, a forest meeting cleared land, or a coastline. My favourite coastline is the low rocky shore, where the solid outcrops of rock give a firm foothold for a whole range of marine vegetation and animals. Here, in *Misty Coast,* there are bladderwrack seaweed, the typical kelp of the Pacific coast, barnacles, limpets, and other molluscs. They get plenty of light and oxygen and are alternately covered and exposed by the changing tides. With the tides come the fish, crabs and shrimp. When the tide goes out, some of the fish and crabs are stranded and they become part of the diet of the waiting gulls.

▶ Misty Coast; acrylic, 41 × 54″, 1974

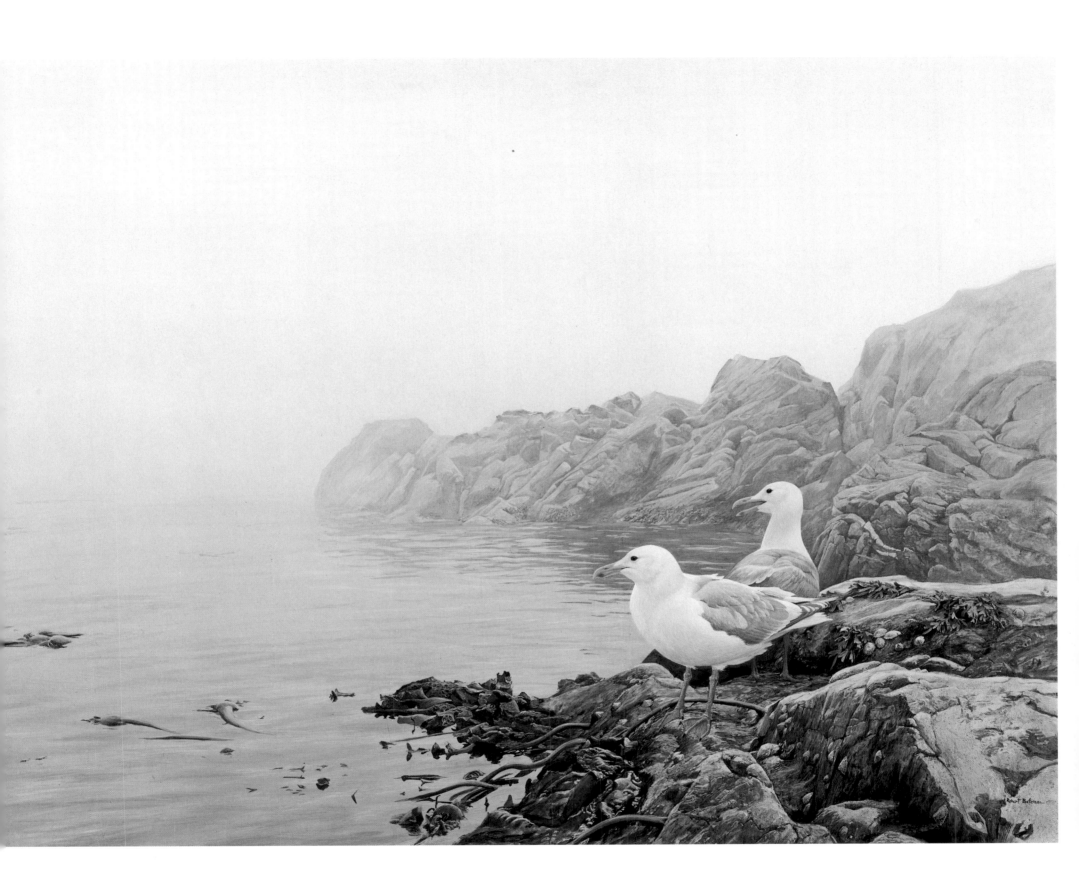

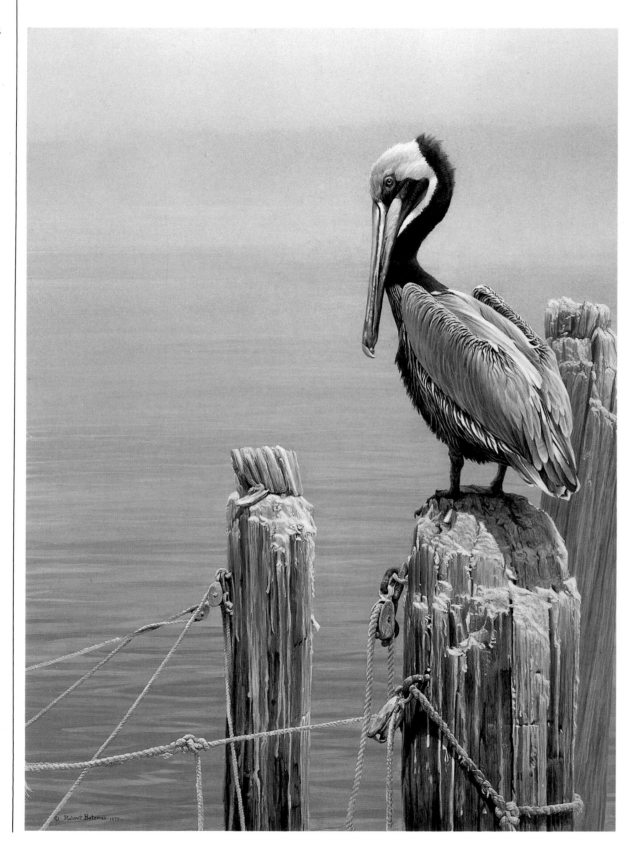

Brown Pelicans inhabit the southern coastal regions of North America extending to South America, and are enough at ease with humans that they sometimes become semi-tame. Elegant yet awkward, they are superbly adapted for catching the slow coarse fish that venture near the surface of the ocean, either while swimming or when diving from the sky.

The pelican's face, with its bare skin, beady eyes, and its bill with all those different plates and sections, is more like a piece of apparatus than a face. I have echoed the shape of the head in the tackle and pulleys and ropes. In the same way, the droppings that run down the pilings echo the light finger-like feathers on the pelican's back.

If I include man-made things in my paintings I usually choose subjects that nature has already taken a bite out of. A new, freshly-painted, steel-hulled oil carrier doesn't have too much appeal for me, but a well-worn wooden fishing boat like this one on the New Jersey coast, with peeling paint and a patina from age and weathering, has become part of the natural world.

◀ Brown Pelican and Pilings; acrylic, 40 × 30″, 1979
▶ The Sarah E. and Gulls; acrylic, 30 × 24″, 1980

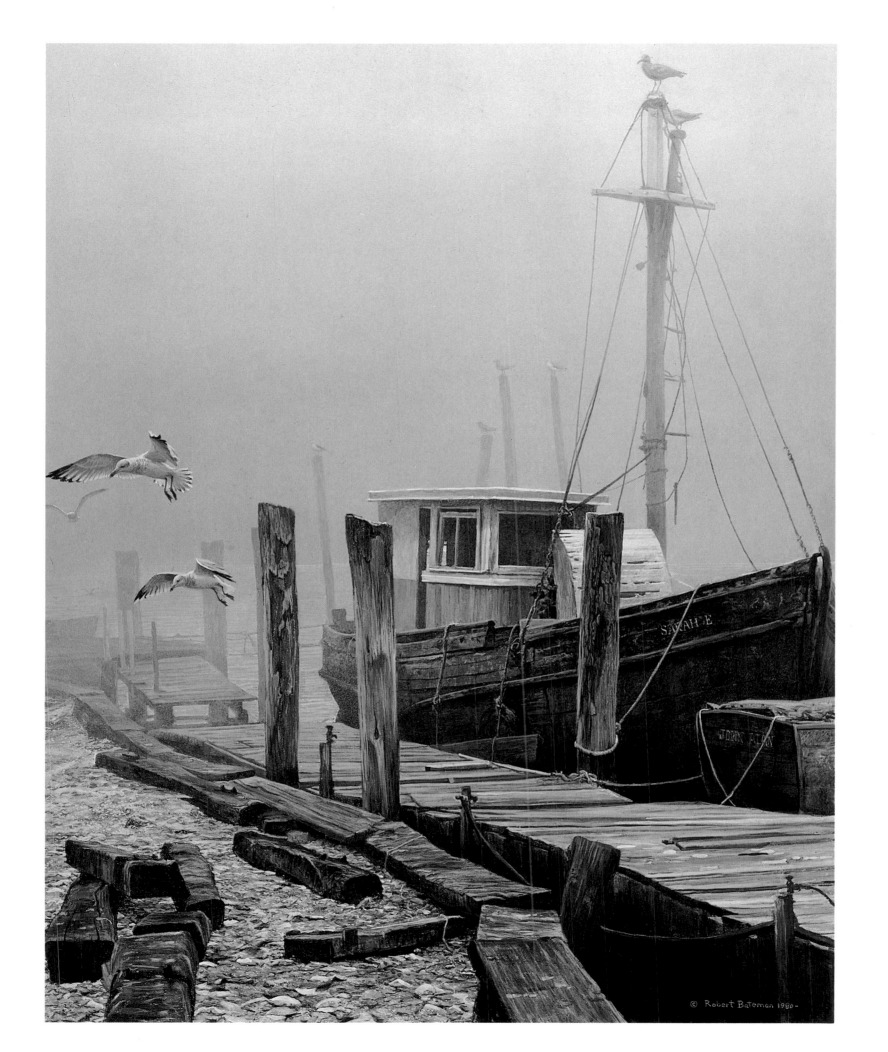

© Robert Bateman 1980·

Kittiwakes

Kittiwakes are among the smaller members of the gull family. They usually nest on the precipitous cliffs of offshore islands and rarely go to the mainland. The background of this painting has the aura of these dark, heavy cliffs. Whenever I have been in a kittiwake colony it has seemed a chaotic, shrieking, smelly, sociable place, busy with arrivals and departures. Whenever some of the kittiwakes return to the colony from their excursions out to sea, there are a few moments of ritual bowing and crying, like a group of old friends at a reunion.

► Kittiwake Greeting; oil, 12 × 16", 1979

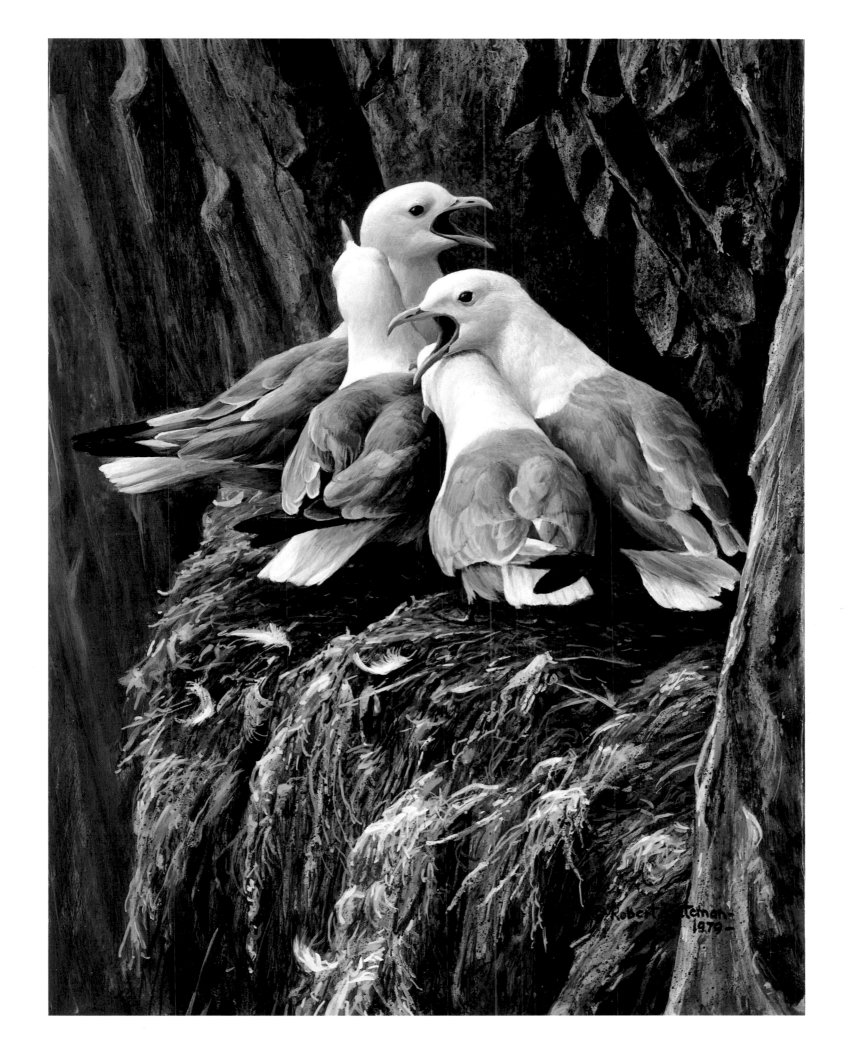

Bald Eagle; Osprey

I n *Vantage Point,* the eagle is sitting on the stump of one of those huge cedars of the northwest coast. In the shelter of the stump a kind of bonsai garden is developing, with all kinds of mosses and grasses and a whole hemlock tree. The miniature bonsai effect is extended by the quality of the pebble beach. The composition of the picture is a series of thrusts in the same direction, with the eagle's wings, its head and neck, the stump and the branch coming out of it and the whole sweep of the beach, all pointing out to the flat gray horizon of the Pacific.

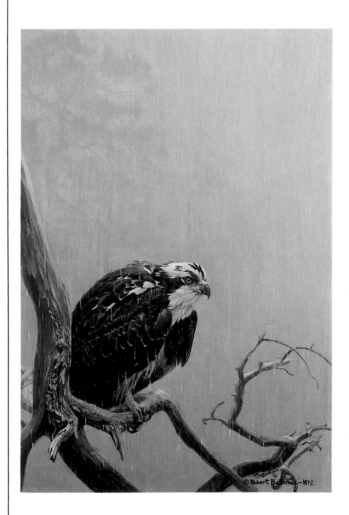

▲ Osprey in the Rain; oil, 12 × 18″, 1979
▶ Vantage Point; acrylic, 36 × 60″, 1980

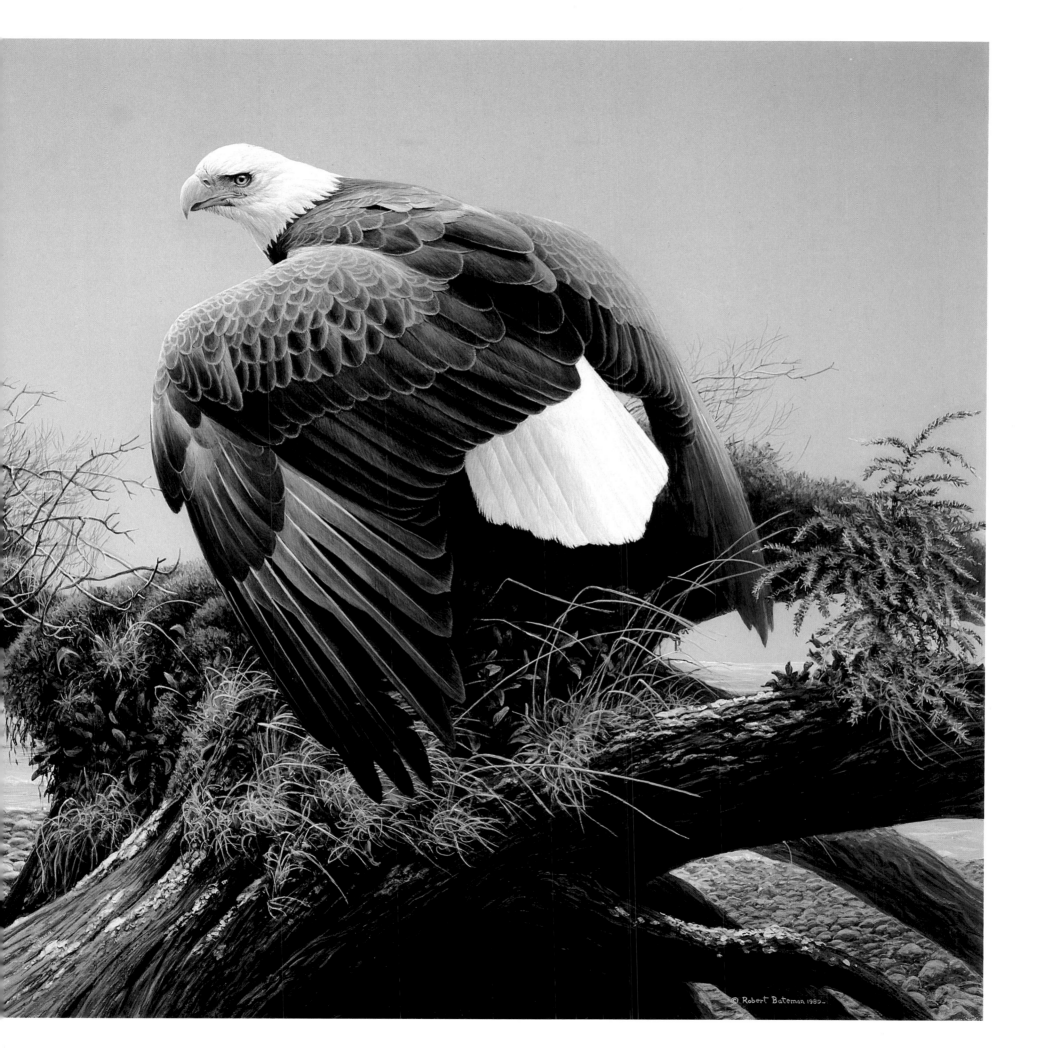

© Robert Bateman 1982

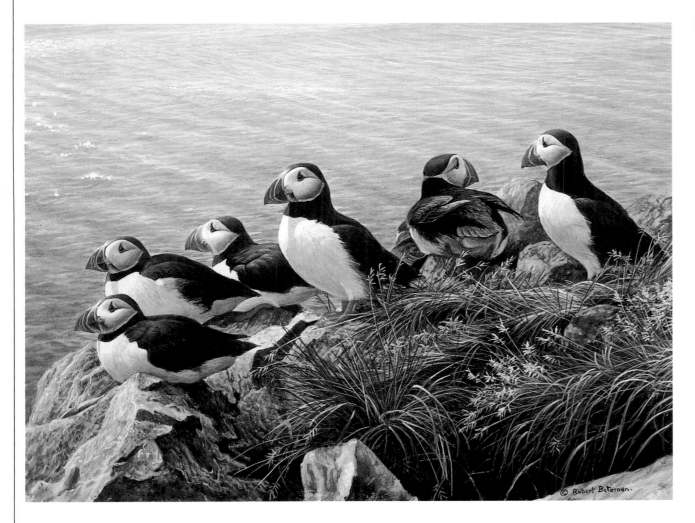

These two species of sea birds have evolved in a rather extreme and specialized way. Puffins are laborious fliers — they have to beat their little wings like anything to keep going, and their big beaks, in which they can store the fish they catch on their long-range fishing expeditions, give them a comical quality. I am a Gilbert and Sullivan fan, and this picture has for me a spanking bright, nautical quality, with the puffins like the chorus in *H.M.S. Pinafore*.

Skimmers, in contrast, have long slim wings and fly beautifully, skimming over the waves with their long lower mandibles a quarter of an inch under the water picking up shrimps and minnows. They are strong looking birds, and here I wanted an intense, rich picture with just the birds and a bit of white sand and green grass.

▲ Atlantic Puffins; acrylic, 18 × 24″, 1977
▶ Pair of Skimmers; oil, 11 × 24″, 1980

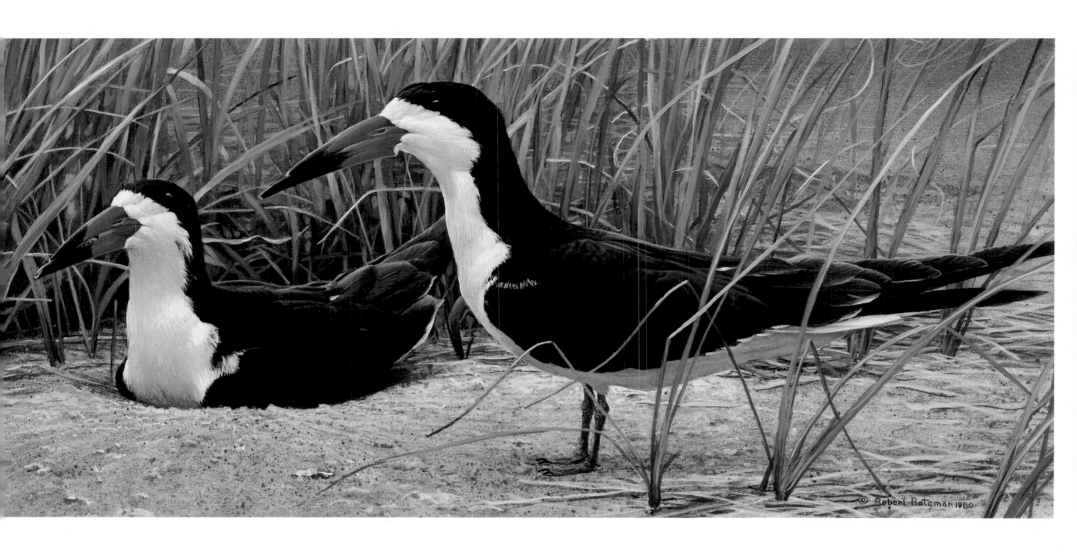

Master of the Herd

The African buffalo is massive, wild and aggressive, with highly developed sight, hearing and smell. The bull buffalo is considered by most expert hunters to be the most dangerous game in Africa, for when wounded it will frequently circle back and wait in ambush for the hunter. Here the herd has been disturbed and has churned up dust, the egrets are flying away, and the bull has turned toward the intruder.

The basic concept for this painting is a big letter T, and which I want to hit you like a Mack Truck. To give a little lyric twist, I echoed the form of the bull's horns in the two egrets that are slipping off to one side. I sketched them in quickly and intuitively at first, and then went through the long rigmarole of sculpting the birds and drawing them from the sculptures.

▶ Master of the Herd; acrylic, 30 × 48", 1979

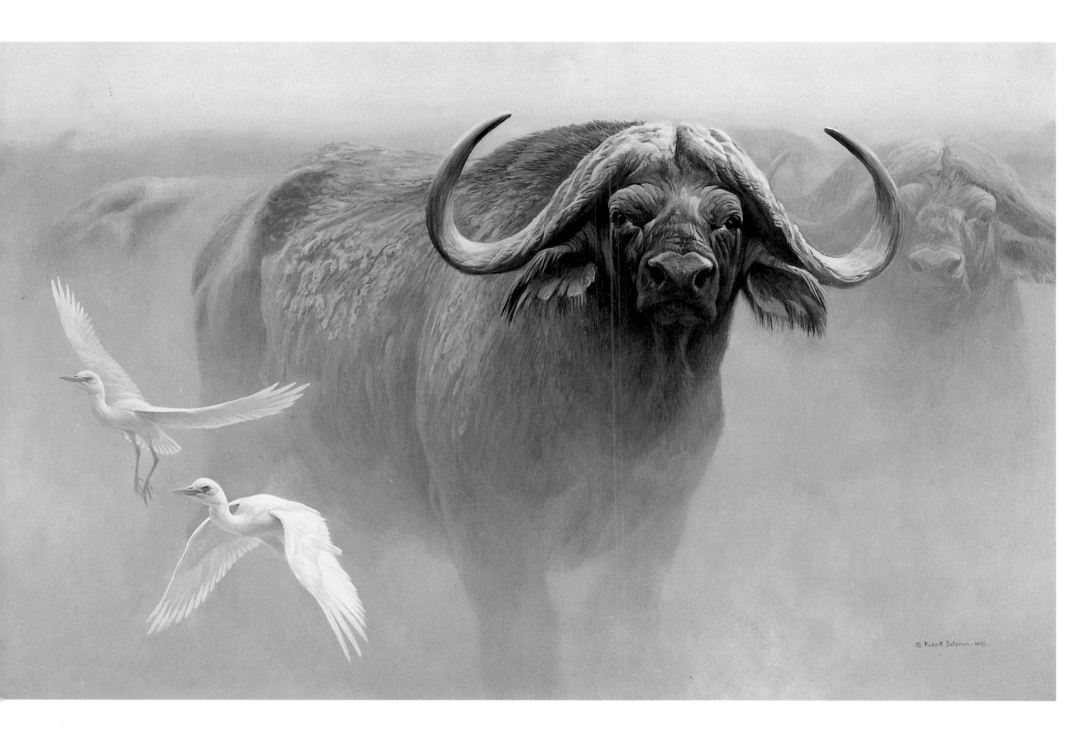

© Robert Bateman 1979

Sparring Elephants

The elephants represent a sort of mountain or landmass, the wrinkles and hollows of the skin resembling hills and valleys. Every square inch of an elephant is a different texture, a different type of wrinkle or a different quality of surface, and I studied the skin with the care of a mountain climber examining a challenging peak.

The egrets spraying out and away from the disturbance caused by the elephants needed to have random positions in the picture as they would in nature. To reflect this, I played a kind of blind–man's–buff, sticking paper models of the birds on the picture with my eyes closed, and then, once the positions were established, painting them in fully.

▲ Elephant Eating Thornbush; pen drawing
▶ Sparring Elephants; acrylic, 48 × 60″, 1975

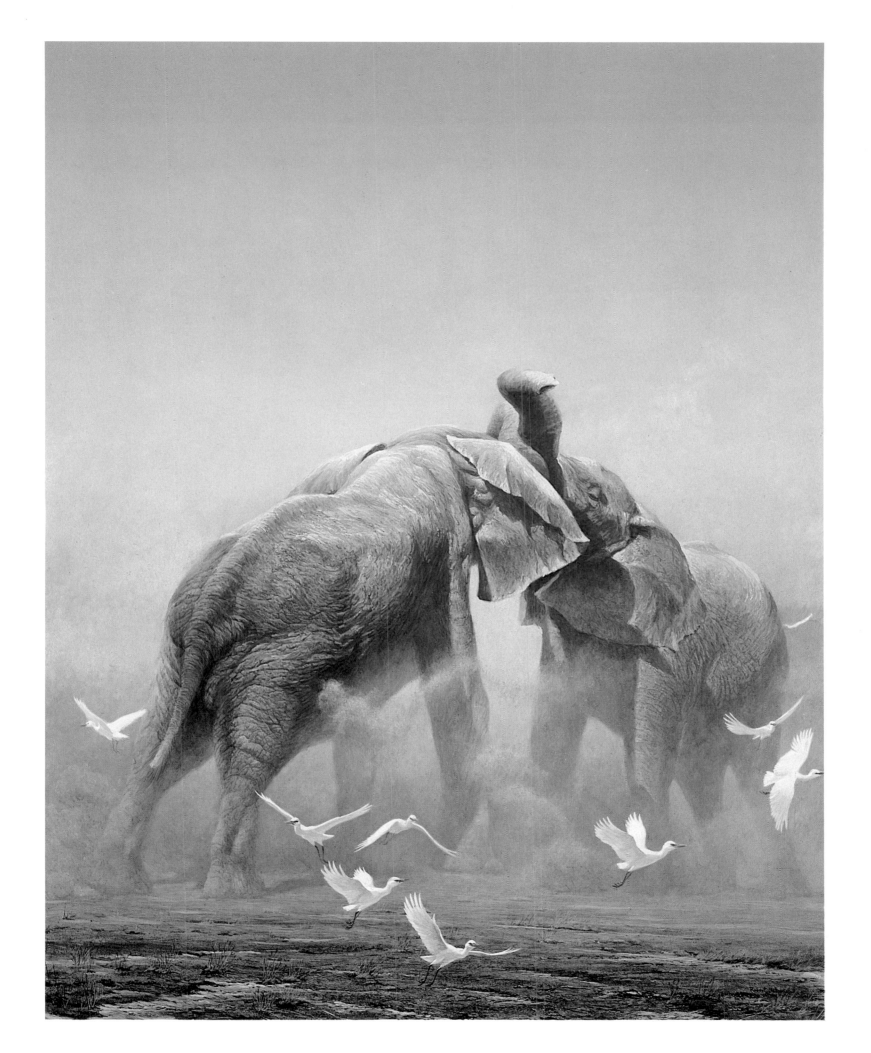

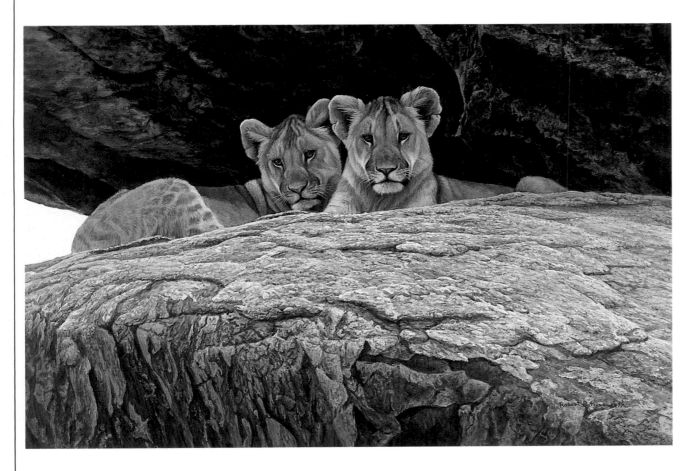

African lions are often lazy and nonchalant and blend in well with the scenery, and, as a result, you sometimes get closer to them than you intend. Driving across the plains you may spot one standing up on a rock and drive over to have a look at it. Then, when you've taken photographs of it and made a few sketches, you start the car engine and suddenly lion heads pop up all around you. In *Pride of Lions*, one lioness is having a look around while three others are still snoozing in the late afternoon sun before setting out on the hunt.

These two lion cubs were part of a pride of twenty-four lions whose favourite haunt was a *kopje* — a granite outcrop rising out of a sea of grass. From it the lions could get a convenient view of the Serengeti Plain and move comfortably in and out of the shade. The two yearlings had found their way around the cliff to this secluded crevice, where they could avoid the fuss of mothers and younger cubs, and survey the world of the Serengeti far below them.

▲ Lion Cubs; acrylic, 24 × 36″, 1977
▶ Pride of Lions, Samburu; acrylic, 36 × 48″, 1975

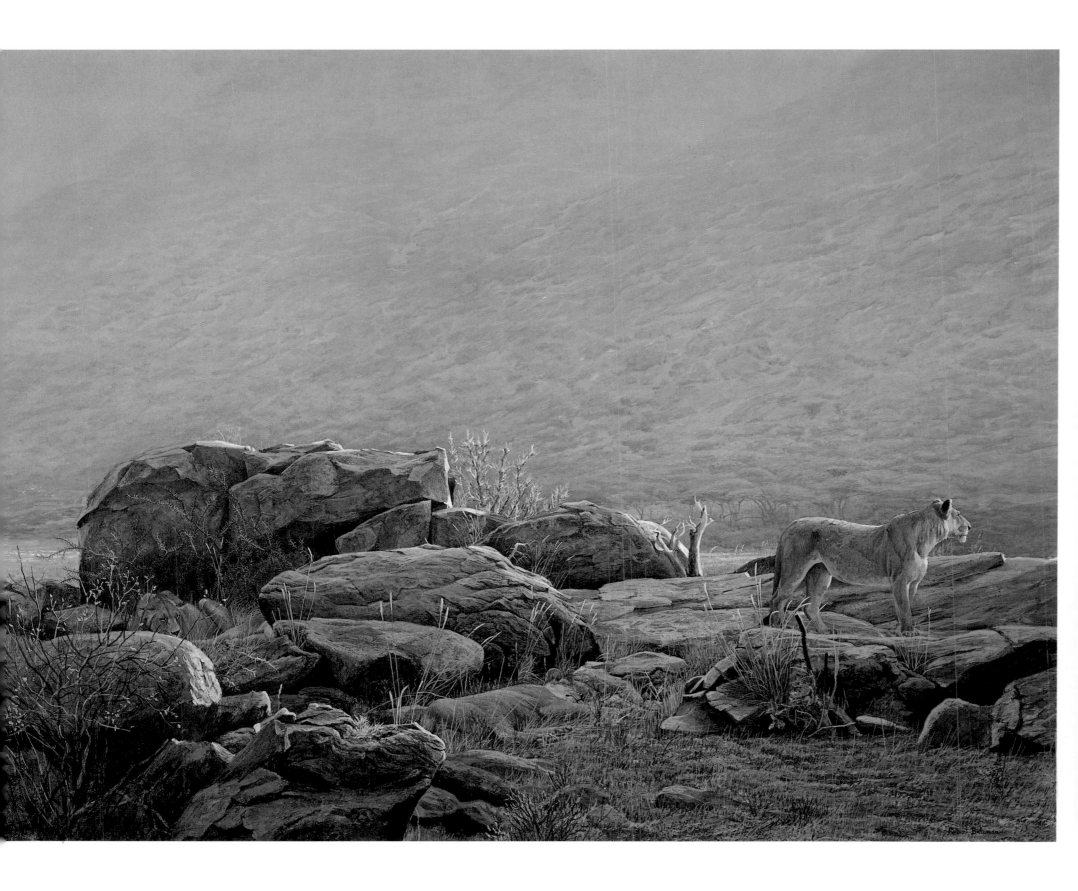

At the Kill

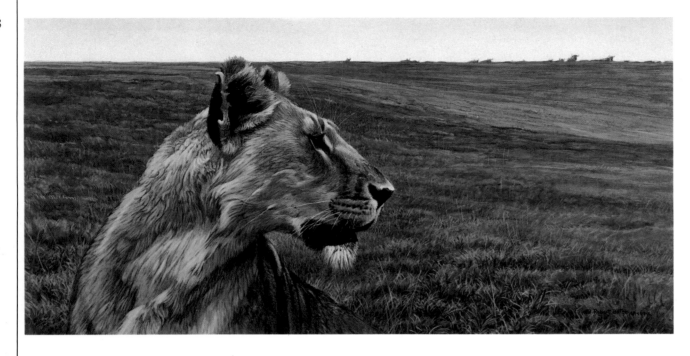

When we came upon this fresh kill, the lions were still resting from the struggle of wrestling down the big wildebeest which probably weighed more than any one of them. After a while they began to feed, and we watched them until dark and then again early the next day as they were finishing up. I liked the way the morning sun struck across the haunches, bringing out the shape of the muscles, and touched the top of the grasses. You can see one foot of the wildebeest that they are still gnawing on while one lioness gives the waiting vultures a resentful glance.

▲ Lioness and Wildebeest; oil, 12 × 24″, 1978
▶ Lions Feeding at Dawn; acrylic, 38 × 51″, 1975

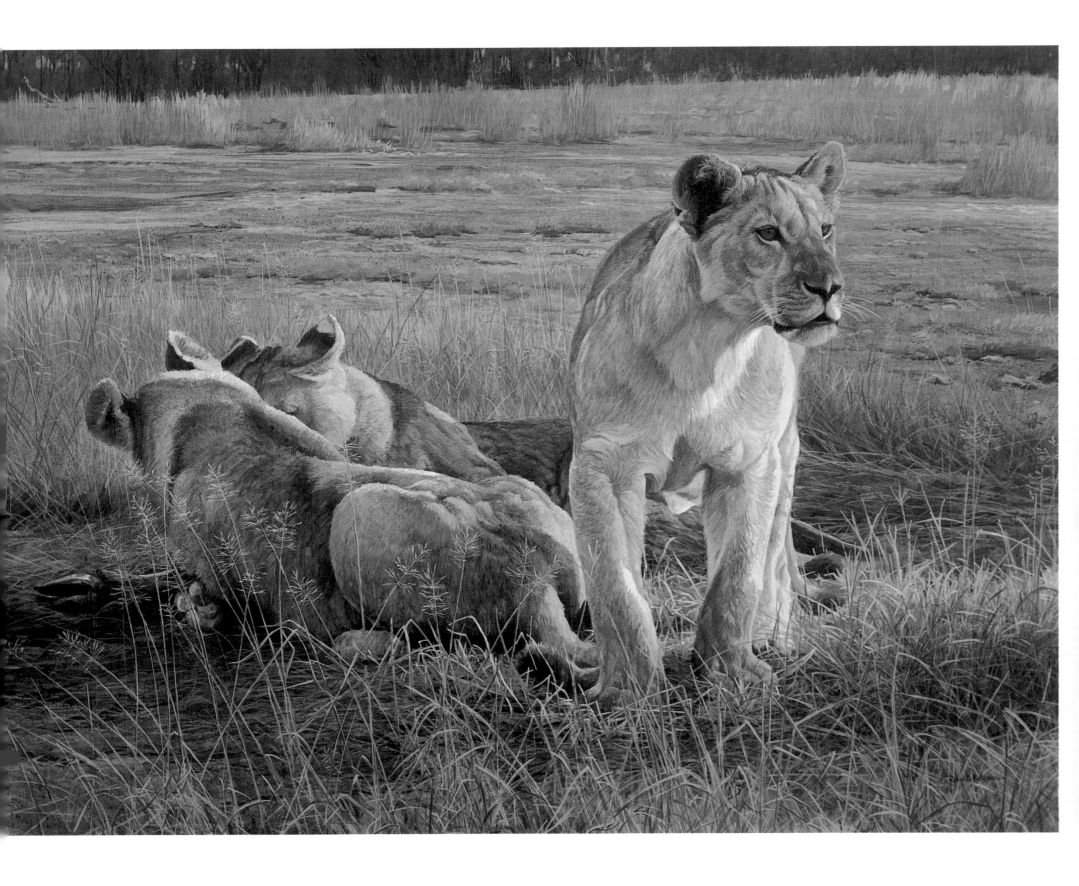

Rhinos

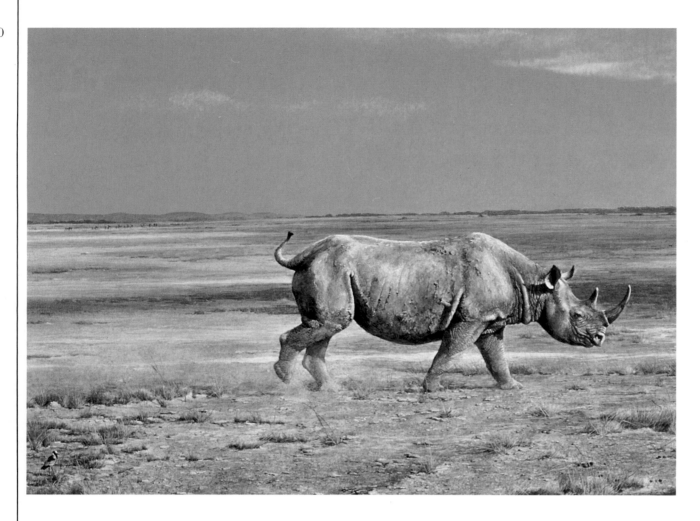

In the same way that I came close in to the heart of an elm tree in *Rough-legged Hawk in Elm* (p. 105), in *Rhinoceros Head* I have filled the picture so completely with the rhino head that much of its distinguishing feature, its horn, is cut off. The resulting white shapes on either side of the horn are important to the structure of the painting. Overall I have treated the rhino and its skin as landscape, and in a way, the bird, a red-billed oxpecker, becomes the wildlife of the picture.

Powdered rhinoceros horn is considered to be an aphrodisiac in the Orient and is tremendously valuable. As a result there is a terrible slaughter of African rhinos by poachers who simply shoot the rhino and chop out the horn with an axe. I was warned that this picture would not sell because there was not enough of the horn in it, but it turned out that art enthusiasts do not put an excessive value on rhino horn for the picture was very popular when it was exhibited.

▲ Rhino at Kilimanjaro; acrylic, 30 × 48″, 1971 (detail)
▶ Rhinoceros Head and Oxpecker; acrylic, 32 × 48″, 1975

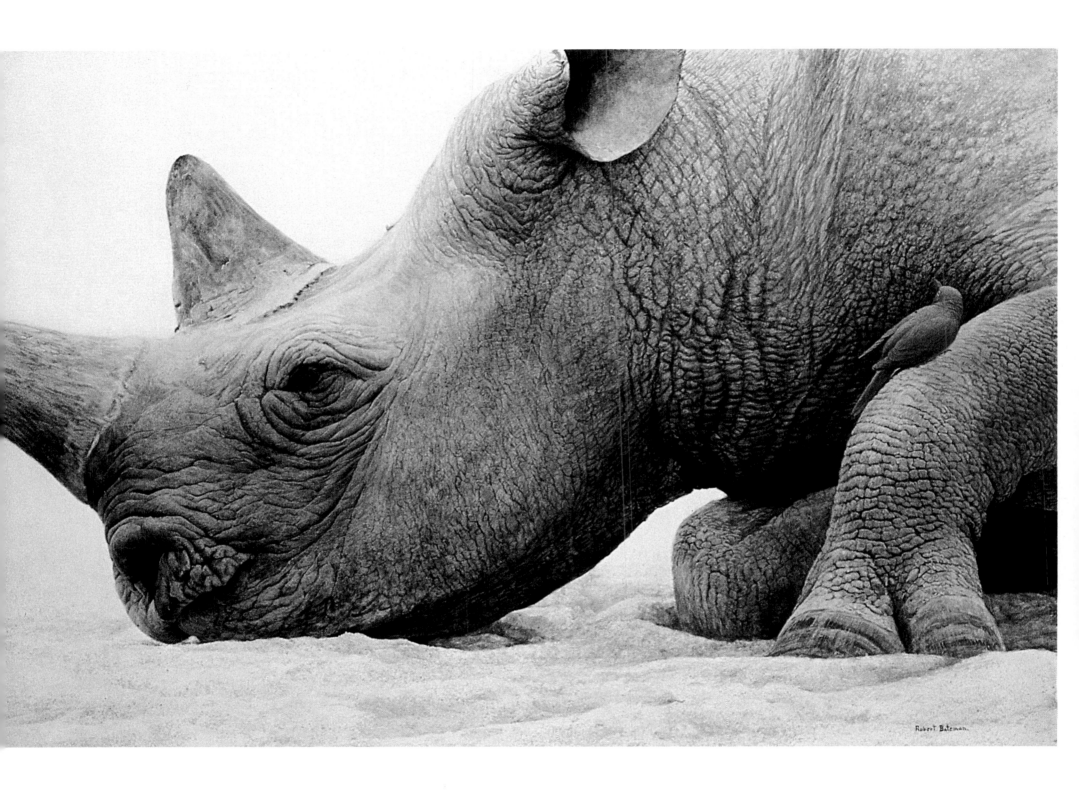

Cheetahs

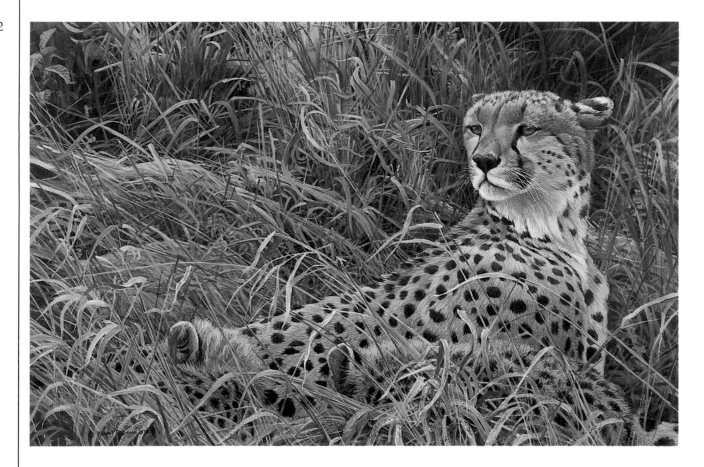

In the big-game country of Africa I am always aware of the huge, overpowering, blue sky, especially at places like the Amboseli plain in southern Kenya, shown here in *Cheetah Siesta*. I wanted to feel the presence of the sky in this picture, but I had to be persuaded by my wife, Birgit, that I could put the horizon as low as it is and still have room for the cheetah and the plain. I also had to resist the temptation to let more tall grasses stretch across the horizon, or to introduce a cruising vulture in the distant sky. By leaving it empty, the sky becomes as strong a force in the picture as the cheetah itself.

Cheetahs are animals of the open plains. They use their excellent eyesight and terrific speed to run down game, such as Grant's gazelles, a few of whose droppings can be seen in the foreground of the painting. However, when they are raising their cubs, cheetahs move into more protected areas where there are thick grasses and bushes. The cubs have darker fur, diffused spots, and long, loose, whitish manes which camouflage them well. Here, in *Cheetah with Cubs*, the two nursing cubs are well concealed, as they are in nature.

▲ Cheetah with Cubs; acrylic, 24 × 36″, 1978
▶ Cheetah Siesta; acrylic, 36 × 48″, 1975

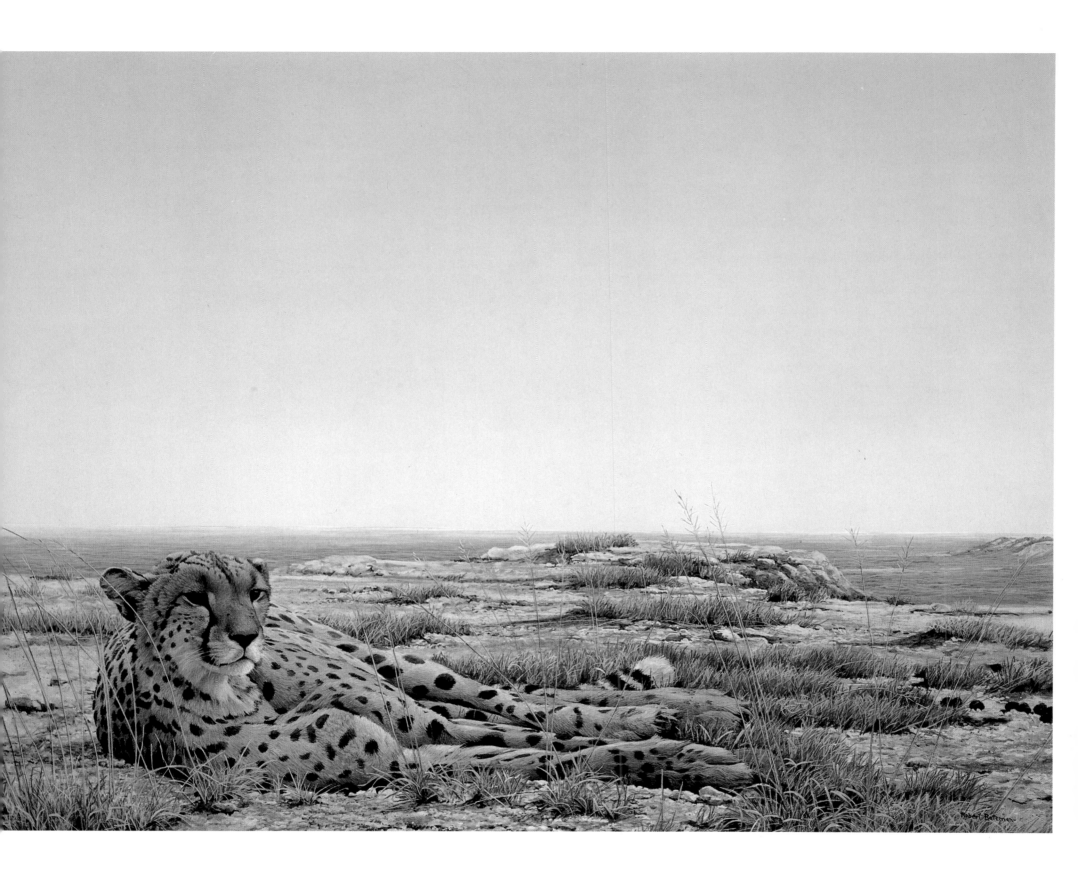

Leopard in a Sausage Tree

One day when we were on a photo-safari in Southern Kenya there was great excitement when someone sighted a leopard that had been chased up a sausage tree by a lioness whose family of cubs was nearby. This was a rare opportunity to see the two biggest African cats together. When I got to the scene I found the leopard posing with dignity among the dangling "sausages" and the lioness sitting on the ground staring about her furiously, thrashing her tail and ready to take on all comers.

After showing a proper lack of concern, the leopard glided through the branches without effort or sound. He instantly blended with the convoluted limbs and mottled colouring of the bark. The coolness of his attitude in his green, airy world reminded me in a strange way of the atmosphere of a tropical café, exotic and relaxed. For some reason *Casablanca,* with Humphrey Bogart, came to mind. The surface atmosphere was cool and comfortable, but there was an undercurrent of menacing power.

▶ Leopard in a Sausage Tree; oil, 28 × 36″, 1979
Following page/Barn Owl in the Church Yard; oil, 16 × 20″ 1979

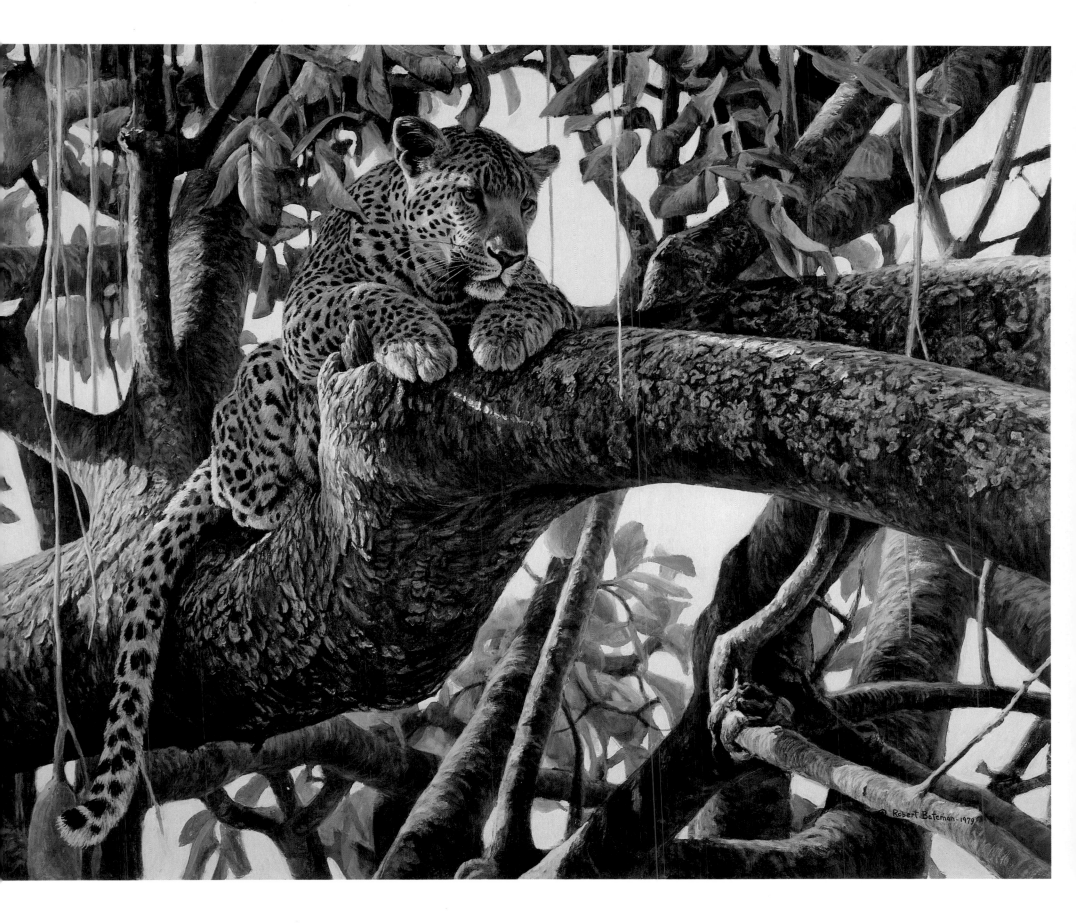

© Robert Bateman - 1979

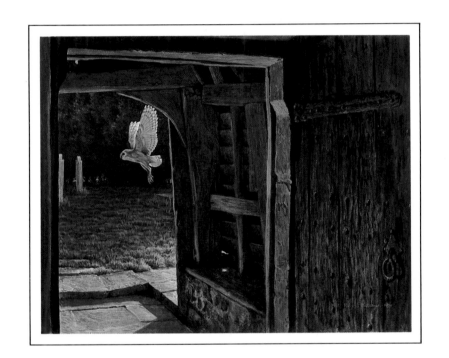

SKETCHBOOKS

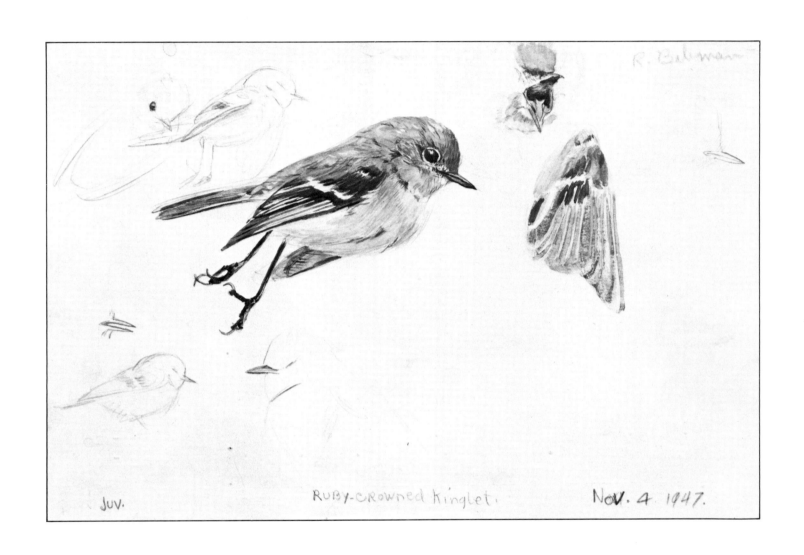

JUV. RUBY-CROWNED Kinglet. NOV. 4. 1947.

Ruby-crowned Kinglet, 1947

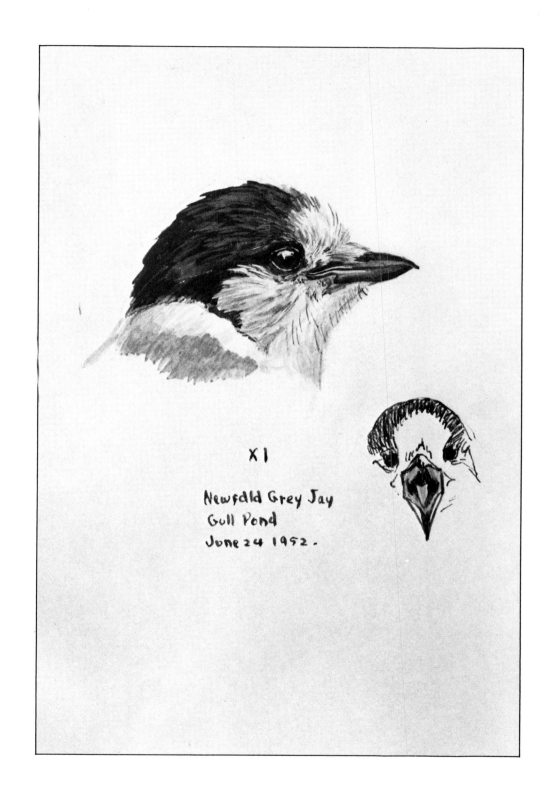

X1

Newfdld Grey Jay
Gull Pond
June 24 1952.

Newfoundland Gray Jay, 1952

June 4 1952
Badger Newfdld.

Great-spurred Violet, 1952

X1

June 25 1952
Gull Pond
Dark spruce woods
Ht. 9"

X1 June 4 1952
Badger. Nfdld.

Moccasin-flower, 1952

Leatherleaf, 1952

Horned Sculpin, 1952

▶ Belted Kingfisher beak, 1976

ivory to tip with
black edge.

A — B A ⌣ B
front
tip of throat
feathers

C — D C () D

Kingfisher ♀
Oct 16
Eramosa

E — F E ⌣ F

168

European Woodcock, 1979

Wilson's Storm Petrel, 1979

170

Lioness, 1979

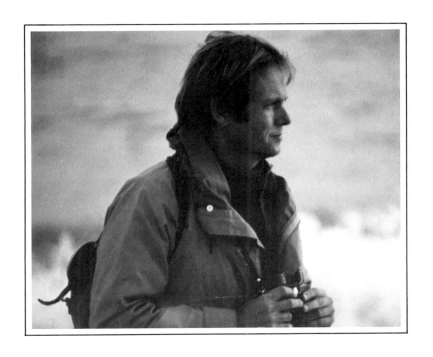

APPENDIX

INDEX TO THE COLOUR PLATES

*These works, as well as other paintings by Robert Bateman, have
been published as limited edition prints by Mill Pond Press. For
more information about their print publishing program please direct
inquiries to the appropriate address.

In the United States:
Mill Pond Press Inc.
310 Center Court
Venice, Florida
33595

In Canada:
Nature's Scene
976 Meyerside Drive, Unit 1
Mississauga, Ontario
L5T 1R9

EXHIBITIONS

1959 – Hart House Gallery, University of Toronto, Toronto, Ontario, Canada

1967 – Alice Peck Gallery, Burlington, Ontario, Canada

1968 – York University, Toronto, Ontario, Canada (group exhibition)

1969 – Pollock Gallery, Toronto, Ontario, Canada

1971 – Beckett Gallery, Hamilton, Ontario, Canada

1972 – *Bird Artists of the World,* Tryon Gallery, London, England (group exhibition)

1974 – *The Acute Image in Canadian Art,* Mount Allison University, Sackville, New Brunswick, Canada (group exhibition)

1975 – *Endangered Species,* Tryon Gallery, London, England (group exhibition)
 – *One Man's Africa,* Tryon Gallery, London, England
 – *Animals in Art,* Royal Ontario Museum, Toronto, Ontario, Canada (group exhibition)
 – *African Bird Art,* Peter Wenning Gallery, Johannesburg, South Africa (group exhibition)
 – *Canadian Nature Art,* travelling exhibit sponsored by the Canadian Nature Federation (group exhibition)

1976 – Beckett Gallery, Hamilton, Ontario, Canada

1977 – *Birds of Prey,* Glenbow-Alberta Institute, Calgary, Alberta, Canada (group exhibition)
 – *Queen Elizabeth Jubilee Exhibition,* Tryon Gallery, London, England (group exhibition)
 – *Federation of Ontario Naturalists Exhibition,* University of Guelph, Guelph, Ontario, Canada (group exhibition)
 – *1977 Bird Art Exhibition,* Leigh Yawkey Woodson Art Museum, Wausau, Wisconsin, U.S.A. (group exhibition)
 – *A Wildlife Exhibition,* Tryon Gallery, London, England
 – *Wolves: Fact versus Fiction,* The Gallery, First Canadian Place, Toronto, Ontario, Canada (group exhibition)

1978 – Art Gallery of Hamilton, Hamilton, Ontario, Canada
 – Lynnwood Art Gallery, Simcoe, Ontario, Canada
 – *Northwest Rendezvous Group Exhibition,* National Historical Society Building, Helena, Montana, U.S.A. (group exhibition)
 – *1978 Bird Art Exhibition,* Leigh Yawkey Woodson Art Museum, Wausau, Wisconsin, U.S.A. (group exhibition)
 – Beckett Gallery, Hamilton, Ontario, Canada
 – *The Artists and Nature,* travelling exhibit sponsored by the Canadian Wildlife Federation and the National Museum of Natural Sciences, Ottawa, Ontario, Canada (group exhibition)

1979 – *Society of Animal Artists Exhibition,* Sportsman's Edge Ltd., New York, New York, U.S.A. (group exhibition)
 – *Four Continents: Birds, Animals and their Environments,* Tryon Gallery, London, England
 – *Wildlife Art,* Cowboy Hall of Fame, Oklahoma City, Oklahoma, U.S.A. (group exhibition)
 – *Northwest Rendezvous Group Exhibition,* National Historical Society Building, Helena, Montana, U.S.A. (group exhibition)
 – *1979 Bird Art Exhibition,* Leigh Yawkey Woodson Art Museum, Wausau, Wisconsin, U.S.A. (group exhibition)
 – *The Dofasco Collection,* Art Gallery of Hamilton, Hamilton, Ontario, Canada (group exhibition)

1980 – St. Louis Museum of Science and Natural History, St. Louis, Missouri, U.S.A.
 – *Selections from the Dofasco Collection,* Art Gallery of Brant, Brantford, Ontario, Canada (group exhibition)
 – *Birds,* Smithsonian Institution, Washington, D.C., U.S.A. (group exhibition)
 – *Northwest Rendezvous Group Exhibition,* National Historical Society Building, Helena, Montana, U.S.A. (group exhibition)
 – *Trailside Group Exhibition,* Trailside Gallery, Jackson Hole, Wyoming, U.S.A. (group exhibition)
 – *1980 Bird Art Exhibition,* Leigh Yawkey Woodson Art Museum, Wausau, Wisconsin, U.S.A. (group exhibition)
 – *Society of Animal Artists Exhibition,* Four Seasons Internacional, San Antonio, Texas, U.S.A. (group exhibition)
 – Sportsman's Edge Ltd., New York, New York, U.S.A.
 – Beckett Gallery, Hamilton, Ontario, Canada
 – Trailside Gallery, Jackson Hole, Wyoming, U.S.A. (two-man exhibition)

1981 – *Images of the Wild,* travelling exhibit sponsored by the National Museum of Natural Sciences, Ottawa, Ontario, Canada

PUBLICATIONS

American Artist: M. Stephen Doherty, "Robert Bateman: The *American Artist* Collection, 1980 Selection," pp. 17, 48-53 and front cover, vol. 44, no. 460, November 1980.

Audubon: "The Raptors of Robert Bateman," pp. 50-59, vol. 82, no. 6, November 1980.

Birds: George H. Harrison, "Birds in Art," p. 41, vol. 7, no. 6, Summer 1979.

Bird Watcher's Digest: cover, vol. 2, no. 3, January/February 1980; cover, vol. 2, no. 6, July/August 1980.

Dofasco Illustrated News: centrefold, vol. 39, issue 3, 1975: Gregg Stott, "Robert Bateman," pp. 2-5 and front cover, vol. 44, issue 6, 1980.

Imperial Oil Review: James Hickman, "Nature's Record," pp. 16-19, vol. 60, no. 4, issue 330, 1976.

International Wildlife: Manuel Escott, "Creatures of the Snow," pp. 20-25, vol. 8, no. 2, March/April 1978.

Nature Canada: J. Bruce Falls, "Robert Bateman," pp. 18-20, vol. 1, no. 1, January/March 1972; pp. 13, 26-27, vol. 9, no. 4, October/December 1980.

National Wildlife: cover, vol. 19, no. 1, December 1980/January 1981.

Ontario Naturalist: photo essay, pp. 18-23, vol. 9, no. 4, December 1971; back cover, vol. 16, no. 4, September/October 1976; back cover, vol. 17, no.4, October 1977. See also *Seasons*.

Seasons (formerly *Ontario Naturalist*): back cover, vol. 20, no. 3, Autumn 1980.

Southwest Art: David M. Lank, "From Mountain Heights to Forest Floor — Robert Bateman Paints Wildlife," vol. 10, no.4, September 1980.

Sports Afield: Zack Taylor, "Robert Bateman: Wonder of the Wild," pp. 78-83, vol. 183, no. 1, January 1980.

The Nature of Birds: "Illustrated Natural History of Canada," The Canadian Publishers, McClelland and Stewart Ltd., Toronto, Ontario, Canada, 1974.

COMMISSIONS

1976 — World Wildlife Fund: designed a relief sculpture of a polar bear for a limited edition silver bowl to raise funds for endangered species.

1977 — Canada Post: designed the annual stamp series depicting endangered species.
— Board of Trade of Metropolitan Toronto, Ontario, Canada: painted "Window into Ontario" to be hung in the Board of Trade Building.
— Tryon Gallery, London, England: painted "King of the Realm" for the Queen Elizabeth Jubilee Exhibition.

1980 — *American Artist* magazine: painted "Kingfisher in Winter" for the *American Artist* Collection.

1981 — Government of Canada: a painting of a Common Loon family to be presented to H.R.H. Prince Charles, the Prince of Wales as one of the wedding gifts from the people of Canada.

FILMS

Images of the Wild: A Portrait of Robert Bateman. National Film Board of Canada, directed by Norman Lightfoot, produced by Beryl Fox, 1978.

Robert Bateman. Canadian Broadcasting Corporation, produced by John Lacky for *This Land,* 1972.

The Nature Art of Robert Bateman. Eco-Art Productions, produced by Norman Lightfoot, 1981.

DESIGN	V. John Lee
PRODUCTION	Susan Barrable
EDITORIAL	Ramsay Derry
EDITORIAL ASSISTANCE	Hetty Ventura Aaron
	Sarah Reid
	Shelley Tanaka
PRODUCTION PHOTOGRAPHY	Robert Bateman
	Mill Pond Press
	Vida/Saltmarche
PHOTO-TYPOGRAPHY	Shervill-Dickson Typographers Limited
COLOUR SEPARATION	Empress Litho Plate Ltd.
PRINTING AND BINDING	Arnoldo Mondadori S.p.A.

The Art of Robert Bateman
was produced by Madison Press Books
under the direction of
A.E. Cummings